# Damaged
## Romanticism
*A Mirror of Modern Emotion*

# Damaged
# Romanticism
## *A Mirror of Modern Emotion*

Terrie Sultan :: David Pagel :: Colin Gardner :: Claudia Schmuckli
With a short story by Nick Flynn

Blaffer Gallery, the Art Museum of the University of Houston
in association with D Giles Limited, London

*Damaged Romanticism: A Mirror of Modern Emotion* was organized for Blaffer Gallery, the Art Museum of the University of Houston, by Terrie Sultan, director, The Parrish Art Museum (former director of Blaffer Gallery); David Pagel, assistant professor of Art Theory and History at Claremont Graduate University; and Colin Gardner, professor in Critical Theory and Integrative Studies at the University of California, Santa Barbara. The exhibition and publication are made possible, in part, by the Elizabeth Firestone Graham Foundation, The Cecil Amelia Blaffer von Furstenberg Endowment for Exhibitions and Programs, and the Consulate General of the Federal Republic of Germany.

Published by D Giles Limited in association with Blaffer Gallery, the Art Museum of the University of Houston, on the occasion of the exhibition *Damaged Romanticism: A Mirror of Modern Emotion.*

D Giles Limited
2nd Floor
162–164 Upper Richmond Road
London SW15 2SL
UK
www.gilesltd.com

Blaffer Gallery, the Art Museum
of the University of Houston
120 Fine Arts Building,
Houston, Texas 77204-4018
www.blaffergallery.org

**Exhibition venues:**
• Blaffer Gallery, the Art Museum
  of the University of Houston
  *August 22–November 15, 2008*
• Grey Art Gallery, New York University
  *January 13–April 4, 2009*

The exhibition and publication were organized for Blaffer Gallery, the Art Museum of the University of Houston, by Terrie Sultan, director.
**Co-curator:** David Pagel
**Project Manager, Blaffer Gallery:** Rachel Hooper
**Editor:** Mary Christian

**D Giles Limited**
**Managing Director**: Dan Giles
**Project Manager**: Sarah McLaughlin
**Editor**: Melissa Larner
**Design**: Miscano Design, London
Printed and bound in Singapore

**ISBN** 978-1-904832-51-5

**Frontispiece**
Florian Maier-Aichen. Detail of *Untitled (Long Beach)*, 2004. C-print, 71 ½ × 92 ½ in. (181.6 × 235 cm)

# CONTENTS

# Acknowledgments

For more than ten years, I have been fascinated by artists who recognize the creative potential of intellectual and emotional disappointment. Along with my colleagues Jérôme Sans (then the co-director of the Palais de Tokyo in Paris), Colin Gardner (then assistant professor at the University of California, Santa Barbara), I developed a detailed thesis in 2000 for an exhibition called *Disappointment and Resignation*. Although that project did not come to fruition, the idea continued to engage my thoughts, until a fresh point of view took shape in 2005 during a free-ranging conversation that I had with David Pagel and Christopher French. What emerged was a recognition that disappointment and resignation could be, and was, in the work of many artists, viewed as a platform from which to build a more optimistic way forward.

*Damaged Romanticism* would not have seen the light of day without the intellectual generosity of what became the co-curatorial team: David Pagel, Colin Gardner, and Claudia Schmuckli. All three played significant roles in the selection of artists and in the development of this book. All provided invaluable suggestions that helped shape my introductory essay, as did Christopher French, who has been a sounding board throughout the long gestation period of the project. With his new work of fiction, Nick Flynn contributed a nuanced and challenging voice to the dialogue, defining the very nature of damaged romanticism.

We are very grateful to our funders, the Elizabeth Firestone Graham Foundation and the Cecil Amelia Blaffer von Furstenberg Endowment for Exhibitions and Programs, whose support was essential in realizing the project.

Mary Christian provided a keen eye in editing all aspects of this hydra-headed manuscript, and Rachel Hooper, Cynthia Woods Mitchell Curatorial Fellow, managed the Herculean task of assembling the photographic reproductions for the publication and oversaw the production of the manuscript. A team of dedicated interns: Aja Young, Elspeth Patient, Cesar Vides and Celeste Diaz assembled the biographies and bibliographies for each artist, and Catherine Essinger and Jackie Rocha worked diligently on fact-checking and filling in details. Special thanks to the staff at Blaffer Gallery, the Art Museum of the University of Houston: Kelly Bennett, exhibition designer and chief preparator; Jeff Bowen, assistant director of external affairs; Youngmin Chung, assistant registrar; Susan Conaway, director of external affairs; Measa Kuhlers, chief of security; Michael Guidry, curator of the University Collection; Nancy Hixon, assistant director and registrar; Katy Lopez, assistant curator of education; Katherine Veneman, curator of education; and Karen Zicterman, museum administrator.

My thanks to the many private collectors who generously agreed to share their works with the public for the exhibition, and to the galleries and their staff for their help in securing loans: Bruce and Barbara Berger, Blum & Poe, Key Collie, Paula Cooper Gallery, Charles Cowles Gallery, Martin Eisenberg, Galerie LeLong, Sandroni Hirshberg and Kristin Rey, George Lindemann Sr., Sue Hancock, June Mattingly, Heather and Tony Podesta Collection, Anthony Reynolds Gallery, Perry Rubenstein Gallery, Mr. and Mrs. Lester Smith, Mia Sundberg Galleri, Ryan Taber/Cheyenne Weaver, Julie and John Thorton, Leslie Tonkonow Artworks + Projects, and Carol Windham.

We appreciate the assistance of the many who helped secure the images and clear the rights and reproductions: Esther Shafran at the Ansel Adams Publishing Rights Trust; Tina Wentrup at Arndt & Partner; Alexandra Gaty and Renée Martin at Blum & Poe; The Bridgeman Art Library; Sofia Coppola and Steven Farneth at Cinetic Media; Paula Cooper and Anthony Allen at Paula Cooper Gallery; Charles Cowles

and Mary E. Dohne at Charles Cowles Gallery; Berlinde De Bruyckere and Annemie Knaepen at the studio of Berlinde De Bruyckere and Peter Buggenhout; Ulrike Bernhard at Galerie Eigen + Art; Alexander Mouret at Fortissimo Film Sales; Mark Hughes and Stephanie Joson at Galerie Lelong; Amy Sullivan and Miranda Lash at The Menil Collection; Felicia Davis at MGM Clip and Still Licensing; Mary McCleary; Betty Moody and Adrian Page at Moody Gallery; Bill Murray; Kristia Moises and Julie Morhange at Galerie Emmanuel Perrotin; Heather and Tony Podesta and Gaby Mizes at the Heather and Tony Podesta Collection; Jona Wirbeleit at Reverse Angle; Anthony Reynolds and Maria Stathi at Anthony Reynolds Gallery; Dan Rizzie; Nicelle Beauchene, Michael McKinney, John O'Hara, and Caroline Dowling at Perry Rubenstein Gallery; Tara Sandroni, Kristin Rey, and Douglas MacLennan Hirshberg at Sandroni Rey; Ellie Bronson at Sikkema Jenkins & Co; Mia Sundberg and Sofia Nilsson at Mia Sundberg Galleri; the studio of Ryan Taber and Cheyenne Weaver; Leslie Tonkonow and Jennie Lamensdorf at Leslie Tonkonow Artworks + Projects; Marcus Schubert at Toronto Image Works; Ronni Lubliner at Universal Clips and Stills; Gosia Wojas at Susanne Vielmetter Los Angeles Projects; and Karen Mansfield at Worcester Art Museum.

Dan Giles, Sarah McLaughlin, Melissa Larner, and Miscano of D Giles Ltd., London, have created this extraordinary publication, where form deftly follows function, and I thank them for their creative insight.

And finally, I extend my deepest appreciation to the fifteen participating artists whose provocative creativity provided the inspiration for this project: Richard Billingham, Berlinde De Bruyckere, Edward Burtynsky, Sophie Calle, Petah Coyne, Angelo Filomeno, Jesper Just, Mary McCleary, Florian Maier-Aichen, Wangechi Mutu, Anneè Olofsson, Julia Oschatz, David Schnell, Ryan Taber, and Cheyenne Weaver.

*Terrie Sultan*

# Damaged Romanticism: A Mirror of Modern Emotion
*Terrie Sultan*

In 1998 Thomas L. Dumm published "Resignation," an essay examining the predisposition toward disappointment in life. He dissected this subject using two letters of resignation: one by an unnamed academic who, having been denied tenure, resigns her position and ponders the exact way her letter should be framed; the other the precise text of Richard Nixon's 1974 letter of resignation from the Presidency of the United States.[1] Dumm concludes that disappointment results in a diminished faith in others, and so is an occasion of resignation in the sense of a loss of appointment. The act of resignation thus marks the site of real or imagined trauma, although it is invariably masked by attempts to contain and eventually smooth over its effects. However, Dumm also writes: "Sometimes disappointment deepens, encompasses such a wide scope that it overmatches our prior expectations, overwhelms our abilities, and threatens to shade into a more general disillusion that would stop us cold. Thus, one ethical task of critical thinking might be to steer us through our disappointment; to prevent it from turning into a permanent disillusionment; to make of our disappointment a plausible beginning, rather than a certain ending."[2]

Dumm's conclusions seemed to outline the core of the human condition on the cusp of a new century. They also closely corresponded to my curatorial experience of the work of many artists who were formulating aesthetic responses to how occasions of rupture and loss in everyday life could in fact lead to optimism, even redemption. In 1999 I conceived an exhibition entitled *Disappointment and Resignation* to explore ideas percolating in the visual arts, but set aside this project after the events of September 11, 2001 precluded the idea of dwelling on this topic.

For the next six years, though, it seemed that everything to which I was drawn—from Paul Auster's emotionally devastating memoirs and fictions[3] to photographs by Richard Billingham, video installations by Jesper Just, sculpture by Berlinde De Bruyckere and Petah Coyne, and films by Wim Wenders (fig. 1) and Wong Kar-wai[4]—demonstrated how redemptive action could arise from the ashes of disappointment. Preoccupied with other ideas, I discounted these occurrences, but by 2006 I simply could not ignore what my eyes were telling me. Although disappointment remained a significant theme into the twenty-first century, it became increasingly clear that other forces were in play, including historical influences as diverse as the baroque, neoclassicism, and especially romanticism. Out of this altered aesthetic landscape was born *Damaged Romanticism*, which focuses on how initial disappointment can be mitigated, so that rather than descending into disillusionment, hopelessness, or despair, what begins as morbidity can be transformed into optimism, laughter, or even creative resurrection. According to the concept of "damaged romanticism," the often phantasmagorical exoticism of late eighteenth-century romanticism crashes headlong into the present, where idylls as well as confrontations are modified by the clarity of pragmatic realism.

The works in the exhibition *Damaged Romanticism* capture the complexity of contemporary reality by giving form to ambivalent, even contradictory sentiments. Suffering is neither sugar-coated as some exquisitely masochistic sign of virtuous victimhood or gloriously symbolic martyrdom; nor does it provide an excuse to wallow in misery, malaise, and trendy world-weary cynicism. In *Damaged Romanticism*, rebellion, disillusionment, and defiance come together, strengthening and tempering each other much as heat tempers iron into steel.

The works included in this exhibition are neither nihilistic nor utopian. Rather, they are stubbornly optimistic and illustrate what we might call an "aftermath aesthetic," determined by the feelings and

**1.** See Thomas L. Dumm, "Resignation," *Critical Inquiry* 25, no. 1 (Autumn 1998), pp. 56–76. The academic chooses to use a blank sheet of paper, and writes: "Dear Professor K, I resign." (58). Nixon, on official White House stationary, wrote to Henry Kissinger August 9, 1974, "Dear Mr. Secretary, I hereby resign the Office of the President of the United States."

**2.** Ibid., p. 56–57.

**3.** For example, *The Invention of Solitude*,1982, *Hand to Mouth*, 1997, *The Book of Illusions*, 2002, and *Brooklyn Follies*, 2005.

**4.** These include films by Wenders such as *Wings of Desire* (*Der Himmel über Berlin*), 1987, *Paris, Texas*, 1984, and Wong's *In the Mood for Love* (*Fa yeung nin wa*), 2000, *Eros* ("*The Hand*" segment), 2004 and 2046, 2004.

Fig.1

actions engaged in after the deluge, heartbreak, or devastation of life. At the core of these works is the recognition that easy answers, like fantasies, are traps; that blank slates actually involve violent erasure; and that starting fresh is both a cataclysm and an opportunity worth the risk of psychological scars. Built on the knowledge that rebirth grows out of experiences of things gone wrong, the ameliorations of damaged romanticism are couched in the recognition that, paradise or no, the future can be better than the present. A survivor's sensibility, damaged romanticism brooks no illusions about the difficulty of the struggle or the chance for success. The works of damaged romantics bear witness to themes common among enduring cultures—the silence of irrecoverable loss, the sadness of mourning, the incomprehensibility of extreme trauma, and the psychological complexity born of an awareness of fate's capricious finality.

### The Themes that Reflect Us

Curatorial explorations into the continuing influence of romanticism on contemporary art over the past decade or so can roughly be divided into two categories: on the one hand, exhibitions that consider the emergence of alternative worldviews as a counterpoint to the multiple economic, political, and social challenges of our age—exhibitions such as *Romantic Detachment* and *Ideal Worlds: New Romanticism in Contemporary Art*;[5] or, on the other, projects focused on harsh visions of reality that foreground the more disturbing aspects of existence—*Disparities And Deformations: Our Grotesque, Dark*, or the 2006 Whitney Biennial *Day for Night*.[6]

**5.** *Romantic Detachment* (New York: P.S.1, October 16–November 7, 2004), and *Wunschwelten/Ideal Worlds: New Romanticism in Contemporary Art* (Frankfurt: Schirn Kunsthalle, May 12–August 28, 2005). Although different in scope, both exhibitions put forward artistic concepts that provided an alternative, safe realm, or promoted an aesthetic of fantastical beauty. In this sense, they manifest the escapist tendency of classical romanticism.
**6.** For all their differences, *Disparities And Deformations: Our Grotesque* (Fifth International Biennial, Site Santa Fe, July 18, 2004–January 9, 2005), *Dark* (Rotterdam, Museum Boijmans Van Beuningen, February 18–April 17, 2006), and *Day for Night* (2006 Whitney Biennial, New York, Whitney Museum of American Art, March 2–May 28, 2006) portrayed the current intellectual climate in terms of obfuscation, impurity, oppression, and secrecy.

Fig.2

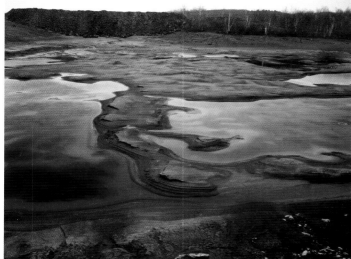

Fig.5

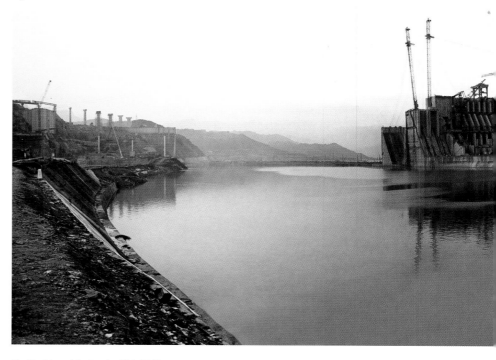

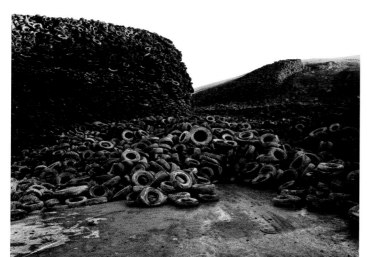

Fig.3

**Fig. 2**   Edward Burtynsky. *Nickel Tailings #36, Sudbury, Ontario*, 1996. C-print, dimensions variable

**Fig. 3**   Edward Burtynsky. *Oxford Tire Pile #5, Westley, California*, 1999. C-print, dimensions variable

**Fig. 4**   Edward Burtynsky. *Bao Steel #8, Shanghai*, 2005. C-print, dimensions variable

**Fig. 5**   Edward Burtynsky. *Three Gorges Dam Project, Dam #2, Yangtze River, China*, 2002. C-print, dimensions variable

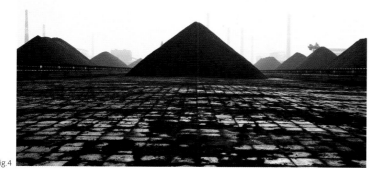

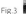
Fig.4

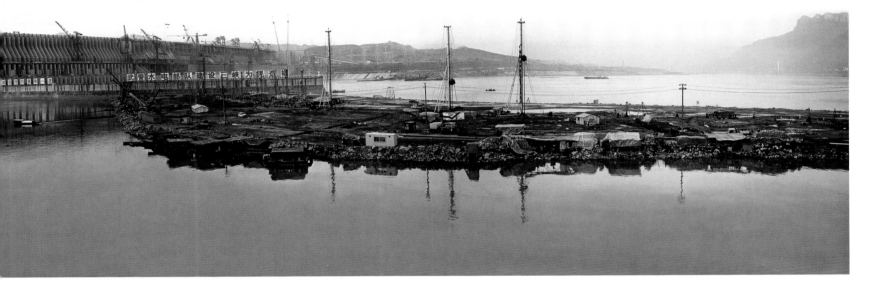

*Damaged Romanticism* takes a different approach: the works assembled here offer the cathartic potential of resolution and redemption. In the face of today's political instability, economic insecurity, and social isolation, these artists present slivers of life in all its complexity and complication while offering glimpses of reconciliation grounded in observation, a profound realism, and a belief in the potential of self-empowerment.

Recent natural and man-made disasters have made the idea of proactive engagement seem like a futile gesture. The collision between romantic ideals and often harsh and depressing contemporary events is central to the idea of the aftermath aesthetic and is viewed through depictions of the modern landscape by several artists in this exhibition: photographers Edward Burtynsky, Richard Billingham, and Florian Maier-Aichen; painter David Schnell; and the collaborative installation artists Ryan Taber and Cheyenne Weaver.

Edward Burtynsky's large-scale photographs capture the upheaval, disaster, and sublimity of industrial globalization. His expansive landscapes are irredeemably altered by human striving, and they merge the sublime with the savagely demeaned. His subjects can be land ruined by mining (fig. 2), altered by refuse (fig. 3), intruded upon by industry (fig. 4) or made to disappear entirely (fig. 5). Beauty abounds in Burtynsky's classically composed landscapes, which superimpose the scale, sumptuousness, and individual perception of traditional romanticism onto a cancerous, perhaps terminally ill world. If Ansel Adams (1902–84) monumentalized the organic splendor of nature in black-and-white through much of the twentieth century (fig. 6), Burtynsky uses color to index the often toxic results of industry, proposing vistas on which some of the main dramas of the twenty-first century will be staged. In his haunting 2000 series *Shipbreaking* (figs. 71–5),

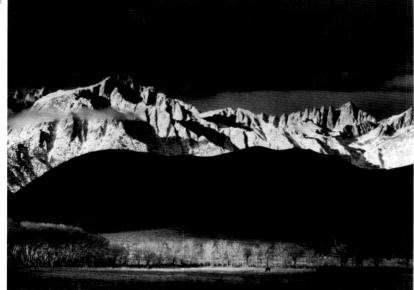

Fig.6

Fig.7

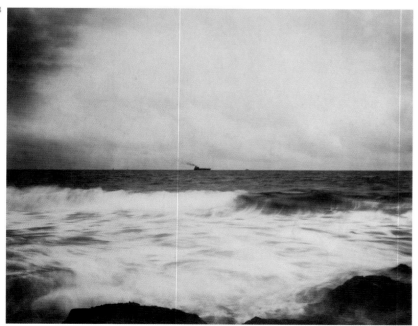

Fig.8

Burtynsky depicts an elephant graveyard, where the hulking majesty of freighters, tankers, and large container ships go to die. The gargantuan remains of these man-made giants are majestically desecrated, inspiring sadness and a sense of loss that overwhelms the human agents of their demise.

Like Burtynsky, Florian Maier-Aichen focuses on landscape as a jumping-off point for understanding how humans relate to nature. However, Maier-Aichen digitally alters the color and compositions of his images, knocking our perceptions off-kilter, creating unreal worlds that challenge our visual acuity and intellectual understanding of time and place by suggesting how the earth might yet become. He approaches image-making like a painter, adding visual gestures that underpin an almost apocalyptic vision of the natural world—whether an acid view of the California coast, seething and hotly red as it meets the sea (fig. 7) or a boiling ocean, rising like a hallucination into the atmosphere (fig. 8). His eerie nightscapes (fig. 9) evoke a silent, distanced interaction between man and nature, a "convulsive movement between micro and macro"[7] that underpins his creative vision. Since the early years of the twentieth century, urban night views have often invited the viewer into a world of sparkling modernist optimism, but Maier-Aichen's view from far above is detached from the roiling masses and gritty interactions that we know must occur below. His images are populated only through suggestion, and his bird's-eye views read like science-fiction prophesies of what is to come. Breathtaking in scope and content, his photographs propose a depopulated world view inexorably altered by technology.

In *Black Country*, 1997–2003, Richard Billingham locates aesthetics and metaphysics in domestic interiors and suburban landscapes. A few years after creating the emotionally wrenching narrative series *Ray's a Laugh*, 1990–5, which captured his family's stark life in a cramped council-housing flat in Cradley Heath, England, Billingham returned to his home turf to re-explore his upbringing in terms of the terrain that shaped the people who inhabited it. The scenarios comprising *Ray's a Laugh* (figs. 10 and 62–3) were shot in claustrophobic, tight compositions capturing the raw emotions that discharge in

7. Jan Tumlir, "Outside the Frame: Florian Maier-Aichen," *Aperture* 187 (2007), p. 51.

Fig.9

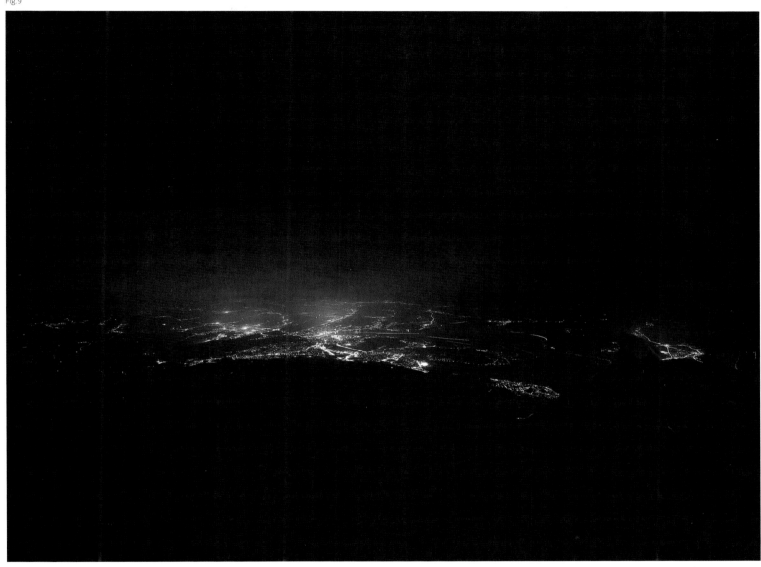

**Fig. 6** Ansel Adams. *Winter Sunrise, Sierra Nevada from Lone Pine, California*, 1944. Silver gelatin, 14 ½ × 19 ¼ in. (36.8 × 48.9 cm). The Menil Collection, Houston

**Fig. 7** Florian Maier-Aichen. *Untitled*, 2005. C-print, 72 × 90 ½ in. (182.9 × 229.9 cm)

**Fig. 8** Florian Maier-Aichen. *Untitled*, 2005. Albumen print, 23 ¾ × 27 ¾ in. (60.3 × 70.5 cm)

**Fig. 9** Florian Maier-Aichen. *Untitled*, 2005. C-print, 72 ¼ × 95 in. (183.5 × 241.3 cm)

Fig.10

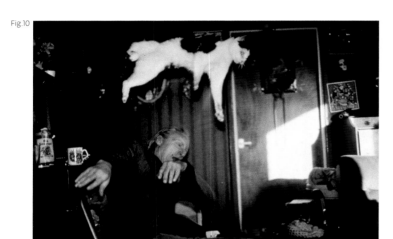

Fig.12

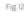

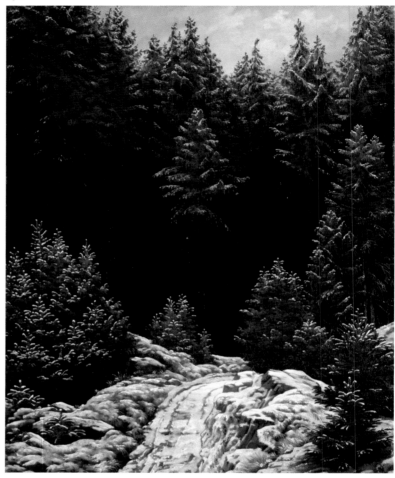

Fig.11

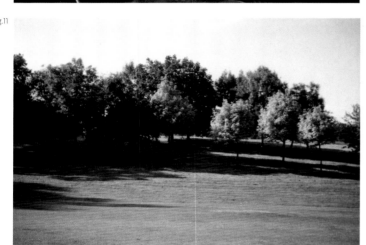

tight quarters, as well as the struggle to construct meaning while living *in extremis*. The disappointment and resignation of these often heartbreaking photographs are mitigated by an almost desperate sense of possibility. By contrast, the images of *Black Country*—the first shot in daylight (figs. 11, 64) and later at night (figs. 65–7) —open out into the urban landscape. As Billingham explains, "To me, the daytime pictures embody that longing and sense of immanent loss ... The night-time pictures are more settled maybe. There is no sense of loss like in the earlier work but more a sense of discovery."[8] Both series are imbued with a feeling of transformation and confidence. In contrast to the noisome composition and psychological claustrophobia of *Ray's a Laugh*, the images of *Black Country* are eerily open and expansive, peppered with humanizing traces even as they are devoid of human presence.

David Schnell paints the present from the point of view of the very near future, looking back on contemporary civilization as if it has just ended. His paintings provide a compositionally complex perspective on the natural world. He is keenly aware of his historical aesthetic forebears—especially the

**8.** Richard Billingham's *Black Country*, interview with David Osbaldestin. It was posted online in May 2005, *Fused Magazine* 23. http://www. fusedmagazine.com/Past_Issues/Issue_23/RICH-ARD_BILLINGHAM.aspx (accessed 10/7/2007).

German romantic landscape painter Caspar David Friedrich (1774–1840), whose depiction of the natural world combined a mystical fusion of religious faith, science, and empirical rationalism (fig. 12). But while the human figure often appears in Friedrich's landscapes, Schnell's unpopulated images feature mysterious yet familiar architectural structures set in dense forests or the bucolic countryside, places that pair visual splendor with contemplative solitude (figs. 13–15). Suffused with an unnatural stillness, their silence has less to do with serenity than with suspension. The artist also outlines man-made structures in a skeletal manner that suggests that they are not part of civilization's infrastructure, and indeed, there are no civic buildings, massive bridges, or other monuments to civilization's progress in his works. Instead, he depicts far less permanent habitations built for leisure and recreation: wooden grandstands, mechanical ski lifts, and rustic wooden bridges. The inessential quality of such places haunts Schnell's depictions of them, giving his understated works an oddly elegiac, poignant power that is couched as much in personal memory of individual times past as in the prospect of a brighter, buoyant future for society.

The intersection of science, history, fantasy, and myth-making is at the heart of the multilayered sculptures, concocted from myriad scavenged and constructed objects, and accompanying drawings by

**Fig. 10** Richard Billingham. *Untitled*, 1995. Color photograph on aluminum, 41 ⅜ × 62 ¼ in. (105 × 158 cm)

**Fig. 11** Richard Billingham. *Untitled #6*, 1997. C-print, 29 ½ × 36 ¼ in. (75 × 92 cm)

**Fig. 12** Caspar David Friedrich. *Early Snow*, c. 1828. Oil on canvas, 17 ¼ × 13 ⅝ in. (43.8 × 34.5 cm). Hamburger Kunsthalle, Hamburg, Germany

**Fig. 13** David Schnell. *Veranda*, 2005. Oil on canvas, 55 ⅛ × 31 ½ in. (140 × 80 cm). Arario Collection, Seoul, Korea

**Fig. 14** David Schnell. *Dorf*, 2005. Oil on canvas, 94 ½ × 63 in. (240 × 160 cm). Arario Collection, Seoul, Korea

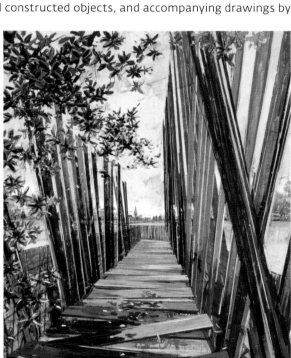

Fig.13

Fig.14

Fig.15

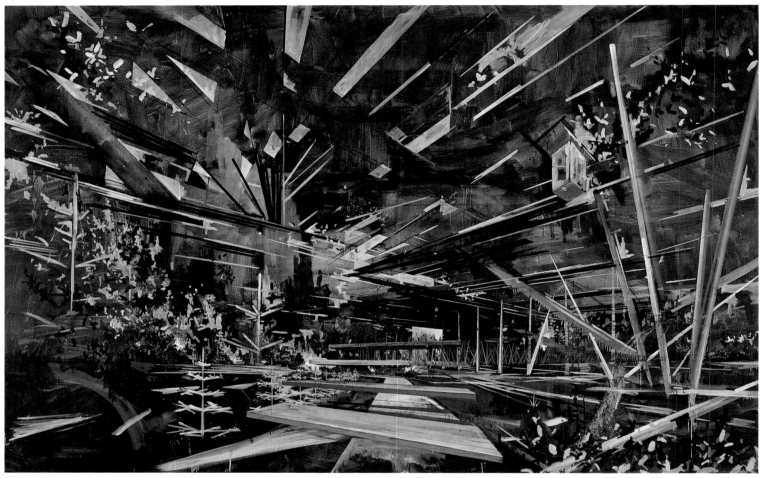

**Fig. 15**  David Schnell. *Treibhaus*, 2007. Oil on canvas, 86 ⅝ × 137 ¾ in. (220 × 350 cm)

**Fig. 16**  Ryan Taber and Cheyenne Weaver. *Yncke Of The Medusa*, 2005, replica of the model of the escape raft built by shipwreck survivors J. B. Henri Savigny and Alexandre Correard, in Théodore Géricault's studio to conduct studies for the painting *Raft of The Medusa*, 1819 (originally built from salvaged material from the sinking of the frigate *Medusa*, 1816) constructed from materials scavenged from a replica of an etching press from Correard's politically dissident print house, Au Naufrage de la Méduse. Wood, foam, epoxy, polyester resin, 156 × 108 × 48 in. ( 396.2 × 274.3 × 122 cm)

the collaborative team of Ryan Taber and Cheyenne Weaver. Their allusions to landscape and nature are embedded in a dense socio-political narrative that takes us from Théodore Géricault's *Raft of the Medusa*, 1818–19 (figs. 16–17), to Richard Wagner's 'Ring' cycle, 1848–74 (figs. 18 and 127–31). Like that of Mary Shelley's 1818 gothic-romantic novel *Frankenstein*, Taber and Weaver's creative aesthetic derives from a moral inquiry into the state of the human spirit in a world altered by the sudden acquisition of knowledge. And like the monster of the novel, the visual manifestation of the team's research and writing is presented in patched-together bits and pieces of fabric and wood, a hybrid of beauty and its antonym. For *Yncke of the Medusa*, 2005, for example, the artists crafted a replica of the raft featured in Géricault's masterwork, more an abject relic than a symbol of remarkable human suffering. "The raft is without crew," the artists write, "and its apathetic sheen seems to recall a suffering more akin to a severe sunburn after a day in the Magic Kingdom."[9] These richly layered installations—marked by loss but filled with potential—are woven from multiple narratives about imperialism, hubris, conquest, taxonomy, unintended consequences, the

**9.**  Cheyenne Weaver and Ryan Taber, Project Statement for *Yincke of the Medusa*, February 23, 2006. http://www.cheyenneweaver.com/collab_medusa.html (accessed 10/9/2007).

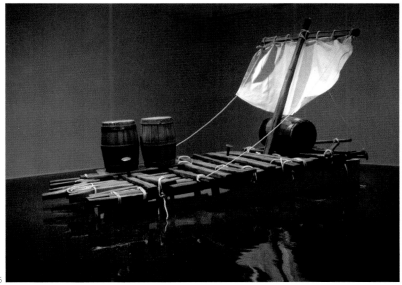

Fig.16

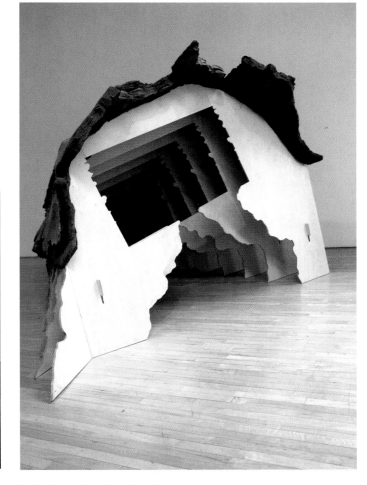

Fig.18

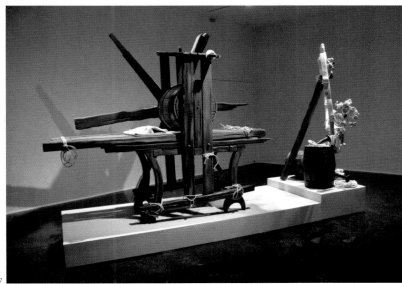

Fig.17

vulnerability of flesh, and the power of art. Above all, they emphasize the role that imagination plays in constructing, verifying, and empowering all forms of human experience.

The human body forms the physical ground on which many of our most psychologically charged issues play themselves out. Identity's mutability, the slippage between reality and fantasy, the ever-changing relationship between the self and the other, and the cyclical nature of time take pointed form in works by Berlinde De Bruyckere, Petah Coyne, and Wangechi Mutu.

Berlinde De Bruyckere operates in the interstices between concrete reality and the realm of the imagination, creating visual transformations that render the familiar strangely mysterious. Her sculptural objects mirror the fundamental ambiguities of life, balancing the impetus for nurture and shelter against the irrefutable end game of entropy. Symbols of hearth and home, such as the baskets containing thousands of lead roses in *I Never Promised You a Rose Garden*, 1992 (fig. 68) and the blankets she has used throughout her career, covering common haystacks (fig. 19), stacked tightly in open boxcar-like containers (fig. 20), or draped

**Fig. 17** Ryan Taber and Cheyenne Weaver. *Yncke Of The Medusa*, 2005, replica of an etching press from Alexandre Correard's politically dissident print house, Au Naufrage de la Méduse, at the Palais Royal, Paris, constructed from scavenged material from a replica of the escape raft built by shipwreck survivors J. B. Henri Savigny and Correard, in Théodore Géricault's studio to conduct studies for the painting *Raft of The Medusa*, 1819 with a Rococo cartouche from a French map of Senegal featuring the ingredients for Iron Gal ink. Wood, foam, epoxy, polyester resin, 156 × 108 × 48 in. (396.2 × 274.3 × 122 cm)

**Fig. 18** Ryan Taber and Cheyenne Weaver. *In Search of a Myopic's Leitmotif, Mal'Aria*, 2005; model of Chinchona Bark with Wagner's *Bayreuth Festspielhaus*, *Dermestidae Anthrenus museorum* (Linneaus, 1761) beetles, and leitmotifs from the Ring's *Waking of Brunhilde*. Europly, foam, audio, Dermestid beetles, 60 × 72 × 144 in. (152.4 × 182.9 × 365.75 cm)

Fig.19

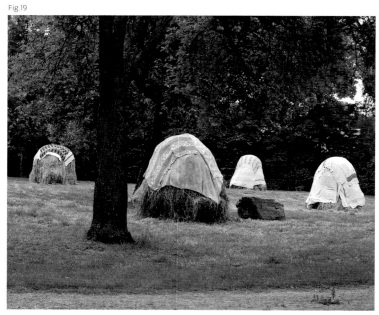

Fig.21

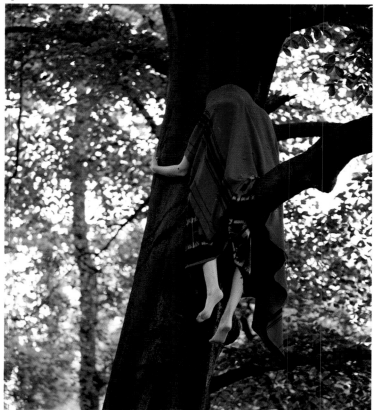

Fig.20

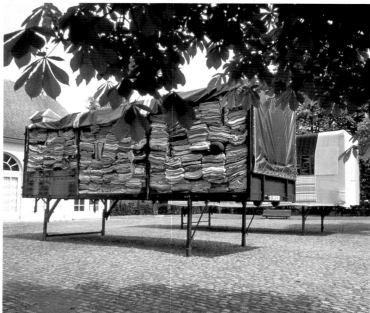

Fig.22

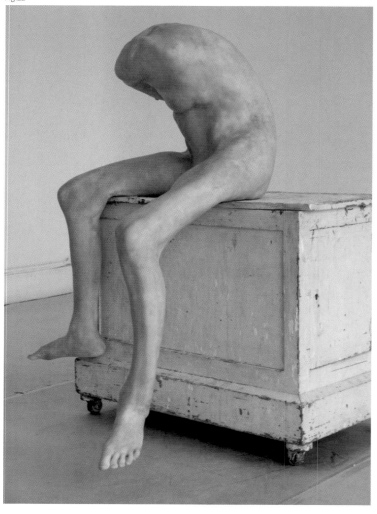

Fig.23

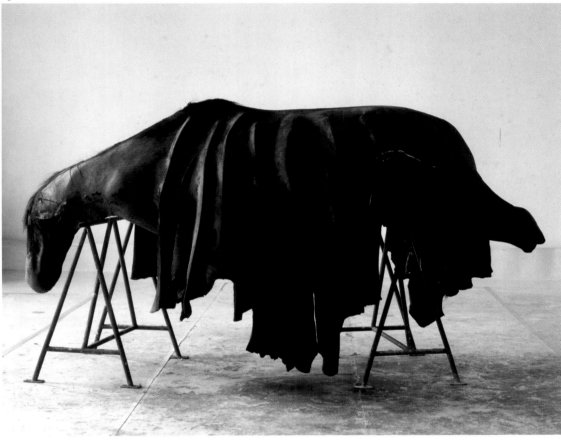

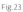

Fig. 19  Berlinde De Bruyckere. *Untitled*, 1993. Blankets, hay, wood, dimensions variable. Installation view at *Kontakt '93*, Park Klinkeshöfchen, Eupen

Fig. 20  Berlinde De Bruyckere. *Untitled*, 1995. Metal and blankets, 232 ¼ × 92 ½ × 145 ½ in. (590 × 235 × 369.3 cm)

Fig. 21  Berlinde De Bruyckere. *Woman in Tree*, 1994. Blankets, polyester, 74 ¾ × 19 ⅔ × 27 ½ in. (190 × 50 × 70 cm). Installation view at *Innocence Can Be Hell*, Park Middleheim, Antwerp

Fig. 22  Berlinde De Bruyckere. *La femme sans tête*, 2005. Wax, epoxy, wood, iron, blankets, 52 × 80 ¾ x48 ⅞ in. (132 × 205 × 124 cm)

Fig. 23  Berlinde De Bruyckere. *Lichaam (corps)*, 2002–6. Epoxy, iron, horse-skin, resin, 113 ½ × 60 ½ × 40 ¼ in. (288.5 × 153.5 × 102 cm)

over abject figures (fig. 21) suggest characters in emotionally wrought mise-en-scènes. Full of extremes, her animal/human hybrids emerge as expressions of the contorted, often contradictory pressures of personal and collective memory in contemporary life. Her materials—woolen blankets, animal skins, wax, and epoxy resin—encompass symbolic opposites of protection and defenselessness as well as security and fear, and her artworks thrive on the tension between these opposites. Works such *La femme sans tête*, 2005 (fig. 22) and *Lichaam (corps)*, 2002 (fig. 23) counterbalance emotional isolation and consolation. Profound sadness and distinctive beauty wrestle for attention in all her objects, haunted by the awareness of their own existence and their vulnerability as they seek both a point of balance and a resurgent identity.

In nature, the will to survive is balanced by inexorable cycles of destruction, decay, and rebirth. Petah Coyne has developed a keen sympathy for these rhythms. Constructed as towering armatures of indeterminate origin hanging from the ceiling (fig. 24) or rising from the floor (fig. 25) and assembled from such unlikely materials as shredded stainless steel, or multiple layers of satin ribbon, or silk flowers and sticky wax, her visceral objects suggest compassion and violence locked in a symbiotic coexistence. Coyne counterbalances horror and humor, illumination and darkness; in her work, memory is often indicated by

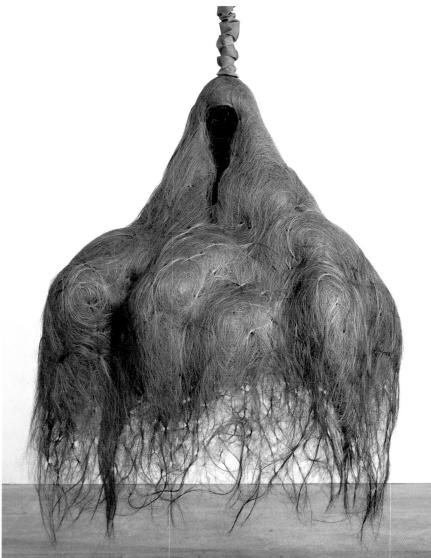

Fig.24

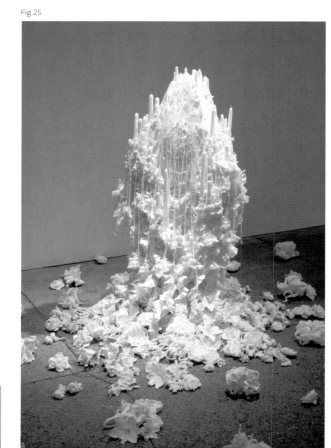

Fig.25

**Fig. 24**  Petah Coyne. *Untitled #720*
(*Eguchi's Ghost*), 1992. Shredded stainless
steel, shredded copper piping, fine strands
of gold metal, phosphorus blue and purple
metal, PVC pipe and PVC connectors,
chicken wire, wire, black silk velvet, gray
metallic organza, gold iridescent organza,
chain, jaw to jaw shackles and cable,
120 × 68 × 75 in. (304 .8 × 172.7 × 190.5 cm)

**Fig. 25**  Petah Coyne. *Untitled #1093*
(*Buddha Boy*), 2002–3. Specially formulated
wax, wax-cast statuary, ribbons, pigment,
silk flowers, bows, acetate ribbons,
chicken wire, plywood, screws, washers,
metal hardware, pearl-headed hat pins,
pearls, candles, 52 × 50 × 48 in.
(132.1 × 127 × 122 cm)

mass-produced material smothered in coatings of wax, creating a productive tension between life and life's traces. Sculptures such as *Untitled #1187 (Life Interrupted)*, 1997–2004 (fig. 26), and *Untitled #1111 (Little Ed's Daughter Margaret)*, 2003–4 (fig. 27), blur the boundaries between physical and spiritual notions of identity. Built around armatures of stuffed birds, antique birdcages, silk flowers, and bows, these compelling objects conjoin the attributes of masculinity and femininity. Tinged with anxiety and the intimation that something could shatter their surface optimism, they seem poised to metamorphose from benign objects into nightmare apparitions. The human conditions with which Coyne is most concerned are interior and psychological, and her complexly layered sculptures conceal turbulent passions under veils of refinement, so that restraint and rationality discipline the wild emotional turbulence that is always lurking just underneath the surface.

Wangechi Mutu's eccentric collages, rendered in the high-key colorations of body parts snipped from glossy fashion and lifestyle magazines, are simultaneously elegant and perverse as they construct post-apocalyptic creatures calculated to entice and repel. In *It's the End of the World as I Know It … Again* of

Fig.26

Fig.27

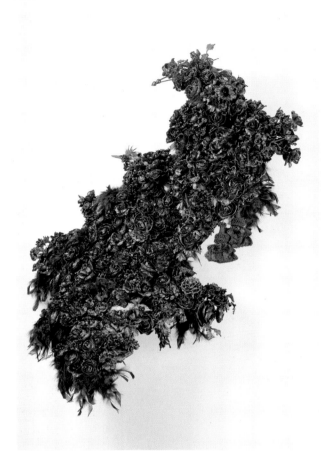

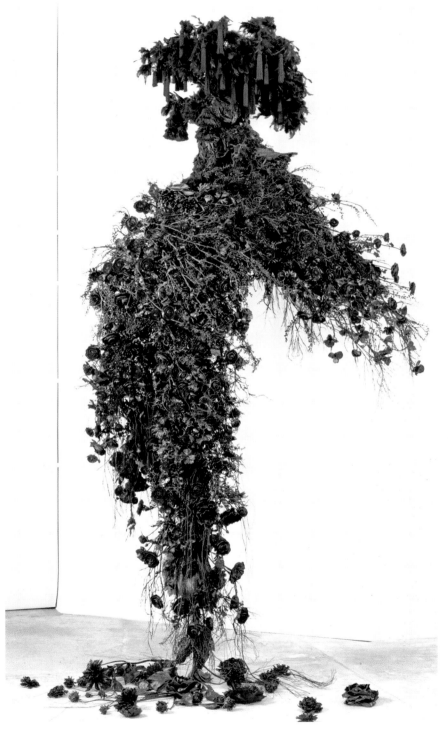

**Fig. 26**  Petah Coyne. *Untitled #1187* (*Life Interrupted*), 1997–2004. Specially formulated wax, fabricated steel understructure, bird taxidermy, silk flowers, feathers, black pigment, pigment, pearl-headed hat pins, black spray paint, chicken wire fencing, and wire, 48 × 46 × 22 in.
(121.9 × 116.8 × 55.9 cm)

**Fig. 27**  Petah Coyne. *Untitled #1111* (*Little Ed's Daughter Margaret*), 2003–4. Specially formulated wax, fiberglass cast statuary, velvet, satin, ribbon, thread, steel understructure, PVC pipe and fittings, tree branches, fabricated tree branches, chicken-wire fencing, wire, silk flowers, pearl-headed hat pins, tassels, feathers,
132 × 63 × 72 in. (335.3 × 160 × 182.9 cm)

Fig.28

Fig.29

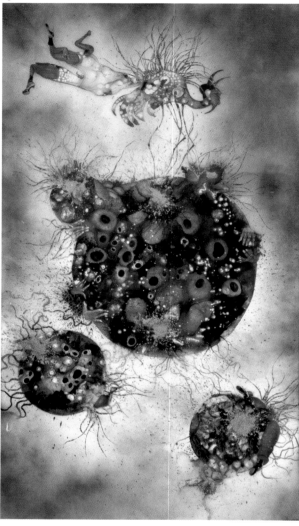

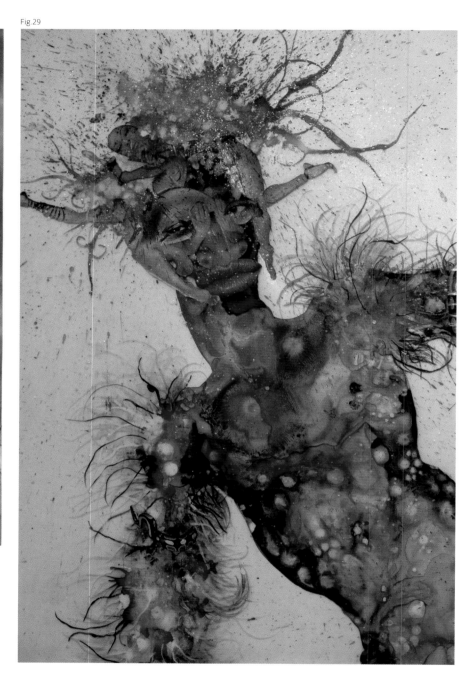

**Fig. 28** Wangechi Mutu. *It's the End of the World as I Know It … Again*, 2005. Mixed media on Mylar, 72 × 40 in. (182.9 × 101.6 cm)

**Fig. 29** Wangechi Mutu. Detail of *She's Egungun Again*, 2005. Ink, acrylic, collage, and contact paper on Mylar, 87 × 52 ½ in. (221 × 133.4 cm)

Fig.30

Fig.31

2005 (fig. 28), Mutu posits an otherworldly, micro- or macroscopic vision of floating, roiling clusters of fantastical conglomerations—hands, gaping orifices, and spindly filaments—that suggest both human and celestial cells. The human body is only more slightly recognizable in *She's Egungun Again*, 2005 (fig. 29), where ecstasy and anguish compete in psychedelic meditations on the mutable facade of identity and the role that societal aesthetics play in the determining of individuality. Mutu's patchwork bodies are both social critiques of contemporary society's obsession with a streamlined, highly stylized beauty and mediations on mythology and allegory. She dissects modern and contemporary ideals of the body by deftly juxtaposing stereotypical, even archetypal, ideals about women with allusions to the vitality of history, memory, and cultural traditions existing outside the Western European canon (fig. 110). Portraying both inner and outer states, the grotesqueries of her bodies imply physical and emotional self-awareness as an opposition to the roles we assume and play out on the stage of public display. Mutu posits a besieged self who struggles to find some peace despite being torn asunder by the conflict between personal urges and societal compulsions.

> A romantic artwork is really only there as provocation and ruse to catapult our "selves" out of humdrum states and reach greater heights, or depths, or whatever else seems weird, dizzying, and naughty.
> **Fred Vermorel**, 2000[10]

The romantic movement was marked by an unprecedented trend to revitalize art by including knowledge of psychology and the unconscious, evidence that seemed to canonize for those painters the persona of

**Fig. 30** Sophie Calle. Detail of *Suite Venitienne*, 1980, printed 1986. Set of fifty-five black-and-white photographs, twenty-four text panels, and three maps, dimensions variable

**Fig. 31** Sophie Calle. Detail of *Chambre 43 – 28 Février*, 1983. Color and black-and-white photographs, 39 × 55 in. (99.1 × 139.7 cm) each

**10.** Fred Vermorel, "Fantastic Voyeur: Lurking on the Dark Side of Biography," *The Village Voice Literary Supplement*, October–November 2000, p. 97. http://www.villagevoice.com/specials/vls/170/vermorel.shtml (accessed 10/7/2007).

Fig. 32

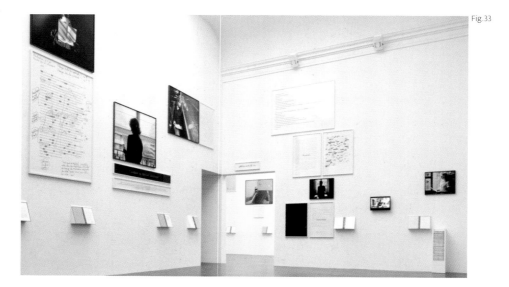

Fig. 33

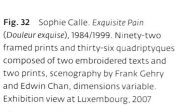

**Fig. 32**  Sophie Calle. *Exquisite Pain* (*Douleur exquise*), 1984/1999. Ninety-two framed prints and thirty-six quadriptyques composed of two embroidered texts and two prints, scenography by Frank Gehry and Edwin Chan, dimensions variable. Exhibition view at Luxembourg, 2007

**Fig. 33**  Sophie Calle. *Take Care of Yourself* (*Prenez soin de vous*), 2007. 106 framed black-and-white and color prints, framed texts, videos, dimensions variable. French Pavilion of the *52nd International Biennale of Contemporary Art*, Venice

the melancholic artist. Similarly, Sophie Calle cures herself of acute disappointment in *Exquisite Pain* by obsessively scrutinizing her own psychic disappointments as well as those of her friends and acquaintances. Anneè Olofsson places herself at the center of intimate familial interactions, allowing us to eavesdrop on actions and conversations that are both revelatory and baffling, and Jesper Just constructs taut narratives laden with allusions to popular culture, whose characters search restlessly for connections between the imprecise boundaries of fact and fiction, and the complex structures underpinning even the most basic human contact.

Blurring the categories of art and life, public and private, truth and fiction, has been a consistent theme throughout Sophie Calle's career. Conflating aspects of performance and behaviorism, her art represents events and ideas through imagistic, obsessive, compelling, and occasionally excruciating narratives. Although Calle's stories are often set in the voice of an empathetic narrator, we are not invited to know her, only the stories of strangers. In early works, Calle conceived and executed performance-based projects that include covertly following an acquaintance from Paris to Venice (fig. 30) and posing as a chambermaid and recording the contents of hotel rooms (fig. 31). These works assert the artist as a proxy for our voyeurism; we see these intimacies with a detachment that might be best described as first-person

impersonal. More recently, however, Calle has put her emotions—and ours—front and center. In *Exquisite Pain*, 1995 (figs. 32 and 76–8) and *Take Care of Yourself*, 2007 (fig. 33) Calle makes us long for psychologically complex journeys through periods of intense sadness, grief, and anger, using obsessive retelling of events and actions to dissect and ultimately dissipate the original emotional charge.

Constructing tightly focused cinematic narrative structures, Anneè Olofsson articulates interactions, often between herself and her parents, as theatrical scenarios. She is both subject and model in her monumental photographs and video installations, in which she investigates the most intimate and personal contact and familial affiliations. A haunting, intensely emotional quiet pervades her photographs, which often show future blending with past, and competing notions of aging, beauty, vanity, guilt, and desire—the building blocks of her own identity. Solitude framed within the often claustrophobic context of basic human contact also pervades her work. In *Demons*, 1999 (fig. 34) for example, Olofsson poses herself in a series of bleak circumstances, in which she is observed by an ominous figure lurking in the shadows. *Girl's Best Friend*, 2003 (figs. 35–6) expresses gestures that are both loving and threatening, as her mother's hands are first seen clasped around Olofsson's waist and then her neck. She dissects the psychological undercurrents of traditional father-daughter relationships in *Unforgivable*, 2001 (fig. 37) by dancing awkwardly with her father. In *The Conversations*, 2006 (figs. 117–18) her psychological explorations form a provocative sound installation in which a woman has her ear pressed to a wall, listening to a private conversation that we can faintly hear from behind the picture. In each of these works, what we see is charged by what we understand of the artist's process, working so closely with her family; through her, they are implicated in life's continuity, even as they reveal their most private feelings.

**Fig. 34** Anneè Olofsson. Detail of *Demons*, 1999. Nine color photographs, each 41 ⅜ × 51 ⅛ in. (105 × 130 cm)

**Fig. 35** Anneè Olofsson. Detail of *A Girl's Best Friend*, 2003. Five color photographs, each 41 ⅜ × 55 ⅛ in. (105 × 140 cm)

**Fig. 36** Anneè Olofsson. Detail of *A Girl's Best Friend*, 2003. Five color photographs, each 41 ⅜ × 55 ⅛ in. (105 × 140 cm)

**Fig. 37** Anneè Olofsson. Detail of *Unforgivable*, 2001. Five color photographs, each 47 ¼ × 47 ¼ in. (120 × 120 cm)

Fig.34

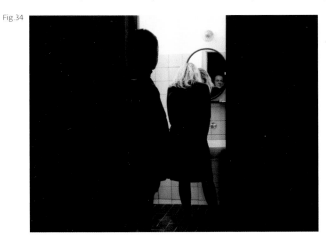

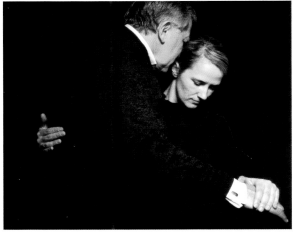
Fig.37

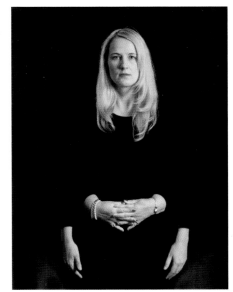
Fig.35

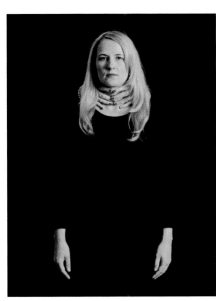
Fig.36

Fig.38

The struggle for lasting human connection forms the basis for the short films of Jesper Just. For Just, as for Olofsson, the word "contemporary" conjures solitude, loneliness, and isolation. In actions and personae, Just's mostly male characters challenge both high- and popular-cultural stereotypes of men as assertive, insensitive, and excessively dominant. Cast in unusual roles, often placed in surreal surroundings, they are sensual and decidedly of this world, expressing their vulnerability through the language of popular music and intricately staged theatrical scenarios laden with romantic drama. Just's characters rarely speak. Action and emotions are instead communicated through songs, with recognizable lyrics telegraphing elemental narratives that offer neither escape nor easy conclusions. In *The Lonely Villa*, 2004 (fig. 38), for example, a group of semi-somnambulant men rouse themselves from a soporific trance in a stuffy reception, room to sing the Ink Spots' "I Don't Want to Set the World on Fire" into telephone receivers. In *No Man Is an Island II*, 2004 (fig. 39), strangers in a dimly lit bar form a momentary community by joining in an impromptu rendition of Roy Orbison's "Crying." Just's sets conjure mundane, even disreputable atmospheres: strip clubs (fig. 40), electrical substations, trucking containers (fig. 41), or desolate parking garages (fig. 42). These locales are the antithesis of intimacy, but his characters nevertheless strive to connect, creating emotional group identities charged by a dynamic tension that is larger than individual personalities.

Many artists fuse the aspects of damage and repair into highly symbolic meditations on reconstruction, reparation, and sometimes redemption. The border between self and community blurs in works by Angelo Filomeno, Mary McCleary, and Julia Oschatz. Each employs the figure as a metaphor, with individual depictions standing in for the body politic and the landscapes they inhabit, as barometers of a belief system's well-being.

Angelo Filomeno's painterly silk canvases conflate corrosive pessimism with hedonistic splendor, depicting death and destruction with sparkling rhinestones and rich metallic threads in a style reminiscent of late nineteenth-century embroideries. Filomeno's tactile overload seduces us into a world where dark emotions produce ecstasy, where intense decoration is couched in the visual vocabulary of fantasy and art history. Elaborately constructed of embroidery on iridescent silk shantung, ornamented with crystals and

Fig.39

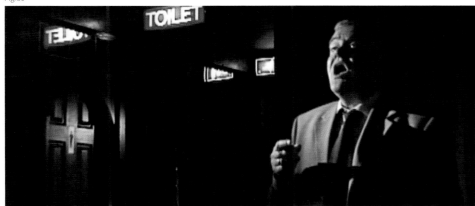

Fig.40

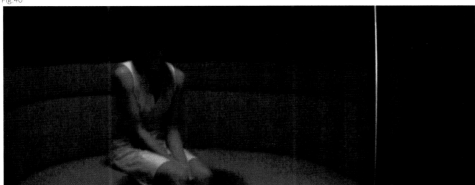

Fig.41

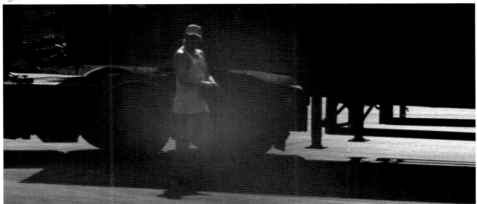

Fig.42

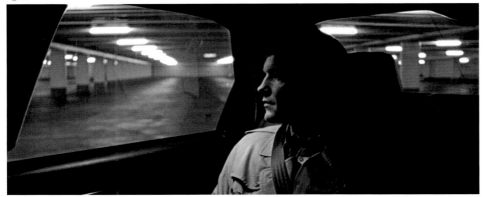

**Fig. 38**  Jesper Just. Still from *The Lonely Villa*, 2004. Super 16mm, color, sound, 4:30 min.

**Fig. 39**  Jesper Just. Still from *No Man Is an Island II*, 2004. DVCAM, color, sound, 4:00 min.

**Fig. 40**  Jesper Just. Still from *A Fine Romance*, 2004. DVCAM, color, sound, 6:30 min.

**Fig. 41**  Jesper Just. Still from *Bliss and Heaven*, 2004. Super 16mm, color, sound, 8:10 min.

**Fig. 42**  Jesper Just. Still from *Something to Love*, 2005. Super 16mm, color, sound, 8:10 min.

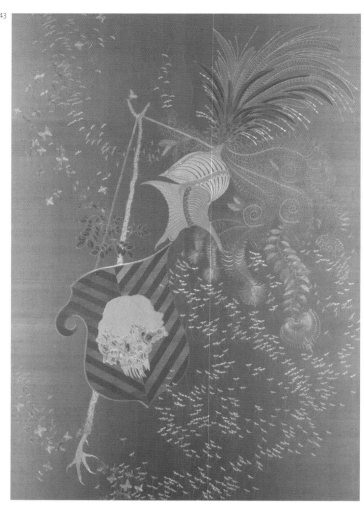

Fig.43

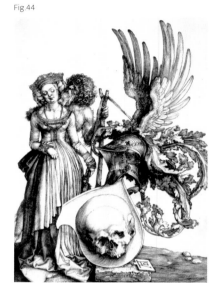

Fig.44

**Fig. 43** Angelo Filomeno. *Coat of Arms with a Skull (after Albrecht Dürer engraving)*, 2006. Embroidery on silk shantung stretched over linen with crystals and quartz, 121 × 80 in. (307.3 × 203.2 cm)

**Fig. 44** Albrecht Dürer. *Coat of Arms with a Skull*, 1503. Engraving on cream laid paper, 8 5/8 × 6 1/8 in. (21.9 × 15.7 cm). Worcester Art Museum, Worcester, Massachusetts, Sarah C. Garver Fund

**Fig. 45** Angelo Filomeno. *My Love Sings When the Flower is Near (The Philosopher and the Woman)*, 2007. Embroidery on silk shantung stretched over linen with crystals, 155 × 90 1/4 in. (393.7 × 229.2 cm)

**Fig. 46** Angelo Filomeno. *Cold*, 2007. Embroidery on silk shantung stretched over linen with crystals, 156 × 89 1/2 in. (396.2 × 227.3 cm)

quartz, Filomeno's skeletons and skulls riff on such disparate references as an Albrecht Dürer engraving of 1500 in *Coat of Arms with a Skull (after Albrecht Dürer engraving)*, 2006 (figs. 43–4), Francisco Goya's *Disasters of War*, and traditional Mexican Day of the Dead icons. In *My Love Sings When the Flower is Near (The Philosopher and the Woman)*, 2007 (fig. 45), or *Cold*, 2007 (fig. 46)—where, on midnight-blue fields studded with stars and illuminated by the twinkling aerial views of a city glimpsed from above, we see black spirits returning to earth to give witness—there is a perfect conjoining of spiritual and material. Filomino's notion of concealed and revealed alchemical secrets underscores the *Arcanum* series, in which exotic flora and fauna are expressed in shimmering gold and jewels. These monsters from the id, surrounded by elaborately filigreed decorations, play the art of emblematic decoration against the enlightened ideals of empirical science, suggesting a dystopian world view where the inevitability of mortality is mitigated by beauty.

Julia Oschatz's *Paralyzed Paradise*, 2004–5 was a series of exhibitions, which included of drawings, paintings, video clips, and sculptural installations that locate metaphors for the discovery of the self and the other in a recurrent figure who navigates multiple landscapes. Like her fellow countryman David Schnell, Oshatz delves into romantic territories first outlined by Caspar David Friedrich (fig. 47), combining it with the particularly American transcendental individualism of Henry David Thoreau (1817–62). Oschatz's neutral, genderless, and expressionless being is her personal doppelganger, whom she calls *Wesen* (German for "being"). Equal parts human and animal, with a small, lithe body and a mouselike head, Oschatz/Wesen

Fig.45
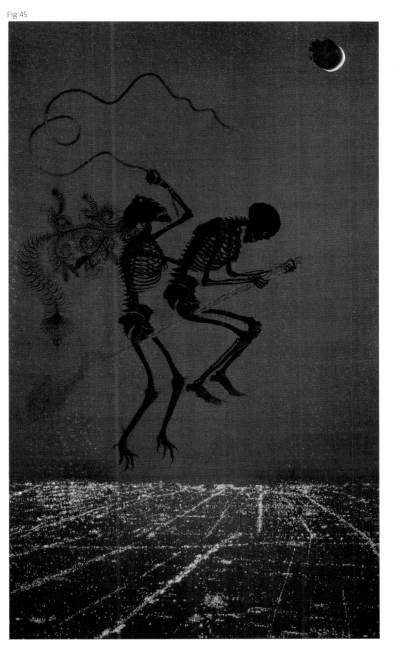

Fig.46
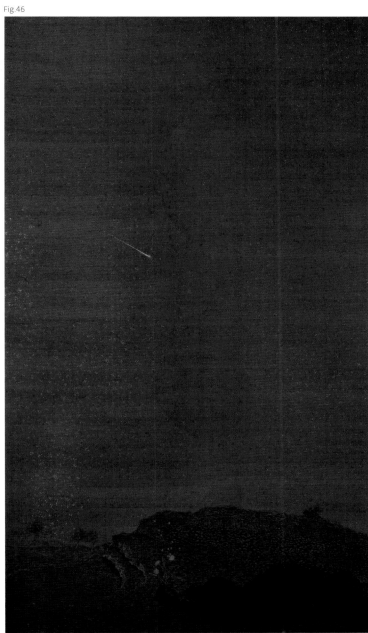

Fig.47

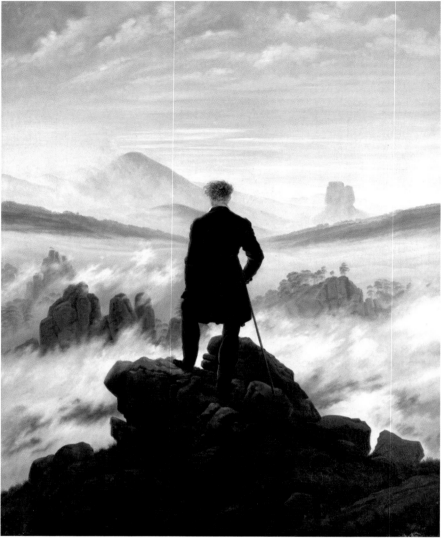

Fig.48

Fig.49

Damaged Romanticism: A Mirror of Modern Emotion

Fig.50                                                                                                Fig.51

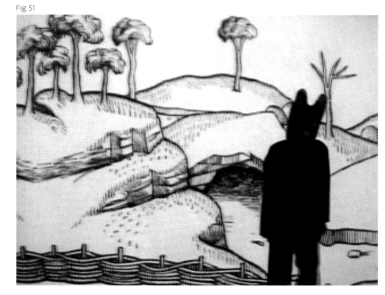

wanders through mostly grisaille atmospheres of soft grays and muted pastels, contemplating its solitary existence in a sublime world. Small in scale, paintings such as *Untitled (06-05)*, 2005, and *Untitled (03-05)*, 2005 (figs. 48–9) are concentrated gestural expressions of nature's harshness—damaged, rough, but ameliorated by a sly existential humor. This wry, even silly side emerges in videos like *Feld Wald und Wei*, 2005 (fig. 50) *Hello Hollow*, 2005 (fig. 51), where our protagonist moves through increasingly bizarre situations, steadfastly alone but never lonely. In exploring the core sense of self in an outsized world, Oschatz deftly combines an ethereal spirituality with a down-to-earth transcendentalism. Her still and moving images seem simultaneously inflected by traditional and "new" romanticism, ameliorated by gestures of both futility and rehabilitation.

Mary McCleary's narratives find their roots in myriad sources, including the Bible, secular literature, and modern history. Constructed from all manner of quotidian materials (sticks, wire, string, Mardi Gras beads, mirrors, glitter), her heavily collaged paintings are freighted with symbols and metaphors that describe the "tension between the contingency of human structures and our persistent hope for a transcendent truth."[11] In fact, psychological tension and spiritual meaning continually contradict each other in her lushly constructed surfaces, which overlay depictions of traditional morality plays with back stories steeped in science, recent history, or popular culture. McCleary's texts, always typed scrolls that wrap around the perimeters of her paintings, convey cautionary stories about the prospect of redemption. *Eden Landscape: Two Trees*, 1994 (fig. 52) shows the lush, unsullied, and unpopulated biblical garden, palpable with beauty, a seductive invitation to contemplate and weigh the fall of man against the fugitive pleasure and terror of life after the fall. *To Be Redeemed From Fire by Fire*, 1999 (fig. 53) frames a different but equally devastating allegorical tale of brimstone purification through the well-documented story of a disastrous 1944 circus-tent fire during a performance of Ringling Bros. and Barnum & Bailey Circus in Hartford, Connecticut. *9.81 Meters Per Second Per Second*, 2005 (fig. 54) addresses a different descent, referencing how

**Fig. 47**   Caspar David Friedrich. *The Wanderer above the Sea of Fog*, 1818. Oil on canvas, 38 ¾ × 29 ⅝ in. (98.4 × 74.8 cm). Hamburger Kunsthalle, Hamburg, Germany

**Fig. 48**   Julia Oschatz. *Untitled (06-05)*, 2005. Acrylic and ink on handmade paper on canvas, 13 ⅞ × 17 ⅝ in. (35.2 × 44.8 cm)

**Fig. 49**   Julia Oschatz. *Untitled (03-05)*, 2005. Oil and lacquer on canvas, 16 ½ × 23 ⅝ in. (41.9 × 60 cm)

**Fig. 50**   Julia Oschatz. Still from *Feld Wald und Wei*, 2005. DVD, black-and-white, 4:27 min. (loop)

**Fig. 51**   Julia Oschatz. Still from *Hello Hollow*, 2005. DVD, color, 4:30 min. (loop)

**11.** Gregory Wolfe, "Mary McCleary: Constructing Paradox" in *Mary McCleary: Beginning with the Word, Constructed Narratives: 1985–2000*, exh. cat., Galveston Arts Center, 2000. p. 6.

Fig. 52

"unsupported objects pick up a downward speed."[12] Here, human identity itself is in free fall, unsupported by faith, drawn inexorably downward by gravity while clinging to life.

> The difference is this almost exaggerated will to believe in something, if only in themselves. It is a *will* to believe, even in the face of an inability to do so in conventional terms. And that is bound to lead to excesses in one direction or another.[13]
>
> **John Clellon Holmes**, 1952

From its inception, romanticism has been tinged with associations of otherness, rejection, or deformation, and artists throughout the modern era have focused on similar themes and subjects. In 1952, John Clellon Holmes expanded on Jack Kerouac's expression "beat generation" to encompass the sense of loss and rootlessness that pervaded the lives of a generation caught up in the romance of disillusionment. This mid-twentieth-century malaise reflected not only a rebellion but an explosion of creative ideas based on individualism, eccentricity, and experimentation. Holmes noted that for the Beats, "The absence of personal and social values is to them, not a revelation shaking the ground beneath them, but a problem demanding a day-to-day solution. *How* to live seems to them much more crucial than *why*."[14] Working at just the beginning of the twenty-first century, the artists in *Damaged Romanticism* ask the same questions. Their work often proposes the present as a deformed, even grotesque version of the past, but unlike the Beat poets, they are not in search of either rapture or rupture, and they do not presume that the present is so different from the past that one has nothing to do with the other. In one of our many discussions about this project, David Pagel remarked that what Francis Fukuyama postulated as "the end of history"[15] is once again connected to history through loss, suffering, and trauma. *Damaged Romanticism* builds on this as well as many other approaches in critical discourse. In their emotionally resonant and visually haunting expressions, these artists explore multilayered responses to the world, identifying damaged romanticism as a powerful mirror of modern emotion.

---

**12.** This painting's text describes the scientific origin of the work's title. "Near the surface of the earth gravity is a downward acceleration. Over time, it causes all unsupported objects to pick up speed. Since gravity is a persistent acceleration, falling objects keep falling faster and faster. For objects near the surface of the earth, gravity causes them to accelerate downward at a constant 9.81 meters (m/sec/sec). This means each second it falls, it will be traveling 9.81 meters per second faster." *Mary McCleary: After Paradise* (Baltimore, MD: Square Halo Books, 2006), p. 24.
**13.** John Clellon Holmes, "This is the Beat Generation," *New York Times Magazine*, November 16, 1952, p. 20.
**14.** Ibid., p. 19.
**15.** Francis Fukuyama, *The End of History and the Last Man* (New York: Simon & Schuster / Free Press, 2006). Originally published as "The End of History?" *The National Interest* 16 (Summer 1989), pp. 3–18.

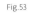Fig.53

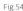Fig.54

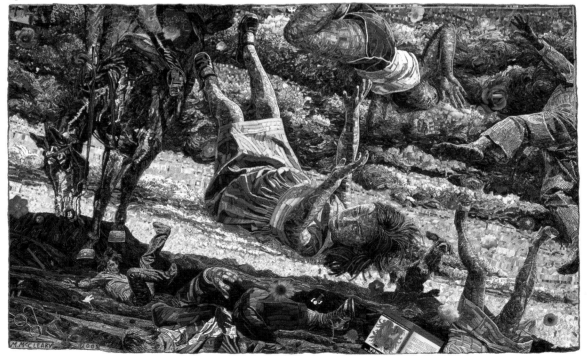

**Fig. 52** Mary McCleary. *Eden Landscape: Two Trees*, 1994. Mixed-media collage on paper, 30 ¼ × 75 ¼ in. (76.8 × 191.1 cm). Craig and Judy Elias, Bellaire, Texas

**Fig. 53** Mary McCleary. *To Be Redeemed from Fire by Fire*, 1999. Mixed-media collage on paper, 45 × 74 ½ in. (114.3 × 189.2 cm). Kathy and Bud Wright, Nacogdoches, Texas

**Fig. 54** Mary McCleary. *9.81 Meters Per Second Per Second*, 2006. Mixed-media collage on paper, 45 × 71 ½ in. (114.3 × 181.6 cm). Sue and Lester Smith, Houston, Texas

# Romanticism's Aftermath: No Illusions, A Little Desperation, Lots of Imagination
*David Pagel*

Romanticism is back. And it isn't what it used to be. In the late eighteenth and early nineteenth centuries, romanticism got off to a great start when such artists as J. M. W. Turner, John Constable, and William Blake in England; Francisco Goya in Spain; Caspar David Friedrich in Germany; and Théodore Géricault and Eugène Delacroix in France struck out in new directions in the hope of making more powerful art. Producing impressively diverse works, they laid the foundation for all of the modern movements that followed in the nineteenth and twentieth centuries. Although romanticism was a complicated, often contradictory movement that differed from country to country, decade to decade, art form to art form— and even within individual artists' oeuvres—it established the basis of what we think of today as avant-garde art. By emphasizing the centrality of the artist's self, his quasi-antagonistic relationship to society, the autonomy of his work, the all-or-nothing tone of its message, and the fact that art is an antidote intended to repair social shortcomings that, left to themselves, were sure to deteriorate, the artists of the romantic generation defined the parameters within which modern art functions, making its meanings by putting these principles to good use.

But since the turn of the nineteenth century, much damage has been done to such a romantic vision, as well as to the world in which it takes shape. Romanticism fell out of favor in the mid-twentieth century, becoming a somewhat pejorative term used to describe naively dreamy works that are generally dismissed for being out of touch with reality, consumed by short-sighted self-involvement, and, for the most part, lost in an idealized world of nostalgic fantasy. Only recently, a growing number of artists have gone back, in their multilayered works, to romanticism's fundamental principles, adapting and transforming—or recycling and customizing—the movement's core values to suit the terms and needs of the present. *Damaged Romanticism: A Mirror of Modern Emotion* surveys these developments. Rather than asserting that the paintings, sculptures, videos, photographs, and installations it displays are new-and-improved versions of, or up-to-the-minute advances on, the achievements of previous generations, the fifteen-artist exhibition suggests that the damage romanticism has suffered has not diminished its capacities but has actually made it a more effective weapon in the battle against business as usual: the increasing efficiency with which corporate consumer culture serves up ready-made experiences of conformity, complacency, and the comfortable numbness of life lived on autopilot, detached from the messy physicality of hands-on engagement, the turbulence of an activated, free-wheeling imagination, and the difficulties intrinsic to thinking for oneself.

Perhaps the single most significant achievement of the eighteenth- and nineteenth-century romantics was their establishment of the artist's self as the ultimate testing ground for often risky and sometimes shocking intuitions. For them, the solitary individual was the crucible in which meaning was

**Fig. 55**  Richard Billingham. *Untitled #12*, 2003. Color lightjet print on Fujicrystal archive paper mounted on aluminum, 44 × 54 in. (111.8 × 137.2 cm)

Fig.55

brewed, stored, and served up, sometimes pouring out faster and more furiously than could be kept up with, and at other times seeping out slowly, in exquisite, precious drips. In the eyes of the original romantics, rationality only went so far. If science inspired, as did many of its latest discoveries and developments, they were all for it. But if it served up cut-and-dried facts that were detached from the passions and deployed to bury the imagination in information-overload, they rejected science and its utilitarian application as just another aspect of the bland standardization that was taking over modern life. On the whole, they put their faith in the inimitable and unpredictable vicissitudes of individual emotions—feelings and sentiments that had their own poetry and that could not be managed or controlled by an increasingly bureaucratic society. Focused on the moment, they shunned imitation and made originality a virtue worth fighting for. They had no time for the past if it was something that bogged down the present, swamping its possibilities in burdensome details and a slavish worship of minutiae. Reverence for its own sake was death. But finding inspiring outsiders, overlooked heroes, obscure ancients, primitive cultures, myths, and legends—the more extravagant, outlandish, and improbable the better—fed their artistic imaginations and fueled their desire that things might be different, that all was not lost.

Cosmic mystery, sublime wonder, and infinite possibility were dear to the hearts of the original romantics, whose souls and emotions expanded to include the psychologically charged landscapes they found in nature, which was, for them, a rejuvenating escape from the dispiriting meanness and claustrophobia of city life—and an often terrifying opening onto the infinite, inhuman vastness of the cosmos. Their focus on see-for-yourself subjectivity established individualism, bohemianism, independent thinking, emotional intensity, skepticism, unfettered creativity, and faith in the imagination as art's—and life's—essentials. Think of romanticism as humanism for folks who prefer drama to logic, surprise to reason, and theatrical grandeur to even-keeled argumentation—who are, strange as it may seem, too egomaniacal to believe they were born into a universe in which humans were the measure of all things.

In classic romanticism, the extraordinary focus on the self went hand in hand with detachment from society. Distancing oneself from one's surroundings, social position, and fellow citizens was often a requisite first step in an aesthetic journey—which almost always constituted a solo trip to a foreign landscape and to the far reaches of consciousness (and beyond), where an individual might have discovered the integrity of his vision or destroyed himself in the process. Returning to everyday reality was often a depressing letdown, and many romantics cut their ties to the uninspired drudgery of daily life, preferring the phantasmagorical flights of fancy permitted and facilitated by the highly aestheticized worlds conjured by their exquisitely cultivated works. The gap between such avant-garde aesthetic adventurers and ordinary middle-class audiences became a potentially unbridgeable chasm, which intensified the antagonistic relationship between romantic artists and society. But, despite the solitary focus and stubbornly cultivated isolation of the studio, their ideas were meant to find a sympathetic audience of like-minded malcontents—a handful of sensitive folks dissatisfied with the status quo and yearning for more meaningful, eye-opening experiences that tested their imaginative capacities and increased the depth and range of their interior lives. While the original romantics rejected the entitlement and privilege of established elites, and preferred, at least in principle, to make works that appealed to ordinary citizens, particularly the disenfranchised, whose sensitivities and sensibilities were far more acute and refined

than their social standing was elevated, they were also in love with their own go-it-alone isolation and maverick, outsider status. More often than not, such qualities became badges of honor that signaled the authenticity of their sentiments and the truthfulness of their visions. Their antagonistic stance toward everyday, middle-of-the-road ordinariness fueled their conviction that they were pursuing truths beyond their day and age, perhaps not timeless universals, but ideas and experiences that transcended their social contexts and historical sources. The romantics' antipathy for the status quo and blasé mediocrity fortified their rebellious, do-it-yourself attitude and fed their desire to be true to themselves, even if no one else understood them.

Such stand-alone individualism or me-against-the-world subjectivity was mirrored in the idea of art for art's sake for which many of the original romantics so strenuously—and often successfully—fought. Autonomous art—like autonomous artists—rejected the plodding functionalism, instrumental thinking, and bean-counting efficiency that were all consequences of science's growing influence, and which turned its potentially mind-expanding ideals into crass economics and mundane utilitarianism. To make room for the imagination, for unpredictability, and for the unexpected twists and turns of stories that are missed when the eye remains focused on the bottom line, romantic artists insisted that their work was most interesting—as in resonant and potent—when it did its own thing, even if no one could say exactly what that was. What was clear was that art would not play second fiddle to some other purpose or program, serving as feckless—if colorful—propaganda for agendas and interests that subjected it to their goals by limiting it to pre-established tactics. The freedom essential to romanticism was most likely to be found when art was left alone to do whatever it chooses or compels or conscripts. For the romantics, art was a sufficiently demanding master: none other was necessary.

Among romanticism's most prominent features was its sense of do-or-die finality. Much of the content of original romanticism is presented as an ultimatum that leaves no room for negotiation, compromise, or dialogue. Many of its urgent claims and bold declarations come across as last-ditch attempts to make something meaningful in the face of such formidable opponents as unjust love and fate, nature's indifference, and a host of social problems, most of which indict the masses for their boorish apathy, dim-witted mediocrity, mean-spirited greed, and lack of appreciation of the artist's exquisite insights into the tragic circumstances of an uncaring world. High-pitched if not quite hysterical, romanticism often sensationalizes doom, making heroes of valorous individuals who stick to their principles, even if it means embracing failure—or death. The fascination with ending it all, rather than selling one's soul and sullying one's reputation, marks romanticism as an art form founded on a curiously fragile absolutism, a personal belief system that remained after the more vigorous and widely shared versions of absolutism—maintained, since the Middle Ages, by religion and royalty—were swept away by the rise of mercantile democracy. The all-or-nothing dualities of traditional religion lived on in romanticism's black-and-white opposition between salvation by truth to one's vision or complete failure by falling into the irredeemable abyss of falsehood.

Romanticism was meant to change the world, to respond to social problems or institutional shortcomings by creating stunningly original works that revealed deeper truths and inspired moral actions. Many of its images and objects set themselves in opposition to neoclassicism, the dominant, state-

Fig.56

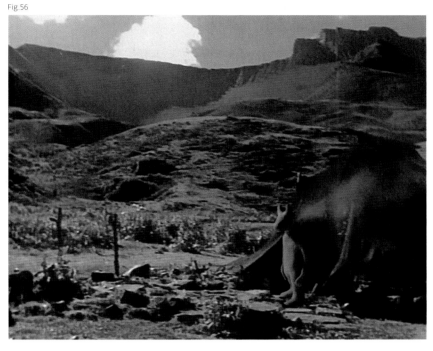

sanctioned style that, supported by academic training and maintained by government patronage, sought to preserve values be-lieved to be directly descended from ancient Greek and Roman precepts. Stylistically, neoclassicism was governed by proportion and harmony; it was grounded in logic, and was an extension of the Enlightenment, the mid-to-late eighteenth-century intellectual movement that promoted free inquiry and held that advances in knowl-edge, science, and technology would result in the improve-ment of society. In politics, the Enlightenment promoted freedom and equality and questioned the authority of the overpowering institutions of the papacy and monarchy; these paths of thought and resistance eventually inspired the French Revolution.

Romanticism was born of the social convulsions that led up to and followed the French Revolution. Taking into account many of the qualities and characteristics that neo-classicism overlooked or repressed—including irrationality, imbalance, illogic, ugliness, horror, darkness, abjection, my-stery, absurdity, and out-of-control emotionalism—romantic artists strove to depict a more complicated, multilayered world, one in which a wider ranger of emotional experiences and sentiments contributed to a more well-rounded picture of life as it is lived in the real world. Disillusionment, bitterness, and apa-thy played into their art with greater urgency as the inner lives of individuals took up the slack between what was promised by revolutionary discourse and what actually took shape in reality. Romantic artists embraced the legacy of the Enlightenment while expanding its province. Romanticism thus established itself as aftermath art—as works significantly defined by their relationship to preceding events that went horribly, tragically, irreparably wrong. Rich interior worlds, filled with turbulent emotions, phantasmagori-cal visions, and extreme, irrational fantasies were often called on to compensate for the depressing failures and dreary limits of the real one. Such visions registered romanticism's disdain for run-of-the-mill reality. More important, they stood in as stunningly original promissory notes for a future that might be different.

*Damaged Romanticism: A Mirror of Modern Emotion* picks up where romanticism leaves off. It surveys a strand of contemporary art that brings many of the ideals and impulses of romanticism back into the picture by adapting them to fit current circumstances.

The self that emerges in damaged romanticism is less grandiose, powerful, and autonomous than that of the romantics two centuries ago. Uncomfortable with such big ideas as genius, inspiration, revela-tion, and nature, these contemporary artists are more down-to-earth, almost anonymous in their every-man ordinariness, and skeptical, if not downright doubtful, about their capacity to encompass the world's myriad truths in their humble art. Like the original romantics, they take nothing on faith; they still believe that each of us is in the best position to determine for ourselves what events and symbols mean. What

**Fig. 56**  Julia Oschatz. Still from *Paralyzed Paradise*, 2004. DVD, 3:23 min. (loop)

distinguishes damaged romantics from their undamaged predecessors is the conviction that go-it-alone individualism is neither the only nor the best option—that human beings are social animals whose thinking and insights emerge from relationships with others, and whose ties to those around them are the foundation on which meaning is built. Think of damaged romanticism as humanism for people whose lives are woven into the social fabric—folks who prefer pragmatism to perfectionism, reality to fantasy, and modest improvements to impossible utopias. Guarded optimism, made all the more poignant by first-hand experiences of suffering and melancholy, comes to the forefront in romanticism's damaged version, replacing the original generation's giddy dreams of absolute, life-changing transformations with measured goals and sober hopefulness, as well as with the pleasures and horrors of everyday reality.

Damaged romantics are not nearly as invested as their predecessors in standing apart from their fellow citizens. Although their art is born of similar dissatisfactions with the status quo—which now takes the form of corporate culture, politics as infotainment, and society's maddening capacity to absorb almost instantaneously every form of dissent—damaged romantics do not presume to detach themselves from our increasingly interconnected world. Instead, they immerse themselves in their surroundings, borrowing from other disciplines and endeavors, gathering information, and piecing it together, proposing connections. Then they appeal to viewers of all shapes and stripes to test the art against their own understanding, perceptions, and memories, to evaluate how a work's propositions fit into and challenge other perspectives, positions, and world views.

The aesthetic autonomy that was essential to first-run romanticism, and accompanied its urge to make a place for unfettered, free-wheeling imagination in cultural life, is not important to damaged romantics. These artists work between and among the diverse spheres of contemporary culture, inserting themselves and their art into the cracks of the big sprawling system, rather than positioning themselves and their labors outside its tainted authority. In the tradition of their predecessors from two centuries ago, they draw on science and technology, documentary news gathering, clinical psychology, historiography, museum display, religious mythology, and therapeutic storytelling. Damaged romantics have translated the idea of art-for-art's-sake into the idea of art as a glitch in the system: a momentary pause that causes a bit of perceptual turbulence—and puzzling, head-scratching uncertainty—by interrupting the seamless transmission of prepackaged, easily consumed gratification that instantly gives way to more of the same. Their works do not presume or aspire to exist in the separate, supra-historical world of Art with a capital A, but instead insist that they belong in the visible world of shared social space, where they are subjected to the same sorts of verifiability as any other event, proposition, or experience. Rather than striving to make a place for emotionally loaded reverie that could exist in a world apart from the trials and tribulations of everyday reality, the twenty-first-century works seek to infuse daily existence with the vitality of the imagination, shooting it through their diverse, genre-bending works.

Awakening the imagination—and following its slippery, serpentine movements—is as much a goal of the damaged romantics as it was of their predecessors. But today's romantics seek to start with what already exists in the world rather than trying to conjure it out of paint, bare canvas, and naked inspiration. Profoundly suspicious of such sui generis creations and godlike powers of originality, damaged romantics instead strive to find room for ideas to freely maneuver among the manifold niches of modern life that are

so vividly exemplified by the internet, where innumerable interest groups have disproportionate room to strut their stuff. The open-endedness of such intentionally fractured multiplicity is played out in works where designer extravagance meets folksy kitsch; singsong loveliness intensifies the tragedy and horror of physical brutality; and Wagnerian opera dovetails with botany, colonialism, and malaria fever dreams. Damaged romanticism follows a path established by pop art. Both movements scramble the signs and symbols they find in the world, creating unexpected occasions for emotional engagement in accessible languages or terms understood by broad swaths of the general public.

Damaged romantics generally temper the ultimatum-style absolutism of their forebears, hiding the emotional intensity of their passionate works in more palatable forms, understated formats, and less shrill, more reasonable presentations. They don't idealize doom and death; nor do they engage in me-against-the-world defiance. A been-there, done-that world-weariness suffuses their works, which begin with the knowledge that the dramatic resolution and formal closure sought by their predecessors are attributes of art (aesthetic effects of impeccably crafted pictures, stories, and songs), and not, very often, parts of life, which are far messier, less resolved, and more complicated than works of art can hope to be. It is as if the tragic finality celebrated and embraced by the original romantics has survived in damaged romanticism as a sort of morning-after melancholy. Its poignancy and pang testify to the bittersweet wisdom that accompanies the realization that being dead wrong about one's convictions and having the opportunity to try again is far better than being dead—that having the capacity to do something about one's existential predicament, however unfortunate or dark, beats being out of the picture altogether.

The tone of the works by damaged romantics is conversational: more freeform, lowbrow, even "street" than that of their predecessors. Never over-wrought or over-dramatized, they strike notes that are subdued, restrained, and measured, sometimes deadpan, objective, and introspective, at other times quietly harrowing, absurdist, exquisite. Gone is the hubris that insists that art is unlike anything else in the world—a glimpse from the beyond to which viewers are suddenly privy. Instead, there is the sense that although significant damage has been done, hope remains. As a group, the works in *Damaged Romanticism* make a place for the ongoing give-and-take of interpretation, requiring viewers' open-mindedness, curiosity, skepticism, and active engagement. Although they are not strangers to flashy spectacle, they generally elicit contemplative responses that resonate in memory, drawing viewers into intelligent and intelligible dialogues that weave their way, often slowly, into the wider social fabric. These works provide disparate glimpses and hints that demand the imagination to get in on the action, not to make many wild leaps, but to move intuitively and flexibly, connecting the dots so that some version of the big picture comes into view.

One of the reasons why the original romantics were able and willing to reject just about everyone and everything around them was because they were confident that future generations would see the truth of their works. In a sense, their paintings, plays, poems, and novels were time capsules dedicated to a far-off future, when as-yet-unborn aesthetes would discover the true treasures of an earlier era, take them up, and build upon their tragic, generally misunderstood achievements. Today's damaged romantics are not so confident that redemption will be found in the future; nor are they so self-assured about their works being of interest to viewers in a century or two. They do not have the patience to play such selfless waiting games because their vision is more apocalyptic than that of their predecessors. First-run romanticism frequently

featured aestheticized apocalypses—including monsters, floods, murders, suicides, betrayals, wars, and earthquakes. In contrast, damaged romanticism steers clear of such dramatic imagery and narratives (now a regular feature of the nightly news) in favor of quotidian explorations of a post-9/11 world, where dirty nukes, bioterrorism, and suicide bombings threaten freedom of thought, not to mention life and limb.

If original romanticism began in the aftermath of historical events that had gone seriously wrong, damaged romanticism takes this attribute to the next level: it comes in the aftermath of both romanticism and recent political developments. Where first-run romanticism sprang from the dashed hopes and shattered dreams of several generations of artists when democracy was struggling, fitfully and violently, to be born, damaged romanticism has emerged at a time when democracy's freedoms are again at risk. The arc that connects late eighteenth- and early nineteenth-century romanticism to damaged romanticism traces the rise and fall of the individual freedoms that emerged with modern democracy, particularly in the United States, where the diversity of its mercantile version is now being threatened by corporate capitalism and de facto oligarchy. In the aftermath of 9/11, fear and terror dominate politics, filling the collective imagination with fantasies of revenge and destruction. While still a globe-spanning empire, the United States can no longer pretend it is more virtuous than any other Machiavellian fiefdom whose leaders have nothing but contempt for the majority of its increasingly disenfranchised citizens. In response, an increasing number of artists in Europe and the United States are making works that embody the sobering possibility of leaving behind deceitful cynicism, quick-fix soundbites, and treacly platitudes. In place of the glib superficiality of much postmodern image manipulation, they neither ignore romanticism's firsthand experience of despair, nor buy into the Enlightenment's idealization of the intellect and naive dream of progress through reason. Most important, they provide powerful counterexamples to the do-or-die rhetoric and good-versus-evil absolutism of much contemporary political discourse.

Forming neither a style nor a school, the works in *Damaged Romanticism* give form to a constellation of sentiments forged in heartbreaking disappointment but never resigned to the social conditions that precipitated the pain, failure, and despair. These artists strive to rehabilitate the grim contexts from which they emerge, taking viewers away from the wretchedness of being trapped in a world over which they have no control. Their works do not propose heaven-on-earth redemption—just basic improvements that may reach a tipping point toward something more consequential. Damaged romantics streamline the defiance of classic romanticism, insisting that art be down to earth and focused on the present, both pragmatic and passionate. Their works reveal ongoing struggles, exasperating predicaments, and unresolved conflicts, leaving the simplicity of dramatic climaxes to old-fashioned Hollywood movies, paperback thrillers, and sporting events. Like their historical forebears, they struggle for what they believe in, for something better than what's out there. But in contrast to their artistic ancestors, damaged romantics are not infatuated with the impossibility of the task of changing a bit of the world they had no choice but to inherit.

# From Her(e) to Eternity: Time, Memory, and Immanence in the "Postmodern" Romance
*Colin Gardner*

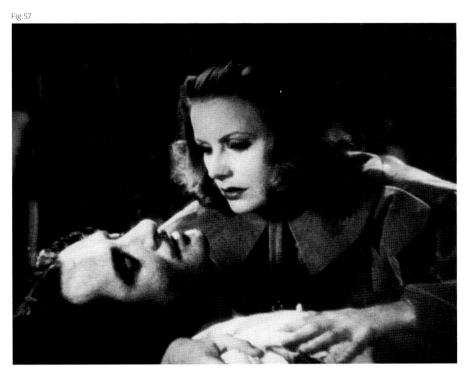

Fig.57

There is a famous sequence in Rouben Mamoulian's *Queen Christina*, 1933 (fig. 57) where, dressed in heavy men's clothing, Christina (Greta Garbo) is obliged to share a room in a local inn with an envoy of the King of Spain, Don Antonio de la Prada (John Gilbert), who, as one might expect, believes her to be a young man. When Christina reveals her true sex by removing her jacket, Antonio—who is unaware of her royal identity—delights in the subterfuge and takes her passionately in his arms. Snowed in for the next several days, the couple pass the time making love in their room and pledge enduring devotion to each other. Although the bedroom scenes are quite controversial, and clearly disturbed the pre-code censors of the day, no actual sex is shown. Instead, Mamoulian suggestively shows Garbo exploring the room, sensuously fondling different objects and surfaces—a decorated cigar box, a spinning wheel, an icon painting, the bed post—and tenderly kissing Don Antonio's pillow as if to substitute these objects for her lover's body but also to commit them to memory for future reference. "In the future, in my memory, I shall live a great deal in this room," she muses. The importance of this scene becomes readily apparent when, at film's end, Christina abdicates the throne to her cousin Charles and, newly liberated, rushes to rejoin her lover, only to find him dying from wounds inflicted during a duel. Although we empathize with her heartbreak, we also know that those tiny details absorbed from that room at the inn will sustain Christina throughout her life, ensuring that the bittersweet memory of Don Antonio will live within her until she draws her last breath.

**Fig. 57** Rouben Mamoulian. Still from *Queen Christina*, 1933

*Queen Christina*'s reliance on a combination of idées fixes and objective correlatives[1] to express highly charged affective and impulsive subjectivities is paradigmatic of a general trend within both commercial and experimental film. For although cinema had a fruitful love affair with romanticism from its inception—one thinks specifically of D. W. Griffith's countless damsel-in-distress narratives with Lillian Gish, King Vidor's faithful rendering of *La Boheme*, 1926, and pioneering film versions of Robert Louis Stevenson's *Dr. Jekyll and Mr. Hyde* (John S. Robertson, 1920) and Mary Shelley's *Frankenstein* (James Whale, 1931)—it has usually been mitigated by a more pragmatic modernist sensibility inflected by a combination of expressionist, symbolist, surrealist, and Brechtian tropes. Thus F. W. Murnau's *The Last Laugh*, 1924 and *Sunrise: A Song of Two Humans*, 1927 pull back from the brink of sugary sentimentality by grounding their protagonists' desires in the seeming trivia of the everyday—for example, Emil Jannings's unmitigated delight and sense of self-worth derived from wearing the uniform of a luxury hotel doorman—while Janet Gaynor in Frank Borzage's *Seventh Heaven*, 1927 refuses to let the minor inconvenience of her lover's death in World War I stand in the way of a truly sublime, almost surreal reunion at film's end.

---

**1.** Associated in a literary context with the criticism of T. S. Eliot, the "objective correlative" is a means of creating emotion through purely external elements, facilitating the author's detachment from the depicted character while at the same time guaranteeing formal and stylistic unity.

**Fig. 58** Wim Wenders. Still from *Wings of Desire (Der Himmel über Berlin)*, 1987

This dogged soldiering on in the face of seemingly devastating existential setbacks was a major component of the so-called Lost Generation of writers—Ernest Hemingway, F. Scott Fitzgerald, John Dos Passos, and John Monk Saunders. Traumatized by the carnage witnessed first hand during the Great War, they balanced a dark psychological fatalism (often leading to alcoholism and suicide) with the spark of renewed hope, usually through the life-affirming love of a good woman, in films such as *The Last Flight* (William Dieterle, 1931), *A Farewell To Arms* (Borzage, 1932), and *Three Comrades* (Borzage, 1938). We find a continuation of this tendency in several postwar noir films, such as Alida Valli's stubborn, unbroken loyalty to Orson Welles's Harry Lime in *The Third Man*, 1949—despite his horrifying involvement in a penicillin racket, leading to hundreds of children's deaths—Claire Trevor's devotion to Dennis O'Keefe's hardboiled prison escapee in Anthony Mann's *Raw Deal*, 1948, and Gloria Grahame's infatuation with both Lee Marvin's criminal psychopath, and Glenn Ford's psychologically damaged cop in Fritz Lang's savage *The Big Heat*, 1953. Of course, such obsession is not gender-specific in film noir. There are numerous examples of inexperienced milksops falling for the black widow or femme fatale—Edward G. Robinson's seduction by Joan Bennett in Lang's *The Woman in the Window*, 1944, and *Scarlet Street*, 1945 are notable examples—or experienced, well-traveled loners self-destructing at the hands of an unhappy trophy wife (Orson Welles's near-fatal attraction to his real-life spouse, Rita Hayworth in *The Lady From Shanghai*, 1947). In each case, the protagonist benefits from this near brush with catastrophe by developing an acute awareness of the ambivalence of sexual desire and a far greater understanding of basic predatory instincts.

Film noir's depiction of this more fractured romantic obsession was quickly adopted by the French New Wave—Godard dedicated *Breathless (A Bout de Souffle)*,1959 to the low-budget noirs of Monogram Pictures; Truffaut drew on the pulp fictions of David Goodis and Cornell Woolrich for *Shoot the Piano Player (Tirez sur le Pianiste)*, 1960 and *The Bride Wore Black (La Mariée était en Noir)*,1968, respectively—which reframed the genre's specifically American tropes within a more sophisticated Parisian or, in the case of

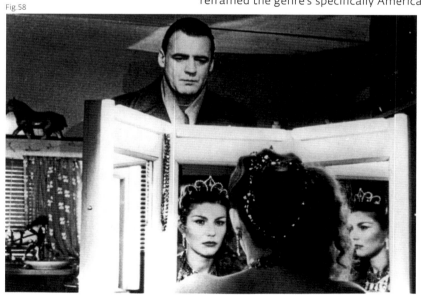

Fig.58

Claude Chabrol's *Le Boucher* and *La Rupture*, both 1970, provincial sensibility. By the mid-1980s, influenced by Douglas Sirk's 1950s melodramatic soap operas (*A Magnificent Obsession*, 1954, *All That Heaven Allows*, 1955) and maverick independent directors such as John Cassavetes, Roger Corman and blaxploitation kingpins Gordon Parks and Larry Cohen, this more politically distanced, highly mannered neo-Brechtian romanticism was reintroduced back into mainstream European and Hollywood cinema. Thus one notes a deliberately self-conscious, postmodern use of pastiche in the "queer" cinema of Rainer Werner Fassbinder and Derek Jarman, as well as more commercial successes such as *Thief* (Michael Mann, 1981), *Blue Velvet* (David Lynch, 1986), *The Pick-Up Artist* (James Toback, 1987), *The Crying Game* (Neil Jordan, 1992), *American Beauty* (Sam Mendes, 1999), and Todd Haynes's *Velvet Goldmine*, 1998 and *Far From Heaven*, 2002. In each case, the films' overly theatrical—

some might say camp—neo-expressionist style often seemed to be way in excess of their often clichéd narrative conventions, forging an analytic space between form and content that encouraged the spectator to reconstruct the very nature of romanticism from the ground up.

Wings of Desire (Der Himmel über Berlin), 1987 (fig. 58), Wim Wenders's and Peter Handke's postmodern homage to the "City Symphony" is exemplary in this regard. It contrasts the transcendental realm of spiritual love—the "Himmel" of the film's title, represented in black and white from the omniscient perspective of the film's guardian angels, Damiel (Bruno Ganz) and Cassiel (Otto Sander)—with the immanent world of daily reality for which they provide unseen solace. Damiel and Cassiel thus bear silent witness to a seemingly endless cycle of births, deaths, attempted suicides, traffic accidents, fears, and disappointments as metaphors for the traumatic psychological and historical re-emergence of Germany as a viable social, cultural, and economic entity following the national shame and horror of the Third Reich. The problem is all the more acute insofar as Germany—having lost its childhood innocence—is too self-conscious of its past crimes (of the guilt of the Nazi fall) to be able to reconnect to an untainted personal or collective memory as the incarnation of a new intentionality, a new dawn of decision. How can Germany bridge the gap between its lost past and present sense of denial? In short, how can it return to zero and remake itself as a creative work of art, in Nietzsche's Dionysian sense, amid such psychological dislocation?

This is all the more difficult insofar as it is no longer a homogeneous, nationalist Germany untainted by foreign occupation and ideological conflict: the Voice of America spews out its daily dose of propaganda in apartments and on street corners, while hoardings advertising Mobil and Opel indicate that the German economic miracle is entirely dependent upon Cold War realpolitik and the pragmatic goodwill of a global capitalist presence. Damiel senses that resurrection can only come through a willed reconnection to the simpler phenomenological and ontological questions posed during childhood: "When the child was a child, it was the time of these questions," he muses. "Why am I me, and why not you? Why am I here, and why not there? When did time begin, and where does space end? Isn't life under the sun just a dream? Isn't what I see, hear, and smell just the mirage of a world before the world?" In contrast, adult relationships and outlooks—like Germany's own self-image—seem to lack seriousness. They blindly accept coincidence and habit and the vagueness of concepts like eternity and infinity instead of asking fundamental questions such as "Why this place, this lover, this brother or sister as opposed to any other?"

We gain our first inkling that all is not quite right with Damiel as the two angels sit in an auto showroom, comparing notes on the minutiae of the day's events. "It's great to live by the spirit," admits Damiel, "to testify day by day for eternity only what's spiritual in people's minds. But sometimes I'm fed up with my spiritual existence. Instead of forever hovering above I'd like to feel a weight grow in me to end the infinity and to tie me to earth. I'd like, at each step, each gust of wind, to be able to say 'Now.' 'Now' and 'now' and no longer 'forever' and 'for eternity.'" "As you're walking," he continues, "to feel your bones moving along. At last to guess, instead of always knowing. To be able to say 'ah' and 'oh' and 'hey' instead of 'yea' and 'amen.'" Later, Damiel avers that he wants to "conquer a history for myself ... I've been on the outside long enough. Absent long enough ... Let me enter the history of the world." It's clear that he is speaking as much for Germany as for himself here; that is, incorporating and accommodating the reality of Germany's sordid Nazi past in the history of Europe without disavowing or forgetting its undeniable horrors.

Cassiel is sympathetic but advises caution: "Stay alone! Let things happen! Keep serious! We can only be savages in as much as we keep serious. Do no more than look! Assemble, testify, preserve! Remain a spirit! Keep your distance. Keep your word." But Damiel is unable to remain in the spirit world, especially after he encounters Marion (Solveig Dommartin), a beautiful French trapeze artist on tour with the soon-to-be bankrupt Circus Alekan.[2] As he watches her rehearse before her last performance, the film slips briefly into color, indicating the first chink in his transcendental armor and the beginning of his inevitable Miltonian fall from Paradise. However, it is important to emphasize that this is not a Christian conception of the Fall, but rather an attempt to deconstruct the difference between the transcendental and the immanent, the sacred and the profane, as a means of forging a more creative awareness of the need to act in and through the nuts-and-bolts surprises offered by the immediacy of living in the now, without resort to conceptual and romantic rationalizations.

As Damiel courts Marion through his presence in her dreams and by touching her hand as she dances in local night clubs, culminating in an intense conversation during a Nick Cave concert, he is aided and abetted by actor Peter Falk (a.k.a., TV's Lieutenant Columbo), who is in Berlin shooting a wartime detective drama. Falk, believe it or not, is himself a former angel, who gave up the ethereal realm thirty years earlier in New York to don the rumpled trench coat of television's most doggedly annoying detective. Glamorous romanticism doesn't get more tarnished than that! Sensing Damiel's invisible presence, he tells him of the somatic and sensual pleasures afforded by a satisfying smoke and a cup of black coffee—especially the two together—or the ability to render a good drawing, where a soft and hard line come together perfectly in synch. "When your hands are cold you rub them together," he enthuses. "You see, that's good. That feels good."

Walking with Cassiel by the Wall, Damiel tells him of his decision to join the mortals: "I'm going to enter the river … Forward in the ford of time, in the ford of death. We are not yet born, so let's descend. To look is not to look from on high, but at eye level. First, I'll have a bath. Then I'll be shaved by a Turkish barber who will massage me down to the fingertips. Then I'll buy a newspaper and read it from headlines to horoscope. On the first day, I'll be waited upon … I'll be known to everyone, and suspect to no one. I won't say a word, and will understand every language. That will be my first day." Indeed, after falling to earth and being hit by a piece of celestial armor (it turns out to be his earthly currency, which he is able to trade in at an antiques store for a plaid jacket, trilby hat, and a watch), the film switches exclusively into color (his subjective focalization of brute reality), and Damiel discovers the untrammeled joys of sensuous pleasure—the taste of his own blood, the pain of a bruised forehead, giving names to all the colors on the Berlin Wall murals. Suddenly, one recalls Garbo's excited exclamation after touching the objects at the inn in *Queen Christina*: "This is how the Lord must have felt when he first beheld the finished world with all his creatures, breathing … living."

Although the film works admirably as a form of existential personal romance, it also has collective ramifications. During their conversation at the nightclub, Marion admits that meeting Damiel means that she can finally admit to and enjoy being alone and put an end to relationships grounded on mere coincidence: "I don't know if there's destiny, but there's a decision. Decide! We are now the times. Not only the whole town, the whole world is taking part in our decision. We two are now more than us two. We incarnate something. We're representing the people now. And the whole place is full of those who are dreaming

**2.** The name is an in-joke reference to the film's cinematographer, Henri Alekan, whose career links *Wings of Desire* to an earlier French and Hollywood tradition of ill-fated fantasy romances such as Jean Cocteau's *La Belle et la Bête*, 1946 and Julien Duvivier's *Anna Karenina*, 1948.

From Her(e) to Eternity: Time, Memory, and Immanence in the "Postmodern" Romance

the same dream. We are deciding everyone's game." The film ends with Marion swinging athletically on the trapeze rope as Damiel, her lover and soul mate, steadies it at ground level (fig. 1). In a voiceover, he admits that he learned the power of astonishment that night. "She came to take me home and I found home. It happened once. Only once, and therefore forever. The picture that we have created will be with me when I die. I will have lived within it … Amazement about man and woman has made a human being of me."

This astonishment is reinforced intellectually by Homer, the aged poet, played by the octogenarian former cabaret star, Curt Bois, who acts as the film's philosophical and narrative conscience. Observed by an attentive Cassiel, Homer walks through the bombed-out wasteland of the former Potsdamer Platz, attempting to situate old landmarks, places where he sat and drank coffee, watched the lively crowd or bought a cigar at the tobacconists, in an attempt to connect the narrative dots of past and present in spite of a devastating spatio-temporal rupture. He sustains himself by thinking day by day on the need to compose and propagate, like his Greek namesake, a constantly self-generating, historical myth, as if the miracle of Damiel and Marion's individual romance required a collective muse in order to allow it to take wing among the masses as a whole: "Tell me, muse, of the storyteller who has been thrust to the edge of the world, both an infant and an ancient, and through him reveal everyman," he states. "With time, those who listened to me became my readers. They no longer sit in a circle, bur rather sit apart. And one doesn't know anything about the other. I'm an old man with a broken voice, but the tale still rises from the depths, and the mouth, slightly opened, repeats it as clearly, as powerfully. A liturgy for which no one needs to be initiated to the meaning of words and sentences." In short, without the myth of history and of love—indeed without artistic creations like *Wings of Desire* itself—mankind will lose its ability to fly from the here and now of the everyday to its contact with eternity, for eternity lies not above the fray, but within its very midst.

If *Wings of Desire* seeks a romantic sublimity in the recognition and pleasurable anxiety of the existential potential of the here and now—a now that consciousness is unable to grasp or formulate—Sofia Coppola's bittersweet love story *Lost in Translation*, 2003 (fig. 59) harnesses the same ingredients to construct, in Proustian fashion, a projected future memory, a time regained that will allow her protagonists fondly to recall what once was in their own relationship as a means of sustaining their ongoing present with their respective spouses. Bob Harris (Bill Murray) is a fifty-something American actor plunged into a midlife crisis. His twenty-year marriage to his surly wife Lydia is rocky, to say the least, and his waning movie career as an action star—shades of Sylvester Stallone or Bruce Willis—has forced him to accept a lucrative contract endorsing Suntory, a popular Japanese whiskey. Arriving in Tokyo to film a TV commercial, Bob is overwhelmed by alienation and culture shock: the streets are a veritable sea of animated neon and LED signs, including a billboard featuring Bob himself, whiskey glass in hand. Tired, jetlagged, and wracked with guilt over forgetting his son's birthday, he fights off a pair of insistent fans before repairing to his room at the Plaza Hotel. There he suffers the first of what will become a nightly bout of insomnia, followed by a series of cultural misunderstandings during the subsequent workday. First, the commercial itself rapidly turns into a comedy of errors: unable to speak or understand Japanese, Bob is confused by the stream of instructions uttered by the intense director, which are reduced to a single line by the laconic translator: "More intensity." Bob: "That's all he said?" Then, back in his room, he is visited by a prostitute (a.k.a. Premium Fantasy Woman) sent as a courtesy by the advertising agency; her heavily accented

**Fig. 59** Sofia Coppola. Still from *Lost in Translation*, 2003

English causes him to misunderstand her demands: "Lip my stockings. Yes, prease, lip them." He fights her off, but not before the whole episode has come to resemble an attempted rape. Lost in translation indeed!

Meanwhile, the Plaza is also playing host to an American couple, Charlotte (Scarlett Johansson), a recent philosophy graduate from Yale, and her photographer husband John (Giovanni Ribisi), who is visiting Japan to photograph a rock band. Like Bob, Charlotte is undergoing an identity crisis. She has little or no career direction—she's accompanying John for want of anything better to do and spends her free time engaged in the usual tourist activities: visiting video arcades and Buddhist shrines—and also fears that her marriage is failing. Events reach a critical head when John bumps into his actress friend Kelly (Anna Faris), whom Charlotte finds vapid and unintelligent. In response, John berates Charlotte for being condescend-

ing. Unable to stand Kelly's company, Charlotte spots Bob—they had met earlier following a mutual bout of insomnia—in the Penthouse Bar and they strike up a conversation. "Can you keep a secret?" asks Bob, conspiratorially. "I'm trying to organize a prison break. I'm looking for, like, an accomplice. We have to first get out of this bar, then the hotel, then the city, and then the country. Are you in or you out?" Charlotte: "I'm in. I'll go pack my stuff." Bob: "I hope that you've had enough to drink. It's going to take courage."

After John leaves for his photo shoot in Fukawaka, it is inevitable, given Charlotte's intelligent beauty and Bob's ready wit, that the two insomniacs will spend more time together. Visits to night clubs and strip joints with Charlotte's friends, the inevitable karaoke scene, where Bob's strained rendition of Elvis Costello's/Nick Lowe's "What's So Funny 'Bout Peace Love and Understanding" recalls Murray's classic lounge act turns on TV's "Saturday Night Live," a comical visit to the hospital after Charlotte stubs her toe, suggest the makings of a classic May–September romance. This seems all the more inevitable when Charlotte has a fit of jealousy after calling on Bob to make a lunch date and discovering that he has slept with the hotel's resident jazz singer (Catherine Lambert). "Well, she is closer to your age. You could talk about things you have in common, like, um, growing up in the '50s!" However, despite often tender physical contact—Charlotte leans her head on Bob's shoulder as they share a cigarette, he gently tucks her under the covers when she falls asleep following a night on the town, and comforts her by touching her foot after a long conversation about career and marriage—Coppola skillfully steers the couple's relationship into something deeper: that of soul mates.

Indeed, it is obvious that a sexual romance is out of the question. First, both are married, albeit unhappily. Secondly, the age difference, despite Bob's often childlike antics, is overwhelming. Instead of following the usual hackneyed Hollywood romantic formula, Coppola allows the couple to develop their relationship in the present tense—they literally learn to live in "the now" by self-consciously making vivid memories to fall back on in the future, almost like creating snapshots—as a means of putting meaningful life back into their respective marriages once they return to the States. Thus one level of romance is restored at the expense of another that is ultimately sacrificed for a greater long-term good. It's no accident that the film is full of memorable moments, like the karaoke sequence or the long scene when Bob and Charlotte talk, fully clothed, on the hotel-room bed, because these are also the unique memories that are created by and for the characters themselves. Indeed, Bob seems to sense this when he stares at a candid Polaroid of Charlotte on his way back from doing a television talk show, and the latter confirms her similar feelings when she later says to the actor, "Let's never come here again, because it would never be as much fun."

It's this need to refine the immediacy of memories that explains the film's ambivalent ending. Unhappy at finally having to go their separate ways and dissatisfied by their awkward farewell in the hotel lobby in front of the fawning Suntory executives, Bob spots Charlotte walking along the street as he makes his way to the airport. He asks the chauffeur to stop, chases her down and finally gives her the embrace and tender kiss that the audience has craved all along. However, although both parties have succumbed to their deepest feelings and Bob whispers something unintelligible in her ear, it's highly unlikely that he is saying "Ditch the loser with the camera and meet me at the airport in an hour," as many fanciful bloggers have suggested. Instead, the music soundtrack—The Jesus and Mary Chain's "Just Like Honey"—tells a more likely, albeit more sobering story about a man and a woman's commitment to keeping their waning

Fig.60

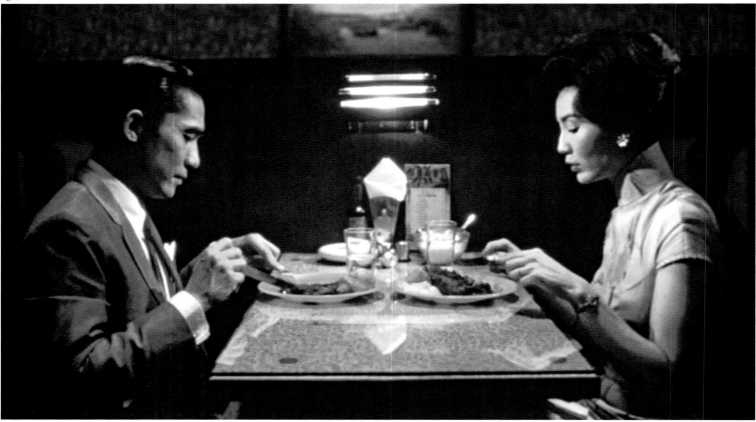

**Fig. 60** Wong Kar-wai. Still from *In the Mood for Love* (*Fa Yeung Nin Wa*), 2000

marriages alive: "Walking back to you, is the hardest thing that I can do ... I'll be your plastic toy for you. Eating up the scum, is the hardest thing for me to do. Just like honey."

This multiple time frame, in which the emotive content of time present generates the memories that will ensure the possible sustainability of future romance, is taken to even more complex extremes in the recent work of critically acclaimed Hong Kong director, Wong Kar-wai, specifically the award-winning *In the Mood for Love* (*Fa yeung nin wa*) made in 2000 (fig. 60), and its ambitious sequel, *2046*, of 2004 (fig. 61). Set in Hong Kong in 1962, the former film focuses on two married couples, the Chows and the Chans, who by pure coincidence happen to move into neighboring apartments on the same day. Significantly, one half of each couple—Mr. Chan and Mrs. Chow—is noticeably absent on move-in day, leaving Chan's wife, Su Li-zhen (Maggie Cheung) and Mo-wan, Mrs. Chow's newspaper-editor husband (Tony Leung), to fend for themselves. Indeed, we quickly realize that the missing spouses spend an inordinate amount of time away from home, whether working late at the office or traveling on business throughout the Far East. Although they are constrained by the rigid moral code of Hong Kong society of the time—the apartment building is a veritable hornet's nest of gossip and almost panoptic surveillance of the tenants' comings and goings—Li-zhen and Mo-wan develop a shy and highly formal relationship as they slowly discover a shared interest in movies, noodles, and martial-arts serials. However, their world is shattered when they discover that their respective spouses are having an affair—with each other!—and they start to forge a more intimate bond.

Puzzled by how such an adulterous betrayal could possibly have occurred without their knowledge, the couple start to role play and re-enact the beginning and development of their respective spouses' affair, with Li-zhen playing Mrs. Chow and Mo-wan impersonating Mr. Chan. Because we have hitherto only seen the backs of Li-zhen's husband and Mo-wan's wife—and their voices are only heard off-screen—it

is easier for the film's audience to project the cuckolded couple into the reconstructed adulterous relationship, thereby accelerating the possibility that Li-zhen and Mo-wan will themselves fall in love and initiate a sexual encounter. However, both parties stubbornly refuse to sink to the moral level of their spouses and their relationship remains purely platonic. Consequently, the almost unbearable sexual tension has to be sublimated throughout the film in a number of ways. First, the pair channel their libidinal energies by collaborating secretly on a martial-arts serial, necessitating the taking of a hotel room—significantly for the film's sequel, it's room 2046—for both their creative and personal assignations. Secondly, they also start to role play Li-zhen's expected showdown and ultimate break-up with her wayward husband, a rehearsal so traumatic that she is clearly conflating Mr. Chan's deceptions with the possibility that Mo-wan has also taken a lover. Has she fallen in love with her collaborator? In the end, the lack of sexual fireworks within the diegesis finds its compensations in the film's lush, highly mannered style. Cinematographers Christopher Doyle and Mark Li Ping-bin establish a claustrophobic romanticism exacerbated by an almost exclusive focus on the two main characters and an emphasis on the melancholic, sensuous texture both of sound—predominantly Nat King Cole love ballads sung in Spanish—and image. Here, secrets seem to be constantly hidden behind the surface façade of closed doorways and oblique mirrors—with their endless doublings and fractured spaces—and lush, flowery draperies, exuding an Orientalist, seraglio-like exoticism. Even the exterior shots provide little relief from the film's spatial constraints, for they are filmed largely at night with a single light source filtered through sheets of pouring rain. Noir never looked so sensuous or lush.

It is the inevitable dissolution of Mo-wan and Li-zhen's unconsummated relationship that spawns the events and complex time frame of the film's sequel, 2046. "In the year 2046, every railway network spreads around the globe," proclaims the film's opening text. "A mysterious train leaves for 2046 every once in a while.

**Fig. 61**  Wong Kar-wai. Still from 2046, 2004

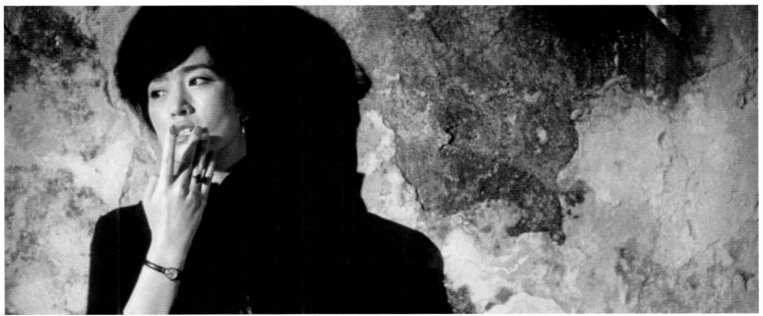

Fig.61

Every passenger who goes to 2046 has the same intention. They want to recapture lost memories. Because nothing ever changes in 2046. Nobody really knows if that's true because nobody's ever come back. Except me." The "me" of the voiceover, the protagonist who actually desires personal change, is Mo-wan, the film's narrator and also the author/chief protagonist of the eponymous science-fiction novel, itself named after the hotel room from *In the Mood For Love*. Obviously in complete denial about the impact of his break-up with Li-zhen (which is left deliberately ambiguous at the end of the earlier film), Mo-wan once again sublimates his true feelings, whether through countless sexual assignations—"Lots of one-night-stands," he proudly asserts, "Never mind, nothing lasts forever anyway"—or through his fantastical fictions.

The film traces his emotional odyssey through four specific relationships, each separated by approximately one year. First there is Lulu (Carina Lau), an old flame from an earlier Wong Kar-wai film, *Days of Being Wild*, 1991, who turns out to be temporarily living in a hotel room whose number is—you guessed it—2046. Fascinated by the coincidence, Mo-wan tries to lease it himself after she moves out, but is forced to take the room next door—2047—while it is being redecorated. Eventually, he decides to stay put, keeping a watchful eye on 2046's comings and goings as he writes his "erotic and bizarre" sci-fi story. As one might expect, the women in his life become the raw material for his novels, and at a certain point—given their mutual inflection and interaction—it is difficult to discern whether we are in the virtual world of his fictions or the actual world of his everyday reality. Thus there is the young prostitute/nightclub hostess, Bai Ling (Ziyi Zhang), the latest occupant of 2046, who eventually falls in love with him but ends up brutally rebuffed, as if Mo-wan were merely borrowing her time and body for both sexual and creative gratification. Then there is his amanuensis, Wang Jing-wen (Faye Wong), the landlord's daughter, who also loves martial-arts stories and is engaged in an illicit long-distance love affair with a Japanese man. Clearly attracted to Jing-wen, Mo-wan writes her into his novel as an android on the train from 2046, where he himself plays a Japanese man unsuccessfully attempting to seduce her while Lulu, also an android, looks on.

Finally, there is the Black Spider (Li-Gong), a professional gambler who helps Mo-wan clear his debts for a percentage of the profits. By coincidence, her name is also Su Li-zhen (Maggie Cheung's character from *In The Mood For Love*) and there is a suggestion that, as in the case of his other lovers, Mo-wan is attempting to mold their relationship in an attempt to resurrect his original, unconsummated lost love and turn back the sands of time through a form of sexual proxy. But, to his credit, he realizes that this is impossible. "Love is all a matter of timing," he notes. "It's no good meeting the right person too soon or too late." Only the artificial world of literature and film can recall and freeze memories from the ravages of lost time, so that even though 2046, the film, offers the possibility of romantic redemption through the critical distance and willful manipulation of Wong Kar-wai's undeniably seductive art, 2046, Mo-wan's roman à clef, must necessarily be found wanting as an authentic romantic confession. "All memories are traces of tears," says Mo-wan, which is exactly what makes them the ideal raw material for art. Just ask Queen Christina.

Special thanks to Felicity Colman, Lecturer in Screen Studies in the School of Culture & Communication at the University of Melbourne, Giorgio Curti, Ph.D. candidate in Geography at San Diego State University, and Terrence Handscomb, for their invaluable suggestions in shaping the content and scope of this essay in its formative stages.

From Her(e) to Eternity: Time, Memory, and Immanence in the "Postmodern" Romance

# a crystal formed entirely of holes
*Nick Flynn, June 2007*

1    At first it was just a kiss, tentative at first, her lips moving over his body, she found the hole, one of them, one that the AK47 had left, this one in his bicep, her tongue fluttered over the wound, healed now, grazing it lightly, as if to say, *it's alright, I still want you, you're still beautiful*, and on the third pass her tongue slid in, at first just the tip, and he didn't push her away, and as her tongue went deeper he shuddered down to some untapped core and moaned and it surprised them both.

Word spread across the base. It was only a matter of time before it caught on.

2    In 2006 a physicist in Texas had synthesized a crystal formed entirely of holes. *A crystal formed entirely of holes*. You couldn't hold it in your hands, but its mass could be measured by how much air it displaced, by the way light passed through it. It came directly from research into the shape of nothing, which had been revealed to great fanfare a few months earlier, with charts and renderings and shadowy drawings.

3    As with most pure science, the military was first to understand the practical applications—put bluntly, they had so many bodies shot through with so many holes, a simple, unavoidable byproduct of their business. Bad enough, the casualties, but the injuries, the wounded—they never play well on TV. A military researcher read about the new crystal—what if one combined this nonentity, this synthetic nothing, with even rudimentary stem-cell technology—he speculated it could create, in essence, an entire new organ, the hole itself would become the organ—an evolutionary leap, but not the first—vegetables had been engineered for decades, every species from one-cell bacteria on up had by now been cloned. The higher-ups didn't care much about the Darwinian aspects of it, they were just tired of bleeding out. If it worked, the idea was to apply this new technology to those wounded in battle—shrapnel blows a hole through your skull, the wound itself becomes a new organ, incorporated into the body. If it worked—and there was every reason to believe it would—even a hand or a leg, blown off, could be restored. You still wouldn't be able to see it, but technically it wouldn't be classified as missing. Every soldier could now walk off a plane into his or her loved one's arms, for all the world to see. Home, waving a hand that wasn't there, the sun shining through the hole shot through his chest. Win-win.

4    A soldier lay in a dusty parking lot in Baghdad, a jagged line machine-gunned across her chest, holes that will kill her, holes that her life will escape through, unless these holes themselves can be incorporated into her body.

Stateside, six weeks later, at her bedside, her boyfriend pulls back the bedsheet to see how she's healing—seven pink-tinged, round-lipped blossoms. His finger hovers briefly over each one, tracing their swelling. She shudders, takes his face in her hands, and kisses him, their first real kiss since the operation, now pressing her whole body against him, rubbing the holes against his chest. He places his finger in his mouth, wets it, and circles the hole shot through her collarbone, slowly working his finger inside, below the surface, working it slowly in and out, making it bigger, slowly, able to accept two fingers, then three.

By the end of the night he'd filled every one.

5   Erika watched the soldiers coming off the plane, waving their empty hands. Her mother was on the couch reading magazines called *Us* and *InTouch*, which Erika called "Them" and "Out of Touch." The air-conditioner whirred to life. This was the apartment they'd lived in since her father vanished. Sunlight shone through a soldier's mouth. *That's messed up*, Erika said to no one, switching channels.

6   Side-effects. As with everything, there's side-effects. Once you're brought back from the other side, once you've gone over, you no longer recognize where you're from, not really—*you're a new freakin species, soldier, what do you expect?* Still, you were shipped back to where you came from, shipped home. It was impossible for you to stay. Baghdad? Tikrit? For what? To wander the desert with a hole through your heart?

7   It wasn't exactly boredom—more a sense of the unreal. Houston, to Erika, felt deeply unreal, even if she couldn't point at anything specific and say, "what *is* that"? Everywhere she looked was another temple to the ultra-real—a coffee shop that smelled like coffee, a record shop lined with bins of used cds. The tattoo on her backside, she'd wake some mornings, keep her eyes shut, trying to remember what it was. Flames? A snake? Three snakes entwined around something? What? Why did she get it? With who? What did it mean? Maybe it was a lotus blossom. She'd read somewhere that because of all the barbeque joints in Houston the air over the city was made up of ten-percent burnt particles of flesh—*particulate matter*. Maybe she heard it on the radio—she could still hear a voice pronouncing the words *particulate matter*. She read somewhere else that the drinking water was six percent antidepressants, from sewer run-off seeping into the groundwater. *Pissing in a river, watch the fish smile*. Erika calls herself a vegetarian, some days. *The air is meat*, the graffiti on a bridge over 59 said—*be happy*.

8   The porn industry picked up the ball, first the low-end companies, the bucket shops, but it quickly spread to the mainstream. Click onto YouTube, type in "a crystal made entirely of holes," and you can see it, a video, homemade. It shows the tonguing, lots of tonguing, but it doesn't show how to make the holes.

9   Houston is the center of the plastic-surgery world—more people alter themselves here than anywhere else on the planet. In Houston there's a plastic surgeon, let's call him Dr. Malick. For a while Malick oversaw the coercive interrogation wing at the federal prison downtown. State-of-the-art facility; high-risk prisoners. With the passage of the Military Commissions Act, safeguards had been put in place to prevent the abuses and embarrassments of another Abu Ghraib. Strict oversight. In the interrogation rooms Malick perfected a technique to simulate the effects of a shrapnel or bullet wound to flesh, and then he would "heal" the wound, a few moments or a few hours later, after the questions had been asked, after the answers had been given, or not given.

10  Word spread. The skateboard punks who used the concrete fortifications outside the prison as jump ramps heard about what was happening on the other side of the walls. They saw the nighttime deliveries—a hooded man, an orange jumpsuit, the spray-painted goggles, the old-school headphones that silenced everything.

11    Malick opened the first Drive-Thru Holery in the desolation of downtown, out of a storefront below the Pierce Street overpass. He'd recently been retired from the prison—rumors he'd gone a little too far, though no formal charges were filed. Malick kept a running tally on an electronic billboard, visible from the highway, of the number of holes he'd "punched." *Your mind is your only limit!* was the tag line. At first he gave out a KrispyKreme to each customer—the perfect synergistic franchise, though now he doesn't bother. No one ate them anyway.

12    Once it caught on, Erika said it was all she'd found to believe in, that her god-given body had always seemed so limiting. Her god-given body filled her with despair, she said. It wasn't a matter of belief, because she professed to believe nothing. She and the other skateboard punks found themselves wanting more, more *options*—the flesh they were born with, the few holes they were given, the few ways they'd found to fill them, it wasn't enough, not any more. Maybe it never was. They wanted some new organs. They wanted to be transformed, they wanted to become new freakin species.

13    Maybe it was the KrispyKremes, but after they got their first hole the punks called themselves "donuts"— those with twelve called themselves "a dozen."

14    One hole per visit was allowed, by law, though there was no limit on the number of visits one could make. One could come every day—Erika came every day. *I'm a dozen*, Erika said, *I'm two dozen*. The day you got a donut someone else had to drive you home—that was the other rule. Those days Erika's boyfriend got the donut instead of her, she'd drive away with one hand on the wheel and her other hand tearing off his bandage. Most days, though, she came alone. For Erika, Malick bent the rules—Saint Erika— pilgrims crossed the parking lot on their knees just to touch her toe, her toe with a hole shot through it.

15    Her body was state-of-the-art. You could see the sky through her forehead, the stars through her palm. Bones were rearranged, bones weren't a problem. She wanted each hole to shoot clean through to the other side, she wanted to shoot through to the other side. One more and she'd be gone. *Pure donut*, it was called, but no one had yet gone that far. A crystal made entirely of holes. Malick knew Erika would go that far, she was that beautiful. From that moment on we'd only glimpse the outline of where she'd once been.

# RICHARD BILLINGHAM

Fig.62

**Fig. 62**  Richard Billingham. *Untitled*, 1995.
Color photograph on aluminum,
41 ⅜ × 62 ¼ in. (105 × 158 cm)

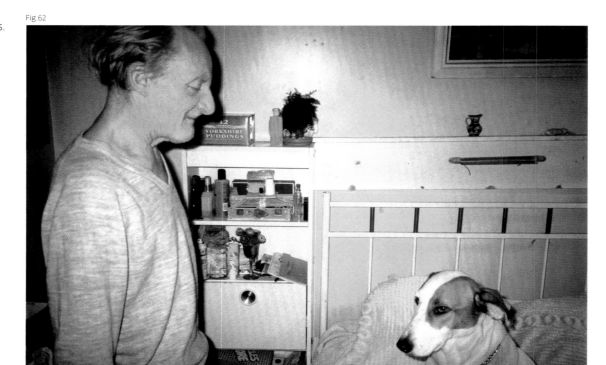

Richard Billingham first gained international attention when he was included in the notorious 1997 *Sensation* exhibition of British artists in the Saatchi Collection, held at London's Royal Academy. This career breakthrough culminated in his being shortlisted for the Tate Gallery's Turner Prize in 2001. However, the Birmingham-born painter-turned-photographer had first come to national prominence in 1994 with a series of candid—some might say grotesque—snapshots of his working-class family in their council flat in Cradley Heath, an industrial suburb deep in the heart of the impoverished Black Country of the West Midlands. Here we encounter his seventy-year-old alcoholic father, Ray (fig. 62), usually prostrate from drinking too much home brew or slumped tipsily on the toilet, pitching forward as if about to crack open his forehead. We also meet the artist's fifty-year-old chain-smoking mother, Liz (fig. 63), with her tattoos and blackened teeth, doing jigsaws in her billowing floral housecoat or feeding a kitten with a syringe. Then there's his homebody younger brother Jason, doing what Jason does best—swatting flies—as well as a cornucopia of bric-a-brac—a fish tank, dolls on the windowsill, saggy furniture, a bird in a cage, hundreds of videos, family photos, and the family dog chewing its rear end on the sofa.

Successfully published as *Ray's a Laugh*, 1996, the series actually began as photo studies for paintings. In fact, Billingham had little interest in the technical aspects of the medium and never studied the work of other photographers, preferring to acknowledge his deeper compositional debt to the work of British pictorialists such as Walter Sickert, Frank Auerbach, and Leon Kossoff, painters who epitomize

critic Peter Fuller's notion of "redemption through form." However, the snapshots' combination of amateurish intimacy (Billingham used the cheapest film available and had it developed at the cheapest place: the local chemist) and ambivalent emotions (he discloses, by turns, affection, amusement, exasperation, and pity for his dysfunctional family) led to flattering critical comparisons with other notable urban anthropologists such as Nan Goldin, Robert Frank, and Larry Clark. In 1998, a fifty-minute Hi-8 video supplement to the series, named *Fishtank* (after Ray's habit of mindlessly watching the fish while he drinks), was aired on BBC 2, prompting inevitable comparisons with "Kitchen Sink" directors such as Ken Loach and Mike Leigh. Billingham was being pigeonholed as a working-class social realist faster than he could take breath from his new-found success.

Fig.63

**Fig. 63** Richard Billingham. *Untitled*, 1995. Color photograph on aluminum, 41 ⅜ × 62 ¼ in. (105 × 158 cm)

Wary of exploiting his family further—they were quickly turning into exotic sociological guinea pigs—Billingham fought back, dismissing those well-intentioned art-world slummers who reduced the work to "a harrowing chronicle of underclass desperation": "It shows they're not looking hard enough. There's emotional meaning to them ... I've always wanted to move people as much as I can, so much that they cry."[1] It's significant that Billingham is deeply interested in the autobiographical films of Terence Davies (*The Terence Davies Trilogy*, 1984, *Distant Voices, Still Lives*, 1988), in which issues of time, memory, and identity are interwoven through lyrical and loving depictions—usually combining elements of song and stylized theatricality—of a sexually repressed, often harrowing upbringing in postwar England. "I was very moved by his films," acknowledged the artist. "It was like seeing his memories, the way the camera seems to hold, to linger: just one hold, after another hold, after another. And the time doesn't seem to be chopped up too much."[2] Davies's use of non-linear tableaux to add emotional resonance to an otherwise alienating urban milieu would become an important element—conscious or unconscious—in Billingham's own landscape work, as we shall see.

Billingham was also critical of spectators who failed to see the artistic skill involved in the careful pictorial framing of the work: "I quickly came to realise that most people only saw the surface of the images, such as my mum's tattoos or the carnivalesque wallpaper, or the type of knickknacks on display, or the dirt on the floor or whatever ... It was like the audience was just leering at this other world. I don't think most people saw any of the beauty underneath or how well the pictures were composed ... So partly on the strength of this, I wanted to take some photographs that stripped away any hint of sensational subject matter but would remain very good photographs. The most boring subject I could think of was the area where I grew up, so I began to photograph those spaces in the same snapshot style as the earlier work. These photographs were much harder to take than the family ones because I was essentially trying to photograph 'nothing:' try taking a photo outdoors that is not essentially a picture of a tree or car, or of the weather. It's extremely difficult."[3] The result was *Black Country*, two series of untitled landscapes taken six years apart, the first (1997) shot in daylight before Billingham moved from Cradley Heath (fig. 64), the second (2003) shot at night on a return visit after he had permanently left the area (figs. 65–7).

**1.** Richard Billingham, cited in "My Family and Other Animals," *The Independent*, November 28, 1998, p. 12.1.

**2.** Richard Billingham, Interview with James Lingwood, *Tate*, Winter 1998, p. 55.

**3.** Richard Billingham, Interview with Claire Canning, *Tank* 3, no. 9 (2004), p. 83.

Fig.64

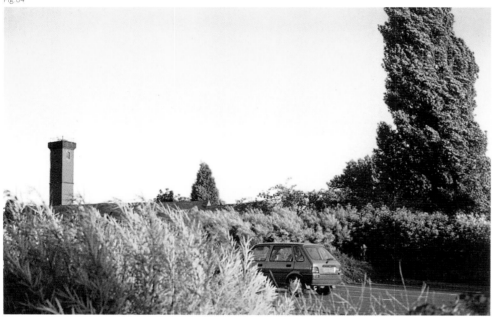

**Fig. 64** Richard Billingham. *Untitled #8*, 1997. C-print, 29 ½ × 36 ¼ in. (75 × 92 cm)

**Fig. 65** Richard Billingham. *Untitled #1*, 2003. Color lightjet print, 43 ¾ × 53 ½ in. (111 × 136 cm)

As one might expect, the similarities and differences between the two series are telling and provide considerable insight into Billingham's emotional attachment to his roots, for as Sylvia King points out, "The Black Country has that strange quality of not letting you go, of keeping you hooked in, and of keeping the relationship going wherever you've been in the meantime."[4] These are the places that, as a child, Billingham passed on his way to school or to his mother's house, so in this sense the landscapes become as personal as family portraits. The earlier series takes the form of hand-held snapshots shot surreptitiously within walking distance of 19 Sidaway Street, where the artist was born. It's a typical urban landscape of anonymous factories, streets, parks, schools, playgrounds, railway tunnels, parking lots and churches, yet there are also the tell-tale signs of Billingham's painterly eye for composition: an overgrown corner lot is framed by rows of black Crimean War cannons, standing erect like so many tin soldiers, while the odd geometries and architectural shards of fully or half-painted gabled ends of row houses give the landscape a distinctive cubistic fracture. But the overwhelming feature of both series is the complete lack of human presence other than the occasional parked car or van. According to Billingham, "I was becoming more aware of things as an artist but I did not want to move out of Cradley Heath and let go of the emotional security and reassurance that my hometown afforded me. To me, the daytime pictures embody that longing and sense of immanent loss rather than try to communicate some kind of human presence. As for the people and traffic, they are everywhere except within the frames of the pictures since I would position myself on a street corner or whatever in a spot that I considered to be the best summary of what I wanted to capture. I would wait until no cars or people were going by, lift the camera quickly and take the picture."[5]

In contrast, the night-time series consists predominantly of views from and through thoroughfares and alleys—a huge tree dominating a grass verge (fig 65), the dark pyramidal shape of a factory roof, a school wall, a churchyard, the boarded-up face of a building with its ironical, almost taunting Neighbourhood Watch sign (fig. 66)—and take on the sickly blue and orange hues produced by the bright sodium, halogen, and neon colors of the adjacent street lighting. "I took the night-time pictures six years on to see how my relationship had changed to my hometown," notes Billingham. "I had moved away and traveled and accepted that I would not live there again. The night-time pictures are more settled maybe. There is no sense of loss like in the earlier work but more a sense of discovery. I think this is because I changed my approach to making them. They were no longer snapshots but medium format images made with long

**4.** Sylvia King, foreword to Richard Billingham, *Black Country* (West Bromwich, England: The Public, 2004), p. 8.
**5.** Richard Billingham's *Black Country*, interview with David Osbaldestin. It was posted online in May 2005, *Fused Magazine*, no. 23. http://www. fusedmagazine.com/Past_Issues/Issue_23/RICHARD_BILLINGHAM.aspx. (accessed 8/7/07).

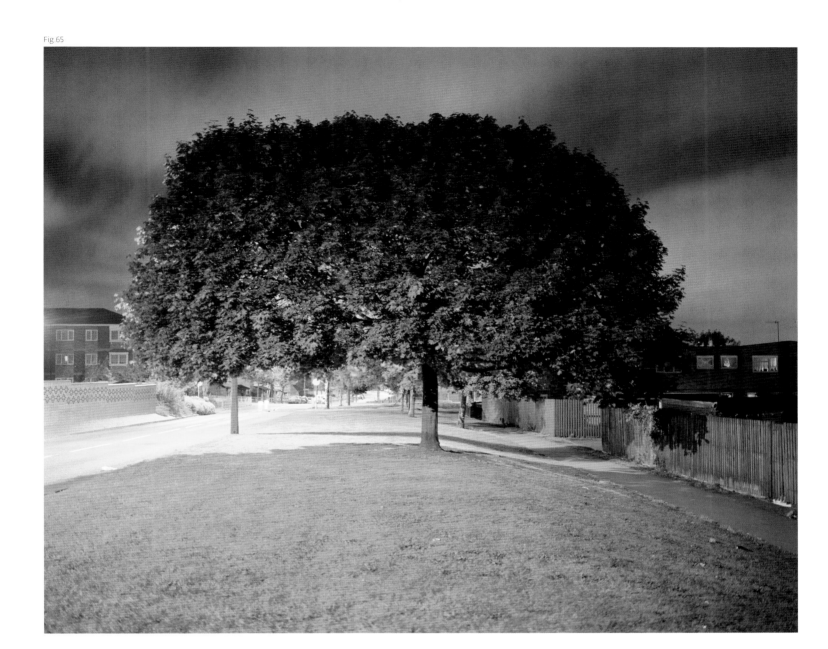

Fig.65

Fig.66

Fig.67

**Fig. 66**  Richard Billingham. *Untitled #11*, 2003. Color lightjet print, 44 × 54 in. (111.8 × 137.2 cm)

**Fig. 67**  Richard Billingham. *Untitled #4*, 2003. Color lightjet print, 43 ¾ × 53 ½ in. (111 × 136 cm)

exposures. The photographs are very detailed and pick up much more information than your naked eye would see."[6] One could argue that through these frozen tableaux Billingham is, in a way, haunting his childhood like a photographic specter, seeking both comfort and resolution by consolidating and constructing memories as he passes. After all, he once played in these vacant lots and parks, and more ominously, would often trek alone to the local pub at closing time to drag his soused father back home to Sidaway Street. As Billingham confirms, "My memories of Cradley Heath are playing on the street with other kids (there were no parked cars congesting the streets back then), building camps on waste ground, exploring derelict terraced houses and factories, inspecting the stripy caterpillars you used to get on Oxford Ragwort weeds, finding mice nests under pieces of discarded corrugated iron in the graveyard. Most kids cannot do these things today, as parents are too fearful to let them outside in case they get run over or abducted. I am glad I grew up like this instead of spending time playing computer games or watching TV."[7] For any artist who gets his creative inspiration from childhood, such banal, everyday details—like the knickknacks and bric-a-brac in *Ray's a Laugh*—are priceless raw material.  C. G.

6. Op. cit.

7. Op. cit.

# BERLINDE DE BRUYCKERE

Fig.68

**Fig. 68** Berlinde De Bruyckere. *I Never Promised You A Rose Garden*, 1992. Refrigerated truck with lead and ice, 106 ¾ × 126 × 56 in. (271 × 320 × 142 cm)

**Fig. 69** Berlinde De Bruyckere. *Fran Dics*, 2001. Horsehair, wax, polyester, life size

Berlinde De Bruyckere's art is permeated with a profound sense of anxiety that is triggered by a complex tangle of corporeal overload. Throughout her career, she has operated in the interstices between abstract typologies and representational depictions; her archetypal images are full of contradictory impulses. Figurative but not portrayals, emotive but not emotional, her sculptures in diverse media state existence as a struggle between memory and immediacy, safety and danger, love and rejection. They are reductive and severe but embody a warm, human softness that is rendered in achingly tender or surprisingly sensual ways. Recollections of innocence lost and experience gained are her overarching themes. "There is the question of access to the image, and there is the question of access to the world," wrote the Belgian art-historian Barbara Baert. "There is the question that overwhelms, and what is overwhelming. There is the question that drifts and what comes to a standstill. There is the question of what one will pick up along the way and what has to be cast off. There is the question of what bears and what is bearable."[1] These fundamental polarities inform all of De Bruyckere's art.

Roses are prickly symbols of romantic love and erotic passion as well as of fidelity, chastity, and platonic friendship. The rose is, "in essence, a symbol of completion, of consummate achievement and perfection. Hence, accruing to it are all those ideas associated with these qualities: the mystic Centre, the heart, the garden of Eros, the paradise of Dante, the beloved, the emblem of Venus."[2] In *I Never Promised You*

1.  Barbara Baert, "What Bears and What Is Bearable," in *Berlinde De Bruyckere*, exh. cat., East Flanders Provincial Center for Art and Culture, Ghent, 2002, p. 131.

2.  J. E. Cirlot, *Dictionary of Symbols* (London: Routledge, 1983), p. 275.

Fig.69

*a Rose Garden*, 1992 (fig. 68), De Bruyckere renders the fugitive perfume and mutable meaning of roses eternal by casting them in lead. Her wicker baskets filled with lead roses reinforce the highly temporal nature of both romance and recollection.

Early works involving old blankets articulated similarly oppositional notions of comfortable security and vulnerable homelessness. De Bruyckere has stacked blankets in containers as if ready for use (fig. 20) and employed them to cover haystacks in a field, as if to protect them from the elements (fig. 19). More provocatively, she has draped blankets over the heads of female forms that stood as isolated sentinels, floated face down in a lake, or perched high in the trees (fig. 21), suggesting in these obscurings the myriad ways in which someone could hide, escape, or surrender. More recent works have featured women whose faces were hidden beneath skeins of long, thick hair (fig. 69). But whether covered with blankets or hair, all De Bruyckere's women radiate the psychological freight of a collective memory that is specifically female—of making one's body secret in order to protect the vulnerable integrity of identity.

In 2002 De Bruyckere presented a ground-breaking work entitled *In Flanders Fields*, an installation involving massive sculptures using casts the artist made from horse carcasses (fig. 23). Their exteriors were covered with cured horse hides stitched together so that their seams were plainly visible; these forms were posed in a dramatic mise-en-scène at the In Flanders Fields Museum in Ypres. Inspired by historical photographs of the carnage-filled aftermath of this famous World War I battlefield, De Bruyckere was especially drawn to images of dead horses whose broken and deformed corpses were strewn throughout the landscape and even suspended from trees.[3] As she continued to mine this fertile territory, her subjects morphed from distinctly recognizable animalistic representations into increasingly eroticized, anthropomorphic shapes that translate the allusions of a tragic battlefield slaughter into a more nuanced exploration of the intersection between destruction and creation. Transforming the iconic horse into an archetypical symbol of heroic endurance, De Bruyckere dissolves the functionality of physical existence into rudimentary forms that only tangentially reflect the many details of observed reality. Lacking defining features, these animals represent the indeterminate longing of isolated individualism for membership in a larger community.

De Bruyckere's use of cages, cases, cabinets, baskets, and blankets suggests the idea of domesticity as both a trap and a sanctuary, a shelter and a prison. Contained within these enclosures, her representations—whether lead roses, stuffed children's toys, or human figures—function as both entirely personal and broadly universal expressions of human experience. In *Pietà*, 2004–5 (fig. 70), two life-size anthropomorphic creatures are housed in a glass display case like scientific specimens in a natural history museum. Their bodies are arranged in a mutually dependent stance of support, rest, and collapse. Amorphous, featureless, and with no obvious means of cognition or expression, they congeal into a vaguely recognizable humanity only at their legs and feet. The interaction between these two beings is uncertain and open to broad interpretation. As in many of her sculptures, De Bruyckere's formal aesthetics here underscore a collision between the modernist gridded geometry of the glass display case and the pliant, undulating physicality of the bodies. Contradictory while coexisting, the industrial materiality and metamorphic articulation broadcasts an underlying theme of isolated humanness, a place where "everything that is brought to life by her has to carry its antipode."[4]

**3.** Ypres was considered a key strategic position, protecting Belgium and France from the German onslaught. There were three key battles, in 1914, 1915, and 1917. Each was brutally devastating, the final battle resulting in some 500,000 deaths and the virtual obliteration of the town.

**4.** Max Borka, "Killjoy Was Here: A Wet Blanket from Flanders," in *Washington Velvets (Two From Flanders): Berlinde De Bruyckere and Philip Huyghe*, exh. cat., Corcoran Gallery of Art, Washington, D. C., 1996.

Fig.70

Human endurance in the face of time's erosive qualities is one of De Bruyckere's constant themes. "The past is our roots," she has noted. "The things you are brought up with. That is the store of essential experiences and images by which you gauge the rest of your life."[5] Fulfilling Roberto Calasso's observation that "the mythographer lives in a permanent state of chronological vertigo,"[6] De Bruyckere steeps metaphors shaped by her own personal experiences, history, and current events in the slippage of time's quickly moving wake. In 1995 she made an artwork entitled *Innocence can be hell*, which can be considered her artistic manifesto. Consisting of two hundred old blankets hung on four enormous drying racks, the sculptures looked like a gargantuan sampling of Salvation Army donations. On close inspection, one could see that each blanket had been subtly altered: sewn around the edges were selvage tapes bearing the phrase "innocence can be hell."[7] Cleaned and pressed, the blankets didn't exude the musty smell one would associate with the idea of cast-off bedding that featured so prominently in the installation *Innocence can be hell* presented in Park Middelheim in Antwerp that same year. Here, rather than hanging tidily on racks as they were in the hallowed confines of an art museum, they were stacked in boxcar-like containers as if supplies waiting to be delivered to the needy. In Middelheim, De Bruyckere's blankets became something other, more vulnerable, more attached to grim images of refugees from places of conflict and instability—Darfur, Iraq, New Orleans—images we see daily in newspapers and on television. Things are never what they seem in De Bruyckere's art, and her work conveys the potential for darkness that lurks beneath the basic human desires for safety, home, and health. Still, for De Bruyckere, the darkness is not an end game; it is the recognition that damage is the first step toward rehabilitation. *T. S.*

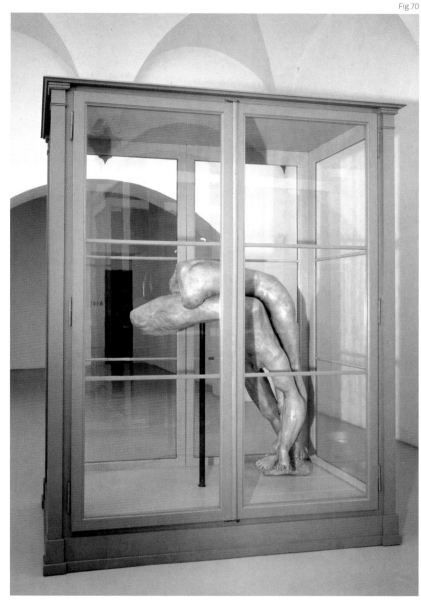

**Fig. 70** Berlinde De Bruyckere. *Pietà*, 2004–5. Wax, epoxy, iron, wood, glass, 97 ¼ × 73 ⅜ × 33 ½ in. (247 × 187 × 85 cm). Heather and Tony Podesta Collection, Washington D.C.

**5.** Isabelle De Baets, "The Male Nude Reexamined: An Interview with Berlinde De Bruyckere," *Janus* 18 (Winter 2005), p. 35.

**6.** Roberto Calasso, *The Marriage of Cadmus and Harmony* (New York: Alfred A. Knopf, 1993), p. 281.

**7.** This version of *Innocence can be hell*, 1995, was presented in the United States in De Bruyckere's exhibition *Washington Velvets (Two From Flanders)* at the Corcoran Gallery of Art, Washington, D. C., January 27–April 8, 1996.

# EDWARD BURTYNSKY

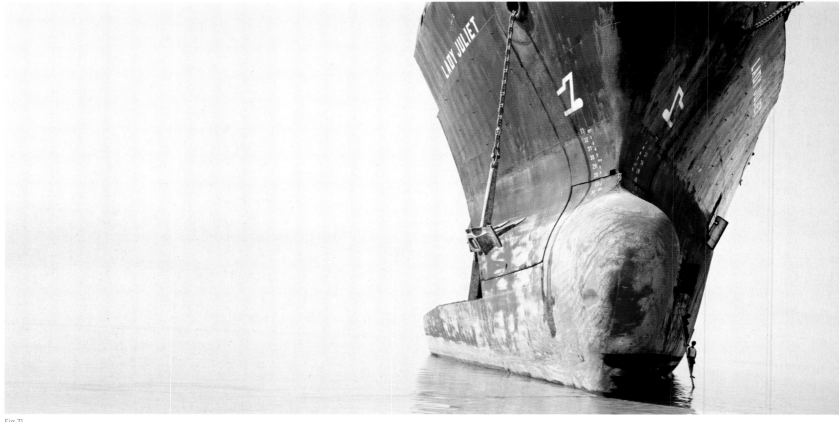

Fig.71

Edward Burtynsky's large-scale photographs depicting the impact that modern civilization has had on the planet evoke a godforsaken place in which the most daunting feats of industrial engineering have come to nothing, or worse: a toxic dump of a world, where human scavengers pick over the remnants of things to which they had no access—and gleaned little benefit from—when they were new, useful, and promising. The power of Burtynsky's images resides in both the relationship they outline between man and nature, a staple of nineteenth-century romanticism, and in the even more charged—and malleable—relationship between the diverse yet linked citizens of the global village: the rich and the poor, the powerful and the powerless, the West and the rest.

Not so long ago, nature was conceived as a potentially infinite realm filled with inhuman forces too vast, grand, and all-encompassing to suffer much at the hand of man. It certainly seemed to stand apart from industry, which was centered in rapidly growing cities and had not yet made much of a mess of the countryside. Throughout the Industrial Revolution—and well into the twentieth century—nature was imagination's springboard, providing poets and painters with a blank slate on which to inscribe their fantasies of sublime beauty, unsullied splendor, and infinite, cyclical grandeur—not to mention adventure, redemption, and self-transformation. By depicting nature as a quasi-divine, seemingly omnipotent power that stood

Fig.72

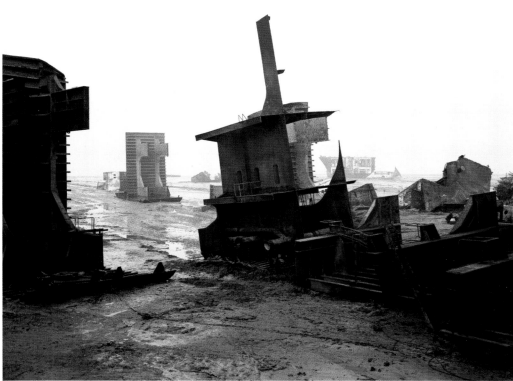

over and above every one of us, this once-dominant outlook simultaneously suggested, or simply assumed, that all humanity formed a unified group—that we were all in it together—joined by our shared subjugation to something bigger than individual efforts and collective endeavors.

Those days are long gone. The opposition between nature and civilization no longer holds much power over adventuresome imaginations and has little sway over popular consciousness. In the information age, humanity is now commonly conceived as being a part of the big messy mix of the global world, with natural and cultural components forming a complicated, multilayered, interactive hybrid. It no longer makes sense to speak of nature as a pure, God-given realm, untouched by human action and free of social artifice. This is the world that Burtynsky's photographs survey with chilling precision, often giving gorgeous form to the ugly underbelly of international commerce.

Burtynsky's *Shipbreaking* images (figs. 71–5), all made in Chittagong, Bangladesh, strip nature down to the basics: earth, water, and air—or, more precisely, mud, puddles, and haze. All that remains of the sweeping vistas, turbulent seas, and snow-capped peaks of the landscapes framed and essayed in eighteenth-century romanticism is unattractive flatness: the ooze and murk of a vast tidal plane under a sky equally flattened by even light, lack of clouds, and bright glare, which makes you squint and comes very close to

**Fig. 71** Edward Burtynsky. *Shipbreaking #50, Chittagong, Bangladesh*, 2001. C-print, 22 ½ × 45 in. (57.2 × 114.3 cm)

**Fig. 72** Edward Burtynsky. *Shipbreaking #10, Chittagong, Bangladesh*, 2000. C-print, 40 × 50 in. (101.6 × 127 cm)

Fig.73

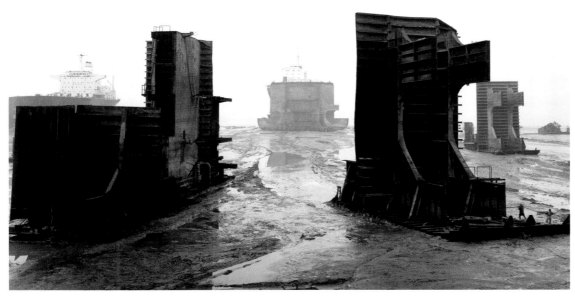

Fig.74

turning the background of many prints into overexposed, bleached-out nothingness. This desolate no-man's-land includes few indigenous details, no signs of local culture, or any hints of the specific way of life it sustains. These absences make the hulking ships that appear in Burtynsky's images seem all the more out of place: massive, out-of-scale monstrosities that look as if they simply showed up one morning, almost as if dropped from the sky or left by aliens. While some of the rusting vessels have the presence of giant objects in the landscape—like illegitimate, industrial-era dolmens, or surrogate Stonehenge-style markers of particular times and places—others become landscapes unto themselves, their tilted, streamlined hulls echoing the walls of narrow canyons or the buildings that line busy city streets.

In either case, Burtynsky's images emphasize the mysterious ways in which international commerce works, zeroing in on its schizophrenic nature: its capacity to move mountains (when it needs to) and, when it's economically expedient, to do nothing but leave a big mess, a littered beach that will take years to clean up, if it is even possible. Partially carved-up carcasses of supertankers are stuck in the mud, like mastodons in prehistoric tar pits, where they die slower, more unnatural deaths as their steel hulls and girded frameworks are cut apart, carted off, and eventually recycled. The landscape that Burtynsky pictures is natural—in that it is simply there, existing whether or not anyone wants it to—and artificial—the result of a global system's irrational machinations, the consequences of which make sense in retrospect but are too absurd to be imagined, much less predicted.

In the past, natural disasters trumped socially engineered ones, and human vulnerability—along with the insignificance of mere individuals—was most strongly felt when coming face-to-face with vast

**Fig. 73**  Edward Burtynsky. *Shipbreaking #2, Chittagong, Bangladesh*, 2000. C-print, 50 × 40 in. (127 × 101.6 cm)

**Fig. 74**  Edward Burtynsky. *Shipbreaking #12, Chittagong, Bangladesh*, 2000. C-print, 39 ½ × 50 in. (100.3 × 127 cm)

panoramic landscapes, where nature paraded its inhuman power. Today, nature is itself vulnerable to human activity. No longer a sanctuary or an escape from the rat race of modern life, it is an extension of human dominion, where the results of industrial-strength shortsightedness play out slowly, perhaps irreparably.

The ships in Burtynsky's pictures are has-beens, rusting hulks of metal that once represented the most advanced forms of modern industriousness but now are reduced to scrap, barely worth the trouble of being cut into manageable chunks and melted down. Yet there's a nobility to many of the vessels and more than an echo of maritime romance. *Lady Juliet*, in *Shipbreaking #50, Chittagong, Bangladesh*, 2001 (fig. 71) is an out-of-commission icebreaker whose precarious tilt is strangely serene, as tragic as the heroine from Shakespeare's famous play and so far from its workaday world of frozen waterways that it seems to be more of a haunted apparition than a real ship. Burtynsky has depicted it just before the tide has drained all the water from the bay to leave a shallow pool, like a reflecting pond in a public plaza. The water level is significantly below the ship's waterline, but that makes the image even more ghostly. The solitary figure, leaning against the stranded ship's side, intensifies the strangeness, conveying scale, revealing the real depth of the water, and, rather than seeming vulnerable, like the dwarfed figures in sublime landscape paintings, making the ship itself seem vulnerable—a fish out of water not long for this world.

*Shipbreaking #2, Chittagong, Bangladesh*, 2000 (fig. 73) has the presence of a back alley in a big city, where danger lurks. Sandwiched between the mud and the metal are silhouettes of men working, like the denizens of some futuristic version of Dante's *Inferno. Shipbreaking #12, Chittagong, Bangladesh*, 2000 (fig. 74) takes a step back from such up-close immediacy, elevating its perspective to give more of a big-picture overview. Laid out before viewers is a flotilla that's going nowhere, a ruined, skeletal city, a set of broken chess pieces on a grid that still evokes efficiency. This postapocalyptic landscape does double duty as a playground for a couple of kids, whose presence is bittersweet, all the more poignant for the forlornness of its abjection. And *Shipbreaking #21, Chittagong, Bangladesh*, 2000 (fig. 75) shows a line of men and women on their way to and from a hulking monster of a ship. As they walk to work like commuters all over the world, their daily movements recall those of ants, suggesting the facelessness of a species rather than the uniqueness of individuals. The optimism of buildings under construction—of I-beams rising heavenward—plays no part in Burtynsky's grim image, which gives form to the downside of labor, to taking whatever one can get and merely scraping by because that's better than not making it. Human adaptability is also evoked by the photograph, which simultaneously measures the vast distance between people on different rungs in different economies, where one man's everyday reality is extraordinary—even horrifying—to another.

Burtynsky marshals the imagination to capture the strangeness of the real world, which is as surreal as anything dreamed up by artists. He doesn't work with the blank slate of nature, but with the messy palimpsest left by human endeavors. Redemption is out of the picture because nature is not what it used to be. And it is not the only thing that has been damaged. The notion that we are all in it together—that human beings are linked, as a species, before the sublime spectacle of nature—is stretched to the breaking point in Burtynsky's incisive pictures, where the once-telling struggle between man and nature has mutated to include a whole slew of struggles within the social world, between classes, nations, and markets, and with consequences as loaded as those at the heart of old-fashioned romanticism. D. P.

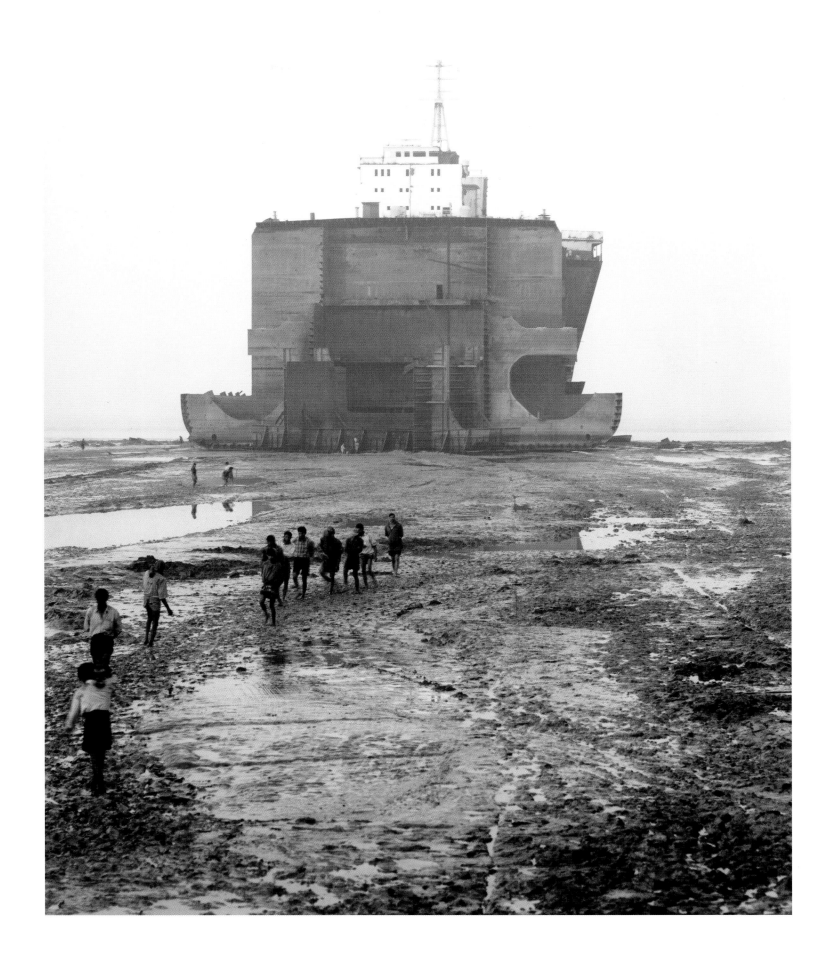

Fig.75

# SOPHIE CALLE

Fig.76

Thirty-six days ago, the man I love left me.

It was January 25, 1985, at two in the morning, in room 261 of the Imperial Hotel. I had gone away to Japan for three months and we were supposed to be meeting up at New Delhi airport. He was coming from Paris, me from Tokyo. For ninety-two days I had been counting the hours keeping me from this reunion. I was happier than I'd ever been before. And just at that moment I was given a message: I had to call my father, M. was in hospital. Since we had just spoken, I imagined an accident on the way to Orly airport. That he was injured, or dead. That my father had been given the job of announcing the news. It never occurred to me that it was just a trick to get out of our rendezvous. It took me ten hours to get through. My father didn't know a thing. I tried to call M. at home. He picked up the phone. He muttered something about an infected finger that needed treatment. I understood that he was leaving me. Over the phone. The cheap way. Saved himself the journey.

It was in 1983. August. There was no hope for him. We all came to Los Angeles. To the Cedar Sinai Hospital. I stayed in his room a whole week, just sitting. Sitting. His eyes had been shut all week. Basically, he wasn't there. On the seventh day, a Sunday – I was holding his hand – all of a sudden he opened his eyes – they were green – and looked at me. I was so overjoyed that I shouted, "He 's awake!" "But he isn't breathing," answered his sister. The last thing he did was look straight at me, then die. I am obsessed by the contrast between my expectations and those few words: "But he isn't breathing." And I thought those open eyes meant there was more time. My image of death is so influenced by the movies that I thought he could revive, like on television. What made him open his eyes? Did he know he was about to die and want to take a last look at this world he was leaving? I can't get that look out of my head. Those staring, open eyes. Busy dying.

"In 1984 the French Ministry of Foreign Affairs awarded me a grant for a three-month scholarship to Japan. I left on October 25, unsuspecting that this date would mark the beginning of a 92-day countdown to the end of a love affair. Nothing extraordinary—but to me, at the time, the unhappiest moment in my life, and one for which I blamed the trip itself."[1]

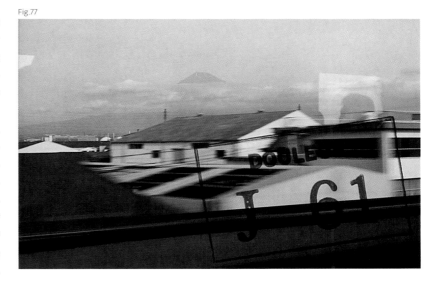

Fig.77

Thus begins *Exquisite Pain* (*Douleur exquise*), 2003 (figs. 76–8), Sophie Calle's narrative suite of photographs and accompanying texts dealing with issues of romantic rejection, memory, self-pity, and ultimate recovery based on her own and others' experience of painful loss. Calle had been alerted to the dangers of taking such a trip. "He warned me that he'd forget me if I left him. But still I went ... Out of pride or bravado? In spite of his threat, he suggested we meet up in India at the end of my journey."[2] But a blissful reunion turned into a shattering disappointment. He failed to show up and a devastated Calle spent the night of January 24, 1985, staring emptily at the red phone and moldy carpet in Room 261 in the New Delhi Imperial Hotel, waiting for a call that never came. "He had made the reservations, chosen this place which would be the setting for my suffering."[3]

The exhibit is divided into two distinct parts. Part one—"Before Unhappiness"—consists of ninety-two color and black-and-white tourist photographs as well as assorted travel memorabilia—maps, hotel receipts, room keys, love letters to and from her boyfriend, Polaroids of passing acquaintances and sleeper-train companions (including Anatoli, a chess-playing Russian, the subject of a later phototext piece)—which Calle shot and collected during the course of a journey that took her from Moscow, through China on the Trans-Siberian railroad, before she settled in Japan for her three-month residency. Each of these images has been rubber-stamped, in red ink, with a numerical countdown to that fateful day in New Delhi. Thus a blurred image of a suburban landscape taken from the speeding train is stamped "61 DAYS TO UNHAPPINESS;" a love letter from her boyfriend, in which he sent "Tenderest kisses to my little nun" is marked "35 DAYS TO UNHAPPINESS;" while, most heartbreaking of all, a black-and-white photo of Calle in a leather jacket, smiling radiantly at the camera, is accompanied by the text: "This is the happiest moment of my life. You have waited. One more day, then." But the following day she received the bad news. As she was about to board the plane, a memo from Japan Airlines bore a scribbled note: "M. can't join you in DELHI DUE ACCIDENT IN PARIS and stay in hospital. PLEASE CONTACT BOB in paris. ---Thank you---."

Part two of *Exquisite Pain*—"After Unhappiness"—covers the immediate aftermath of the breakup and its eventual transformation into a more analytic, conceptual-art framework. As Calle explains in a wall text, "I got back to France on January 28, 1985. From that moment, whenever people asked me about the trip, I chose to skip the Far East bit and tell them about my suffering instead. In return I started asking both friends and chance encounters:—'When did you suffer most?' I decided to continue such exchanges until I had got over my pain by comparing it with other people's or had worn out my own story through sheer repetition. The method proved radically effective. In three months I had cured myself. Yet, while

**Fig. 76** Sophie Calle. Detail of *Exquisite Pain* (*Douleur exquise*), 1984/1999. Ninety-two framed prints and thirty-six quadriptyques composed of two embroidered texts and two prints, dimensions variable.

**Fig. 77** Sophie Calle. Detail of *Exquisite Pain* (*Douleur exquise*), 1984/1999. Ninety-two framed prints and thirty-six quadriptyques composed of two embroidered texts and two prints, dimensions variable.

**1.** Sophie Calle, *Exquisite Pain* (New York: Thames & Hudson, 2005), p. 13.

**2.** Ibid., 206.

**3.** Ibid., 208.

the exorcism had worked, I still feared a possible relapse, and so I decided not to exploit this experiment artistically. By the time I returned to it, fifteen years had passed."[4] This section is organized as a series of machine-embroidered diptychs. One half (outlined in black text on a white ground) is devoted to Calle's friends and acquaintances, who tell their heartbreaking tales of love and death, funerals, suicides, and car accidents in direct, unsentimental prose that is often painful to read. Each reminiscence is accompanied by a single photograph depicting the central mise-en-scène or emotive object in the story—The Opéra Métro station, a row of mailboxes, a coffin, a bathroom washbasin—which represents the punctum that triggers the painful memory for each of the participants.

The other half of the diptych consists of Calle's own story, embroidered in white on black silk, told in retrospect over an extended period of ninety-nine days. Unlike the accounts of her acquaintances that, reawakened by the tastes, smells, and images of everyday life, remain in sharp, painful relief throughout their lives, Calle repeats her story to extreme redundancy, as if the monotony of repetition will make the hurt seem all the more banal, and thus ultimately dismissible. Her accounts are reinforced visually by the idée fixe of the Delhi hotel's red telephone—also featured as an indented motif on the cover of the catalogue—which appears above each text. However, the repetition also produces a marked transformation in Calle's relationship to her earlier trauma. During days five to fifteen, while reiterating the enormous pain of the breakup and the details of that final day in New Delhi, we gradually learn more details about her lover: that he was an older man, a friend of her oncologist father, on whom she had had a crush since she was a little girl. She waited until she was thirty before eventually seducing him, wearing a wedding dress on their first night together. His hospital stay and his alleged "accident" turned out to be an infected finger—appropriately called a *felon* in French. Through days sixteen to ninety-one, the account becomes briefer and more matter-of-fact with increasing distance—a fairly banal and trivial matter in the bigger scheme of things. By day twenty-two she curses herself for taking the trip but at the same time rationalizes that the relationship was doomed anyway: "Sooner or later I would have let it go. But he was quicker. He didn't give me the time to leave him first." Days seventy-one to ninety-six warrant little but a brief summary of the affair in two or three sentences. Finally, by day ninety-eight, her love for her boyfriend is relegated to the past tense for the first time: "98 days ago the man I loved left me. January 25, 1985. Room 261. Imperial Hotel. New Delhi. *Enough*." Day ninety-nine is completely blank. By the end of the series, Calle's series of banners have not only become empty of words—her obsessive grief presumably exhausted—but the white text itself has slowly started to turn into a dark, illegible gray, as if the sharp contrast with her friends' more visceral memories had ultimately subsumed her own. The annihilating loss of selfhood generated by the trauma of the original event has thus been compensated by the gradual appropriation of the Other—in Lacan's sense—as a mirror substitute.

Fuelled by Calle's own glib comments, some critics have argued that *Exquisite Pain* continues the artist's tendency to sublimate passionate emotions and highly personal matters by diverting them into intellectualized, repetitive conceptual frameworks—methodologies typical of her early 1980s voyeuristic projects such as *Suite Vénitienne*, *The Sleepers*, *The Shadow*, and *The Hotel*. As Calle admits, "I look back on it now and I realise that I didn't suffer that much. In a way I feel I was really lucky, when you see how some people carry their sorrow. In the end it was an excellent deal: three months of mourning, one exhibition and one book."[5]

4.  Ibid., 202–3.
5.  Sophie Calle, Interview with Amelia Gentleman,
"The Worse the Break-Up, the Better the Art," *The
Guardian*, December, 13, 2004, Features, p. 10.
<http://arts.guardian.co.uk/print/0,,5084351–
110428,00.html>. Accessed 8/8/07.

Fig.78

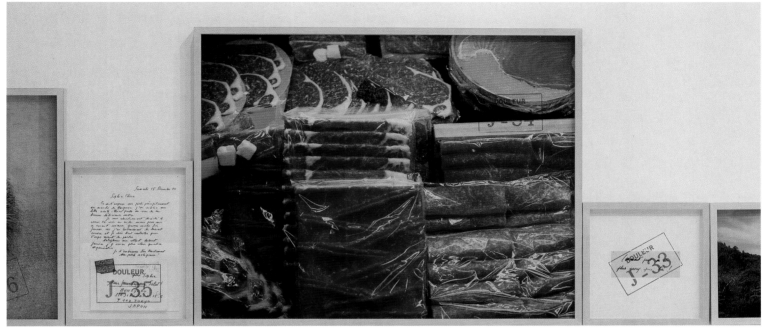

**Fig. 78** Sophie Calle. Detail of *Exquisite Pain* (*Douleur exquise*), 1984/1999. Ninety-two framed prints and thirty-six quadriptyques composed of two embroidered texts and two prints, dimensions variable. Exhibition view at Luxembourg 2007

However, it's important to remember that Calle herself is not directly coincident with any of the characters in her narrative. As in Proust's *Remembrance of Things Past*, time is split into multiple narratives that don't necessarily represent a single subjectivity. The young "Marcel" (analogous to the innocent, love-struck "Sophie" in 1984, a character who takes photos and collects memorabilia in full expectation of being reunited with her lover in Delhi) is the subject of an apprenticeship told by the narrator, Marcel (an older and wiser Sophie in 2003, recreating and remembering events in order to assemble an artistic "text" from the perspective of both painful hindsight and distant reappraisal). Both subjectivities are constructions of the ostensible author of the work—respectively Marcel Proust and Sophie Calle—who survey their seemingly naïve pasts like probing semiologists, mnemic archivists who gather the facts in order to discern whether romantic loss—in effect, lost time—can in fact be regained through the mechanism of rational discourse.

It would appear that the answer is "no," for there is no pain more exquisite than the pain that is so acutely felt that it can only be sublimated in and through the work of art itself. Indeed, Calle admits that she is given to introspection only when unhappy. Grief is always a better subject than joy, she argues: "When I'm happy I don't photograph the moment to share with people on the wall of a museum. It doesn't translate so well. Do people like hearing someone's story about how happy they are? Not usually," she muses. "I was happy with someone for seven years recently and all my friends were very worried about what I was going to produce in this pink period. I did produce a lot but mainly it wasn't about me; I didn't feel like I needed to use my feelings."[6] If Calle were no longer hurting, there would be no need to artistically resurrect her fifteen-year-old affair in the first place. It turns out that romantic pain will always be Calle's own best coping mechanism.  C. G.

6. Op. cit.

# PETAH COYNE

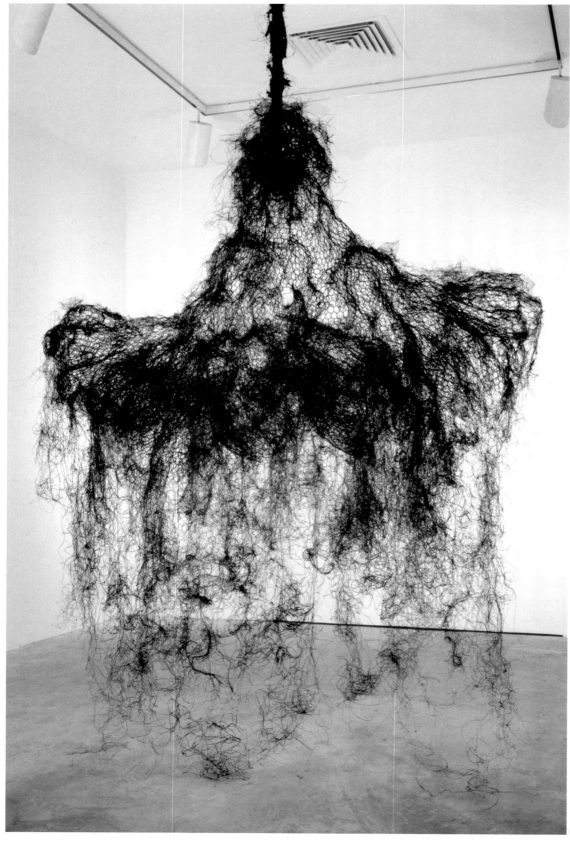

Fig.79

**Fig. 79**  Petah Coyne. *Untitled #695 (Ghost/First Communion)*, 1991. Antique chain hoist, forged links and hooks, rope, wire, steel, shaved car hair, cable, cable nuts, horse- and chicken-wire fencing, acrylic polymer, acrylic paint, black sand, baby powder, and shackles, 87 × 77 × 62 in. (221 × 195.6 × 157.5 cm)

**Fig. 80**  Petah Coyne. *Untitled #638 (Whirlwind)*, 1989. Rope, wire, tree branches, muslin, acrylic paint, soil, shackles, forged links and hooks, shaved car hair, steel, cable nuts, chicken wire, acrylic polymer, black sand, antique chain hoist, swivels, cables, Celluclay, metal hardware, and screen mesh, 111 × 60 × 63 in. (281.9 × 152.4 × 160 cm)

Fig.80

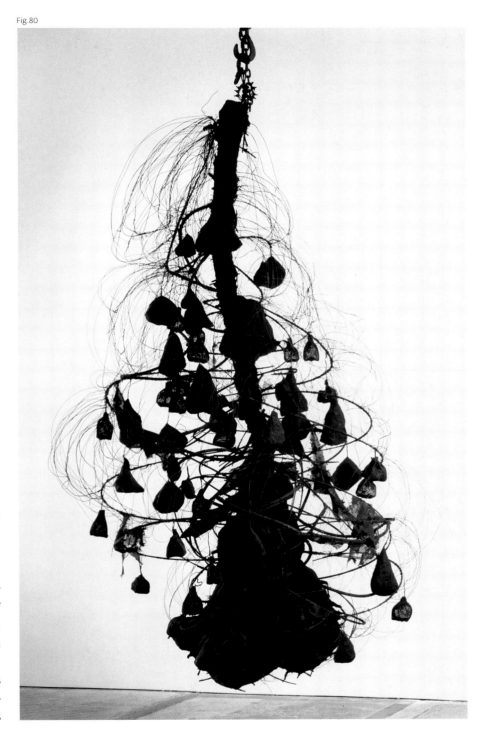

In the depths of joy dwells sorrow, and the greater the happiness the greater the pain. Try to tear joy and sorrow apart, and you lose your hold on life. Try to cast them to one side and the world crumbles.

**Natsume Soseki**, *The Three-Cornered World*, 1906

For twenty-five years, Petah Coyne has challenged aesthetic complacency by creating startlingly beautiful works of art that delve deep into the concepts of life and death, growth and decay, order and chaos. Her towering sculptures, created from all manner of organic and inorganic materials not commonly associated with art, embody the language of opposites: physical and spiritual, masculine and feminine, beauty and violence, ephemera and permanence, life and death, while steadfastly refusing any easy resolutions to these dualities. In all her work, beauty ameliorates entropy. "Beauty comes when you least expect it, and that beauty is the kind I love most, although often I am criticized for it. Seduction and the power to seduce cannot rely just on that beauty. It must be poised to reveal yet another layer, possibly a darker layer, but at the very least, something more."[1]

Coyne has a gift for spotting beauty in the unorthodox. Her first major installation was constructed from dead fish that she collected in the Chinatown markets, selected because she felt that they were too beautiful to eat. She hung them from trees in parks around the city like Christmas ornaments, and used them to line the walls of her loft. (She coated them in resin in an attempt to prolong them, but eventually had to dismantle her installation in consideration of her husband's health.) Later she used mud, sticks, and branches excavated from the swamps of the American South, shredded metal from industrial waste sites (fig. 79), and black sand left over from the casting process (fig. 80)—the sifted detritus of time passing. Her interests and influences are deep and diverse, informed as

**1.** Jan Garden Castro, "Controlled Passion: A Conversation with Petah Coyne," *Sculpture* 21, no. 5, June 2002, p. 28.

Fig.81

much by her peripatetic upbringing in a military family as by her mother, who encouraged creative and independent thinking in her children. Coyne was devoutly Catholic as a child, and this is perhaps why her art often refers to the ritual sensibilities of religious and spiritual exercises. The transubstantiation of organic form is one of the core tenets of her creative process.

In the early 1990s, she began experimenting with wax, inspired by a trip to Italy and the votive candles that illuminated the many churches she had visited there with a friend. When her friend later sent her a box of candles, Coyne used them to make her first wax sculpture—a sort of emblematic hat constructed from wire and candles and held together with glue—a decidedly precarious combination. This work erupted in flames, but Coyne recognized the potential of wax as a sculptural medium and consulted with a chemist in order to formulate a suitable admixture of waxes.

What followed was a period of intense creativity. In 1992 she presented a collaborative dance project with Irene Hultman entitled *Beauty and the Beast* that featured enormous sculptural objects suspended from the ceiling, allowing dancers to inhabit these hanging hybrid creations—equal parts insect-like creatures and candlelit chandeliers—as costumes. For the 1996 exhibition *Petah Coyne: black/white/black*, she pushed this idea further, creating a series of monumental black or white sculptures that hung from the ceiling in a synchronized multitude of references to passages and ritual: prom dresses (fig. 81),wedding cakes (fig. 82) and the reverential aspect of a Shinto shrine (fig. 83). Presented as a gallery-filling installation, these sculptures proposed a compelling treatise on the complex conundrum of hope and disappointment. Also in 1996—following her brother's long illness and death from cancer—she ventured down a darker path, constructing *Fairy Tales*, a series of works made from black tendrils of horsehair that formed masses and tangles of primordial ooze seemingly on the verge of complete disintegration. Alluding to myth, witchcraft, and ritual, they proposed an art "fraught with suggestions of disease, death, and inner—as well as outer—demons."[2] Seven years later she mounted *White Rain*, featuring ever more massive floor and wall works, replete with references to personal memory and history, notably post-9/11 apparitions of people in the streets covered in layers of white dust, which reminded her of the white-faced performers of Japanese Butoh dance—what Coyne calls the dance of the dead.[3]

The story of Daphne and Apollo embodies the contradictory concepts of *eros* and *thanatos*, and remains one of the most enduring stories in Greek mythology. Seeking to escape Apollo's aggressive romantic overtures, Daphne petitions her father, the river god Peneus, to save her. He turns his daughter into a laurel tree.

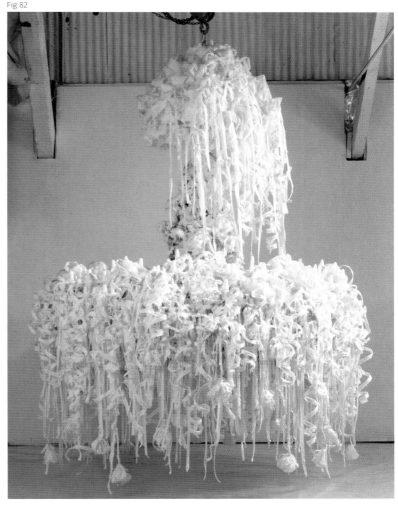

Fig.82

**Fig. 81** Petah Coyne. *Untitled #802*, 1994–5. Mixed media, 72 × 67 × 79 in. (182.9 × 170.2 × 200.7 cm)

**Fig. 82** Petah Coyne. *Untitled #807* (*Miss Haversham*), 1995–6. Mixed media, 116 × 88 × 81 in. (294.6 × 223.5 × 205.8 cm)

**2.** Barbara A. MacAdam, "Petah Coyne," *Artnews*, November 1998, p. 166.
**3.** Butoh was invented in Japan in 1960 by Tatsumi Hijikata (1928–6), and his partner Kazuo Ohno (b. 1906).

Fig.83

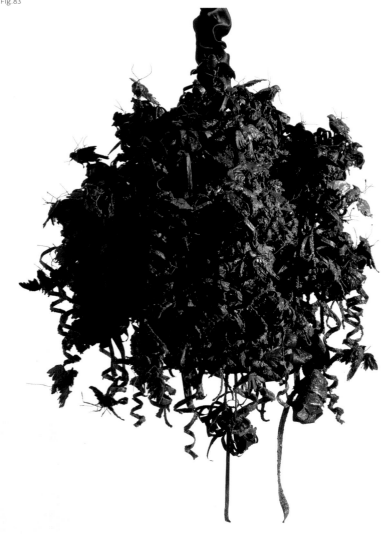

Daphne's feet take root, her arms become lithe branches, and she ceases to exist in human form. Apollo, only slightly deterred, claims the laurel as his symbol, elevating this lovely but mundane tree to lofty status. These intertwined aspects of love and death formed the core of Sigmund Freud's psychological explorations into human behavior, and serve as a rich narrative motif for Coyne's *Untitled #1103 (Daphne)*, 2002–3 (fig. 84). Her startling aggregation of materials is typical of her transformative approach to sculpture. *Daphne* rises from the floor out of a thick mass of blood-red and painted black flowers covered in sticky black wax that culminates in a crown of willowy curlicues and open filigree. The dense thicket of this massive base is barely penetrable; the red of the roses mostly obscured by oily black, while the pinnacle breaks apart into an airier but no less threatening crown. She (Coyne refers to all her sculptures as "my girls") is surrounded by individual flowers scattered in a wide circle around her, like fallen laurel leaves, or rather, like miniature acolytes trailing their queen. Made of wax, human and horse hair, ribbons, curly willow, silk flowers, bows, feathers, metal hardware, hatpins, and tassels, *Daphne* is both beauty and beast, enchanted being and creature from the black lagoon. The work embodies the concept of corporeal growth and decomposition within the elemental progressions of nature's cycles.

Coyne's emphatically physical presences are fragile but steely visual metaphors for highly personal emotions. A profound sense of loss and sadness is embedded throughout her work, mitigated by the possibility that equilibrium can be gained from loss. Like her forebears Eva Hesse and Louise Bourgeois, Coyne has undertaken the task of using sculpture to portray the elemental coordinates of human existence. *T. S.*

**Fig. 83**   Petah Coyne. *Untitled #822*, 1995–96. Mixed media, 56 × 37 × 38 ½ in. (142.2 × 94 × 97.8 cm)

**Fig. 84**   Petah Coyne. *Untitled #1103 (Daphne)*, 2002–2003. Specially formulated wax, wax statuary with human and horse hair, ribbons, pigment, black spray paint, fabricated rubber, wire tree branches, curly willow, chicken-wire fencing, wire, acrylic primer, silk flowers, bows, acetate ribbons, feathers, plywood, metal hardware, pearl-headed hat pins, tassels, 77 × 83 × 86 in. (195.6 × 210.8 × 218.4 cm)

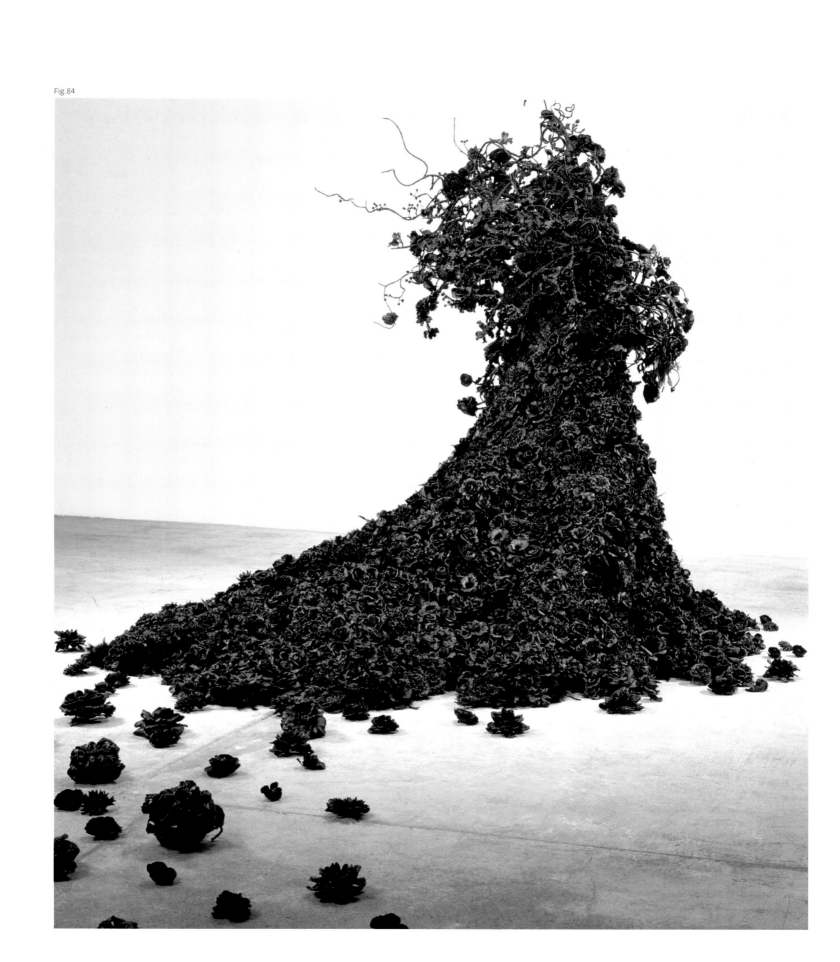

Fig.84

# ANGELO FILOMENO

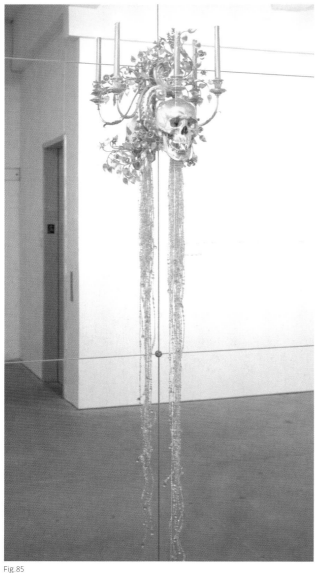

Fig.85

Angelo Filomeno's allegorical paintings and sculptures made of shimmering fabric embroidered with metallic thread, cascading crystals, and precious metals seduce us with their material riches into contemplating the harsher realities of our existence. Couched in an ecstatic decorative language, Filomeno's images are emblems of temporality, a world occupied by highly symbolic fauna and flora, where man is present only in death.

The son of a blacksmith and a dressmaker living in a small one-bedroom house, Filomeno grew up poor but happy in Ostuni, a village in Italy's rural south. As if anticipating their premature deaths, his parents insisted that he apprentice at the age of seven to a tailor. They countered his initial resistance with the argument that they were putting gold in his hands, knowing little how their intent to provide him with a reliable means of earning a living would translate not only into a profession but a passion that has brought him riches and recognition in the new world that he set out to conquer in 1992. His parents passed away in quick succession when he was in his early teens, and after six years of tailoring he used the little money he inherited to enroll in the Academy of Fine Arts in Lecce. Having earned a degree in painting, he moved to Milan in pursuit of a career in fashion design but found himself reduced to work in local tailors' shops instead. When the great breakthrough he had dreamed of failed to materialize, he moved to New York and found work at Carelli Costumes. Recognizing his extraordinary talent with thread and needles, the patroness of Carelli's actively supported his desire to carve out a path in the realm of the visual arts. The workshop is still Filomeno's creative and emotional haven, the place where he keeps his Singer sewing machine and where his creations take shape with the help of his extended American family of former colleagues and friends.

It shouldn't come as a surprise that his art, having been honed in the worlds of fashion and performance, is luxurious, rarefied, highly theatrical, and for the most part devoid of irony but pervaded by an existential sense of humor that takes delight in the abject as much as in the heroic. The impoverished circumstances of his childhood and the early loss of his parents continue to haunt and inspire him, and they play an essential part in the legendary definition of his artistic persona. He often and openly invokes his life story and freely culls from memory to create elaborate allegorical images about love, life, and death that transcend the personal in favor of the universal. Conceived as modern day vanitas and memento mori images, they are reminders of the transience of life, the futility of pleasure, and the certainty of death. While greatly indebted to the history of tapestry and textiles, Filomeno's work is conceptually more in line with the grand trajectory of Western art history, in particular the skeletal life-and-death iconography popular in late-medieval art, the allegorical symbolism of still-life paintings prevalent in Northern Europe in the sixteenth and seventeenth centuries, and the nineteenth-century carnivalesque imagery drenched in fin-de-siècle malaise.

Fig.86

Fig.87

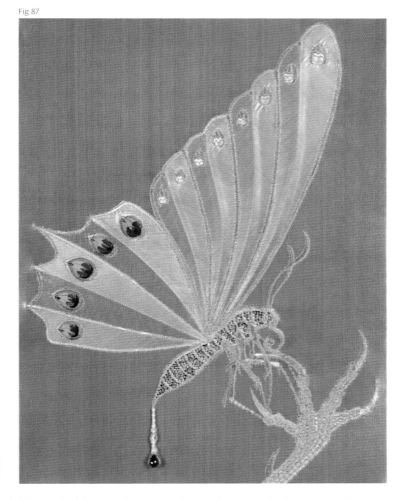

References to natural history and alchemy abound in image and title, and with it, to the humanist tradition of the artist-scientist who is intent on unlocking and controlling the secrets of nature. In *Paracelsus Pissing*, 2006 (fig. 85), Filomeno has cast Paracelsus (1493–1541), the father of alchemy, as a timeless ideal as well as a body haunted by demise. But the golden shower of citrines cascading down from the skull indicates that Paracelsus's wisdom transcended his death. Even if he failed to turn stone into gold, his legacy is as precious as the metal he sought to create.

The *Arcanum* series (2006) openly refers to alchemical theory and practice, where gold is the color of revelation. Executed in silver thread on gold silk shantung and adorned with crystals, citrines, and diamonds in 18-karat gold settings, they dazzle with the extravagant splendor of their fauna and flora. In *Fountain of Vanity* (fig. 86), a crowned peacock spews strings of gold chains into the mouth of a cock helmeted in diamonds, who only too willingly picks at the precious stones fastened to them, drinking eagerly from this glittering fountain as if it had transformative powers and could turn an aspiring peacock into

**Fig. 85**  Angelo Filomeno. *Paracelsus Pissing*, 2006. 22-karat gold leaf on human skull, wrought iron candelabra with crystals, citrines, wax candles, mounted on mirrored wall, dimensions variable

**Fig. 86**  Angelo Filomeno. *Arcanum: Fountain of Vanity*, 2006. Embroidery on silk lamé stretched over linen with crystals, citrines, and diamonds in 18-karat gold setting, 21 × 16 in. (53.3 × 40.6 cm)

**Fig. 87**  Angelo Filomeno. *Arcanum: Duel of Envy*, 2006. Embroidery on silk lamé stretched over linen with crystals, citrines, and diamonds in 18-karat gold setting, 21 × 16 in. (53.3 × 40.6 cm)

Fig. 88 Fig. 89

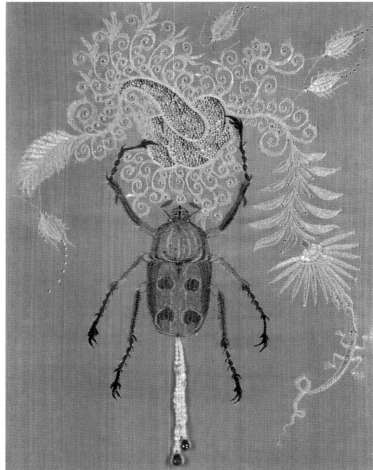 

**Fig. 88** Angelo Filomeno. *Arcanum: Rolling Shit*, 2006. Embroidery on silk lamé stretched over linen with crystals, citrines, and diamonds in 18-karat gold setting, 21 × 16 in. (53.3 × 40.6 cm)

**Fig. 89** Angelo Filomeno. *Arcanum: Beast*, 2006. Embroidery on silk lamé stretched over linen with crystals, 21 × 16 in. (53.3 × 40.6 cm)

the real thing. This image of vanity feeding cockiness demonstrates a rare formal restraint in Filomeno's oeuvre, the animals forming elegant S-shaped lines that gracefully curve over the fabric, giving center stage to the string of jewels that passes from one mouth to another. In *Duel of Envy* (fig. 87), a splendid butterfly fights a clawed hand that reaches out to claim its winged beauty, or its symbolic powers of transformation and renewal. The scarab adorned in turquoise and blue in *Rolling Shit* (fig. 88) literally does what the title suggests. But what shit it is! Given that it is made of diamonds and gold, one can understand why this beetle does not want to share its prey and is guarding it carefully from the cockroaches and lizard who are closing in on it. The scarab, also a symbol of transformation, renewal, and resurrection, was believed in ancient Egypt to be an all-male species that reproduced by placing semen into dung, which it rolled into a ball that was associated with the sun. While Filomeno celebrates the sacred nature of the scarab's sperm and its fertile host in casting both in gold and diamonds, he also alludes to the fact that its appetite for excrement makes the creature just as abject as the common cockroach—as with many things in life, the question is one of perception: what inspires awe and wonder in one is only encountered with disgust in the other.

Cockroaches reappear in *Beast* (fig. 89); they are joined by butterflies in the attack and flight from a gigantic set of jaws. Skeletal and archaic, *Beast* speaks of death in a Darwinian way; its presence is at odds with the intricate and fleshy tree-of-life ornament into which the small-legged and winged animals disappear, as if the answer to looming death lies in the recourse to beauty for beauty's sake. In *Birth of*

*Cock* (fig. 90) the animal in question seems to grow out of a fantastic cocoon or armor; his spine a series of sparkling diamonds. Here, even more than in *Beast*, the decorative embroidery defining the bottom half of the image is reminiscent of heraldic emblems, which fueled Filomeno's obsession with Albrecht Dürer. *Death and Vanity*, *In the Garden*, and *Thanksgiving* similarly juxtapose death and vanity symbols—the skull and the turkey—with floral ornament in opulent compositions that fight mortality with luxury.

Filomeno's kinship with Renaissance men also extends to the technique of their artistry. He revels in his craftsmanship and aligns his skill to that of master printers of that time, such as Dürer, whose engraving *Coat of Arms with a Skull*, 1503 inspired the 2006 piece *Coat of Arms with a Skull (after Albrecht Dürer engraving)* (figs. 43–4). Filomeno has stated on many occasions that "there is a direct relationship between sewing and engraving, as the burin similarly wounds the plate"[1] and so it comes as no surprise that he frequently pays homage to the most famous printmakers throughout history, including harbingers of the modern age like Francisco de Goya. Traces of Goya's satirical edge, evident in the famous *Caprichos*, 1799, are as much in evidence in Filomeno's creations as is Goya's darker, nihilistic worldview that inspired his series *Disasters of War*, 1810 (published in 1863).

While Filomeno is similarly prone to a disillusioned worldview, his uninhibited embrace of material beauty and visual excess mitigates his depictions of the horrific and macabre. His dedication to the decorative has a redemptive effect that obstinately resists tragedy. While it is tempting for us to view sewing and embroidery as healing gestures, Filomeno offers quite a different interpretation: "I think of the sewing process as wounding the fabric and the imagery often reflects the visceral, in literal ways as well as in emotional and personal terms."[2] The wound, of course, is just another metaphor for the human condition, but rarely in recent times has it been rendered with comparable idealistic ardor and visual splendor. c. s.

Fig. 90

**Fig. 90** Angelo Filomeno. *Arcanum: Birth of Cock*, 2006. Embroidery on silk lamé stretched over linen with crystals and diamonds in 18-karat gold setting, 21 × 16 in. (53.3 × 40.6 cm)

**1.** Angelo Filomeno in conversation with David Ebony, *52nd International Art Exhibition: Think with the Senses—Feel with the Mind. Art in the Present Tense*, exh. cat., Rizzoli, New York, 2007, p. 98.
**2.** Ibid.

# JESPER JUST

Fig.91

Fig.92

Fig.93

Fig.94

**Figs. 91–6** Jesper Just. Stills from *It Will All End In Tears*, 2006. Anamorphic 35mm film transferred to HDV, color, sound, 20:00 min.

A deserted harbor. Night. A dark blue Audi is parked next to the dockside. Inside, two men sit silently, waiting. Something's about to go down. A drug deal? A gangland hit? The low-key lighting conjures up 1940s film noir, the B-picture world of Anthony Mann and hard-boiled tough guys like Lawrence Tierney and Dennis O'Keefe. But something's not quite right. It's the soundtrack. Instead of ominous or jarring strings, we hear an ethereal glockenspiel, more akin to Tchaikovsky's *Nutcracker* than to a hard-boiled crime thriller. Suddenly, a young man emerges from the trunk of the car. This is more like it. He's either going to get whacked or there will be a bloody shoot-out and the Tierney character will ... But wait. The kid is starting to sing. Can that possibly be ... ? It is! It's *Cucurrucucú Paloma*. Tomás Méndez? Now that's going too far. That's Perry Como material for heaven's sake. Tierney and O'Keefe won't stand for that. The kid's going to be whacked for sure. But instead of delivering a quick bullet to the back of the head, they gently lift the young man out of the trunk and then watch transfixed as he dances along to his song. OK, this is just delaying the inevitable. They'll put him back in the trunk and fill it full of lead, just like Cagney

Fig.95

did in that great scene in *White Heat*. But wait—now this is getting really weird—Tierney invites the youth to join him in the back seat. He leans over, rests his head on the young man's shoulder and closes his eyes. The driver shoots them a knowing look. Méndez's ballad of lost love has transformed into a homoerotic lullaby as the Audi drives off into the night. Fade out.[1]

With its deliberate "queering" of conventional Hollywood formulas, Jesper Just's work is paradigmatic of a long-established undercurrent in both mainstream cinema and artists' videos that treat gender roles and sexual identity as a cultural construction, all the better to deconstruct its performative and narrative tropes as so many contrived orthodoxies and stereotypes. Numerous critics have aligned the Danish artist stylistically with filmmakers such as Luchino Visconti and Rainer Werner Fassbinder, as well as the lavish production values and operatic mannerisms of Gus Van Sant, David Lynch, and Pedro Almodóvar, in addition to Hollywood staples such as film noir. But Just also owes a strong historical debt to the overwrought gothic melodramas of Robert Aldrich (*Whatever Happened to Baby Jane?*, 1962) and Douglas Sirk (*Written on the Wind*, 1956) and experimental practitioners of the psycho-dramatic trance film such as Maya Deren (*Meshes of the Afternoon*, 1943). However, Just extends this expressive tradition—where metaphor, affect, and emotion override linear plot and causal narrative—in several unique ways.

First, following the tenets of Greek tragedy, almost all of his characters are played by male actors. This allows him to subvert the normalizing narrative codes that are usually associated with traditional gender roles, whereby men are regularly deployed as the active loner hero—stoic, withdrawn, driven by heterosexual desire—and women are framed as the catalyst for that desire (whether as heroine or femme fatale) as well as the nurturing symbol of community and domesticity. "As Virginia Woolf has put it in *A Room of One's Own*," notes Just, "women need a place of their own to redefine the feminine existence without relating to the already existing definitions of relations to the man. So my point is that maybe it's time for men to have a place like that as well, after all to redefine themselves, to adjust to these new 'game settings,' and that's one of the things I'm trying to question by staging male relations in these closed masculine surroundings, in an attempt to make it legal for a man to be emotional towards other men, even in public."[2]

**1.** Jesper Just, *This Love Is Silent* (2003).

**2.** Jesper Just, interview with Kelly Gordon, http://www.hirshhorn.si.edu/Just_interview.pdf (accessed August 6, 2007).

Secondly, Just often structures his narratives as a musical dialogue between a youthful emotional catalyst (invariably played by Johannes Lilleøre, who acts simultaneously as Just's alter ego and as a sexual cipher for shifting patterns of masculinity) and an all-male chorus. This emulates the Greek theater's impulsive dynamic between the hero (in effect, Dionysus) and the community, as well as its use of song and dance to express irrational emotion instead of the realist drama's reliance on dialogue or teleological action. This dynamic often crosses the generational divide, so that the apparatus of homosexual desire ultimately defies a simple oedipal rationale as the manifestation of a family romance. This "queering" of Freudian stereotypes also extends to the specific nature of the film's location, with its social conventions of how to behave, and the contextual role of the accompanying gaze. Devoid of women's actual bodily presence, bastions of masculine privilege such as the gentlemen's club or strip joint now become locations for emotive and scopic male bonding and the forging of collective identity. Finally, Just's films celebrate rather than hide their indebtedness to other films. As in the early Brechtian cinema of Jean-Luc Godard or in Brian de Palma's playful homages to the work of Hitchcock, we are always aware that we are watching a film, more conscious of the source or reference of a shot or sequence than its ostensible role in the narrative itself.

    *It Will All End In Tears*, 2006 (figs. 91–96), for example, is a trilogy that creates a series of loose narrative sequences involving Lilleøre as emotional spirit guide, Alex Wipf as the repressed older man/father figure, and Mieskuoro Huutajat, the Finnish Screaming Men's Choir, playing the role of the Greek chorus. Part one—"A Little Fall of Rain," introduces the protagonists in a blue-tinted, sfumato-bathed, Japanese-style botanical garden. Fulfilling a pre-arranged assignation, Wipf meets Lilleøre on a small footbridge and, as they make bodily contact, the scene shifts miraculously into color (reminiscent of *The Wizard of Oz*, 1939), as if re-cognition of the self through the presence of the Other had swept away Wipf's isolated,

Fig.96

Fig.97

Fig.98

Fig.99

Fig.100

**Figs. 97–102** Jesper Just. Stills from *A Vicious Undertow*, 2007. Super 16mm, black-and-white, sound, 10:00 min.

Fig.101

self-pitying longing. As Lilleøre pounds away on a tin drum (shades of Günter Grass), Wipf starts to croon The Platters' 1950s doo-wop hit, "Only You" and it starts to rain red rose petals. But the ecstasy of emotive bliss dissipates as quickly as it came and Wipf falls to the ground in a puff of smoke. The blue tint returns and the rose petals are replaced by raindrops. Under the watchful gaze of the chorus, Wipf scrambles desperately to retrieve the rose petals, but to no avail: the last petal sinks below the surface of the arboretum pond. Part two, "And Dreaming is Nursed in Darkness," is set in a dimly lit wood-paneled courtroom, where Wipf, head bowed in submission, is berated by the hectoring chorus/jurors, who belt out a rendition of Cole Porter's "I've Got You under My Skin" like aggressive football fans baiting the opposition supporters. Only when Lilleøre intervenes does Wipf lift his head in belated defiance and they leave the courtroom, hand-in-hand. The final section, "It Will All End In Tears," is set on a dockside in Queens, New York. Having retreated from the withering onslaught of the jurors in part two, a fearful Wipf lurks in the shadows, as if afraid to show his true emotional colors. However, the film ends in ambiguity and a vague sense of hope as the chorus inexplicably link hands and jump in unison off the side of the dock, a collective suicide that cues a vibrant, ejaculatory fireworks display over Manhattan, suggesting both real and symbolic sexual release as well as a playful homage to the standard Hollywood clichés for orgasm.

Filmed in noirish black-and-white, in a Japanese-themed former Copenhagen brothel (now a lesbian bar), *A Vicious Undertow*, 2007 (figs. 97–102) references, by turns, the psychodramas of Ingmar Bergman (*Persona*, 1966), Sergio Leone's spaghetti westerns, and Michelangelo Antonioni's phenomenological exercises in alienation (*L'Eclisse*, 1962), to create an ambiguous meditation on sexual desire through the narrative form of the classic ménage à trois. Benedikte Hansen plays a middle-aged woman who sits pensively in what seems to be an empty nightclub. She is whistling (or, more accurately, lip-synching) the

Fig.102

film's soundtrack—an Ennio Morricone-like arrangement of The Moody Blues' "Nights in White Satin," thus evoking Sergio Leone's "Man With No Name" spaghetti westerns. However, instead of Clint Eastwood, Hansen makes eye contact with a young woman (Laura Drasbaek), who may be her lover, her daughter, or a younger version of herself. Gradually, the interchange of seductive looks (the widescreen close-ups cleverly parody those in the final Mexican standoff in *The Good, the Bad and the Ugly*, 1966) begins to incorporate the presence of Lilleøre, who may be Drasbaek's current lover or a mind-screen image of Hansen's husband from years before. The mutual seduction reaches an emotive climax in the form of a waltz (a shoe-gazing arrangement of The Clash's "Rebel Waltz"), whereby Hansen constantly switches partners with Drasbaek and Lilleøre to the point that her "lovers" appear to have merged identities. Leaving them to their waltz, she turns, and suddenly finds herself outside, slowly but deliberately climbing a spiral staircase that winds around the outside of a looming observation tower. The film ends with a tight shot on Hansen as she nears the top of the steps. Is she about to commit suicide? Or has she reached some form of emotional resignation and self-acceptance? We will never know, because the camera pans left, removing her from the shot in order to take in the lights of the city below. Just thus offers no explanations, no back story, no pop psychology. Instead, we are forced to relate each scenario to our own social and cultural baggage, a baggage that includes the conventions of cinema itself. c. g.

# MARY MCCLEARY

Fig.103

Mary McCleary's patiently cobbled-together images put abundance and abjection into odd conversation with one another, neutralizing the extremes that these ordinarily opposed qualities represent—surplus and scarcity—to evoke a world whose equilibrium is so far out-of-whack that it is all the stranger for being normal. Weird things happen in some of the Texas-based artist's narrative images, but never so unsettling as when nothing much happens. Most of McCleary's peculiar pictures depict regular folks in recognizable settings, where events unfold with the mundane ordinariness and nothing-special sameness of everyday life. Middle-of-the-road existence, as it takes shape across the wide swathe of America—and other parts of the world that are neither tourist attractions nor so far off the beaten path as to be unique or even remotely exotic—is the subject of McCleary's obsessively crafted art.

A great leap of imagination is not required to see the similarities between her big, realistic land-scapes, portraits, street-scenes, interiors, and still lifes and the photo-based images that appear in newspapers and on internet news sites. Like those reality-driven pieces of documentary reportage—which seek out the unusual, the unique, and the newsworthy—McCleary's hand-painted collages nego-tiate a precarious balance between believability and preposterousness. If they were to stray too far in either direction, boredom or dismissal would be the inevitable reactions: viewers would quickly turn their attention to other scenes in the image-glut of modern life. A master of balance, McCleary strikes just the right note: the out-of-synch quotidian.

Fig.104

Her peculiar talent is to render the events and experiences that make up everyday life at once familiar and alien. This uncanny combination of comfort and disquiet is not quite dread and drama, but the lurking unease of suspicious senses, of intuiting that something, somewhere nearby, is out of joint, but not knowing what it is or how to convince others of its presence. Such anxiety-laced outlooks have much in common with paranoia, but McCleary's even-keeled images steer clear of such fanatical absolutism and reductive single-mindedness. A queasy stillness that has nothing to do with serenity or tranquility suffuses her pictures, which seem to be compressed or seen through the haze of anti-psychotic drugs, when nothing is urgent because it seems far away. The realistic, highly individuated figures in her works have the presence of people, but they also seem to be zombies, robots, or humans who merely haunt the world, going through the motions without conviction but because that is what they have become accustomed to doing. The atmosphere made palpable by McCleary's uncanny images suits the unstable times in which we are living, when the gap between the haves and the have-nots is increasing dramatically, yet the global world is increasingly linked. This allows the smallest, seemingly incidental story from some out-of-the-way place in another part of the world suddenly to become the focus of the international news, where it has more impact than ever before. In popular consciousness, the anecdote that captures this interconnectedness between tiny, trivial cause and momentous effect is that of a butterfly flapping its wings in one hemisphere and causing a hurricane in another. In McCleary's hands, the maelstrom of stuff that has swirled into the perfect storm forms crowded, often claustrophobic compositions. These hallucinatory scenarios gives compelling shape to an age in which surrealist shock value has long been passé, its attempt to jolt viewers into awareness of the inadequacy of rationality no match for the mind-boggling irrationality of contemporary reality. Using the currency and lingua franca of the moment, McCleary, like Dickens in his age, captures the sense that the present is both the best of times and the worst.

Her easy-to-read images and the quirky materials from which they are made never settle into harmonious wholes or resolve themselves into airtight illusions. We see the images first, from across the gallery, where they seem to belong to the school of clunky realism, their awkward forms, unwieldy spatial shifts, and deliberately unblended palettes standard signs of an adventuresome artist's rough-and-ready approximation of the real world. Their funky, perfunctory quality also embodies a sense of urgency, a sort of good-enough-to-get-the-job-done illusionism that is less concerned with the niceties of formal refinement than with the rudiments of communication—with getting the basic message across to viewers, loudly and clearly, with as little static as possible. Just what that message is, however, proves to be a confounding and fascinating matter, especially as we move in to see things more clearly.

**Fig. 103**  Mary McCleary. *Nazi Pets*, 2004. Mixed-media collage on paper, 36 × 71 ½ in. (91.4 × 181.6 cm). Collection of Carol Windham, Clyde, Texas

**Fig. 104**  Mary McCleary. Detail of fig. 103

Fig.105

**Fig. 105** Mary McCleary. *Henry Ford's Peace Ship*, 2004. Mixed-media collage on paper, 30 ½ × 44 ¾ in. (77.5 × 113.7 cm)

**Fig. 106** Mary McCleary. *When Sparrows Fell*, 2001. Mixed-media collage on paper, 45 × 67 ¾ in. (114 ⅔ × 172 cm). Private Collection

From mid-room, McCleary's wall-size works begin to resemble paint-by-number pictures. Each depicted object—the sky or the sea or a girl's burgundy blouse—fractures into many single-color shards, like the tiny monochrome sections that hobbyists dutifully paint with the knowledge that, from a distance, the viewer's eye will mix together the innumerable, abstract fragments, creating the illusion of blended wholes, shaded sections, shining highlights, and volumetric objects. As you move closer to McCleary's images, even stranger changes take place: real three-dimensional objects appear, as if out of thin air, in the idiosyncratic patchwork—carefully sharpened pencils, old postcards, plastic spiders, google eyes. Up close, every square inch of a work's surface is jam-packed with small objects and bits of material that McCleary has purchased at craft stores or thrift shops or found around the house or been given by friends. The inventory of unexpected stuff expands to include costume jewelry, broken mirrors, Halloween decorations, brass compasses, bottle labels, trinkets, glitter, pins, upholstery piping, yarn, buttons, wood veneer, scraps of wood, colored string, animal fur, foil, glitter, and toothpicks—as well as quantities of ordinary construction paper that she has cut, folded, bent, and twisted into a cornucopia of shapes that resemble twisted ropes, broken snowflakes, swept-up confetti, and poorly turned-out origami.

McCleary treats all of these inexpensive materials with the same devotion as passionate hobbyists do when building models of such monuments as the Eiffel Tower or the White House out of toothpicks or popsicle sticks, transforming individually insignificant objects into cherished surrogates for internationally recognized icons. It's a sort of desert-island inventiveness, of making things serve

other purposes, sometimes with simple stubbornness and at others with MacGyveresque ingenuity. But McCleary takes such obsessive dedication a step further: her materially resplendent and visually dense works embody an ethos of willful adaptation and can-do improvisation—of making do with whatever materials are at hand. The memory of another time and place lies behind her works—not exactly a Golden Age, but a past that is increasingly distant and at risk of disappearing altogether. McCleary's works tell major twentieth-century stories, opening windows onto the tragedies and travesties of Mao Zedong's China, Hitler's Germany, and Henry Ford's America. Others go back to the Bible and to the myths of classical antiquity.

At the root of McCleary's art is desperation, defiance, and optimism. Rather than despairing over the fallen world we inhabit, her pictures hold out hope for the future, not in the form of sudden redemption, but by means of seemingly insignificant gestures: gluing a trinket here, folding a sheet of colored paper there, working slowly and surely to redeem a few everyday moments. If stuck to, such small acts expand into days, months, and years—becoming, with sufficient persistence, a life spent in pursuit of the moral principles one cherishes. It isn't easy, lots can go wrong, and much is beyond our control—as is shown in almost all of the stories that McCleary's works tell. But there is no other option for a hardscrabble romantic who is dissatisfied with the status quo but in love with human possibility. *D. P.*

Fig.106

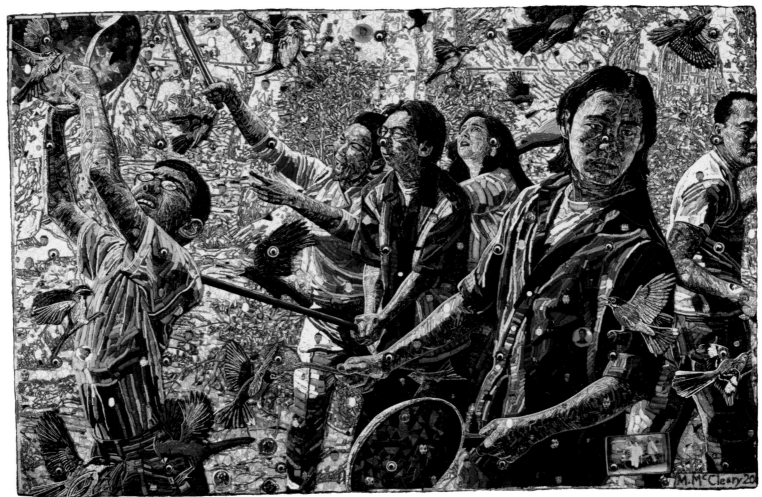

# FLORIAN MAIER-AICHEN

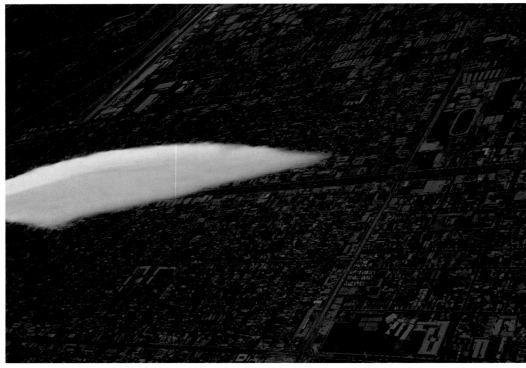

Fig. 107

**Fig. 107** Florian Maier-Aichen. *Untitled*, 2001. C-print, 48 × 67 in. (121.9 × 170.2 cm)

Florian Maier-Aichen makes nature look unnatural. His gigantic photographs of relatively small sections of the earth's surface take nineteenth-century panoramic imagery to the next level: sometimes literally, surveying the global landscape from the perspective of telecommunication satellites, and at other times metaphorically, scrutinizing segments of the visible world with something beyond the cool detachment of a scientist so committed to the truth that he cannot be bothered with old-fashioned sentimentality or unduly concerned with such incidental details as individual human beings—much less their particular wants, needs, and desires. These subjective aspects of life were central to art long before romanticism made them its focus and raison d'être, and part of the power of Maier-Aichen's photographs is that they depict a world in which such emotionally loaded experiences simply don't matter. Species, not individuals, are the subject of Maier-Aichen's disquieting images. Survival, not civilization or culture, is their subtext and storyline. Evolution isn't pretty, they insist with chilling precision, but it is something to see, and it is happening right before your eyes.

The artist's dread-inducing pictures function at the level of general tendencies, like gradual shifts in temperature, rates of toxicity, and otherwise difficult-to-detect calibrations. Requiring and sustaining long, slow looks, they take their place in the world of scientific research, where knowledge is based on the capacity to analyze and synthesize more data than has ever been available to human beings, throughout our relatively short history. They are effective and potent because they make an inhuman world or heartless perspective seem not only sensible, but attractive, poetic, and gorgeous—far more stunning

and stimulating than the world of everyday life with which we are familiar and think we know intimately, and where the majority of our experiences begin in and circle back to our own subjectivities, making each of us the center of our own little self-involved universe.

Maier-Aichen's bold photographs begin with that world we think we know: bird's-eye views of contemporary cities, their infrastructure (bridges, freeways, and factories), environs (the suburban sprawl that dissipates at their edges into the no-man's-land of the wilderness), and beyond (national parks partially domesticated for recreation, leisure, and tourism). Outside these social spaces of civilized niceties, Maier-Aichen includes sweeping views of seemingly untamed mountain ranges, oceans, and skies. Such views of nature evoke a vastness that was once deemed inconceivable—and seemed to be untouched or unsullied by human endeavors. But today it is at risk, vulnerable, endangered. Maier-Aichen's big pictures link nature and culture, weaving the two elements into an inseparable, inescapable network with humans in the middle of things but neither in charge nor in control.

*Untitled*, 2001 (fig. 107) could be a view out of the window of any commercial airliner as it circles a modern city in preparation for landing. As the jet makes a steeply banked turn, passengers are able to peer almost straight down at the urban expanse below, its grid of streets locking into place and providing a rational structure for block upon block of a wide range of buildings—a mix-and-match patchwork of light industry, residential, commercial, and public. From a few thousand feet in the air, the scene has the presence of a thriving organism or living system, every element seemingly laid out with care by a meticulous diorama builder. The cacophony of living at street level disappears into the silent serenity of detached observation and the casual enjoyment of the aestheticized composition. Its edge-to-edge expansiveness suggests a world unto itself, a totality with porous borders that make the dynamic whole resilient, able to grow as it incorporates and transforms foreign elements.

But something is not quite right in Maier-Aichen's depiction of the mundane scene. The dense cloud—the only thing in the picture not made by man or grounded by the grid—seems to be the most unnatural object depicted. Its shape too neatly echoes that of the plane's invisible wing, as if it is an impossible shadow, a floating doppelganger or some kind of quasi-angelic surrogate. No clouds appear anywhere else in the sky, intimating that the wing-shaped form is both out of place and a purposeful intrusion into the scene's ordinariness—a mysterious entity that cannot be explained by the logic at work in the rest of the picture. Once your suspicion about the cloud is aroused, doubts begin to gnaw at the innocence of the photograph. The bright white cloud begins to look more and more like a smear or a swipe made by an eraser, perhaps a technical glitch in the printing process that produced the image or an attempt, after the fact, to obscure or eliminate whatever lies beneath it.

Close scrutiny reveals that Maier-Aichen is a masterful image manipulator, an artist whose work begins with images of the world he finds or takes himself, often from helicopters or mountaintops, and then manipulates digitally with off-the-shelf software that allows him to merge pictures and mix in the photographic equivalent of Hollywood special effects. The cloud appears to be a digital addition, a computer-assisted, handcrafted component that transforms an unremarkable scene into something somewhat out of the ordinary. But it's impossible to know for certain. In the end, the opaque white streak with blurry edges could just be an oddly shaped cloud.

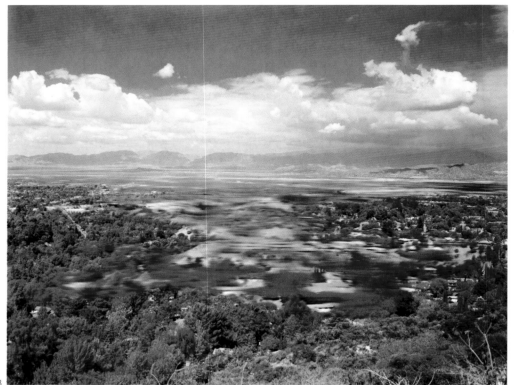

Fig.108

Unlike the movie studios, which use computer-generated special effects to make impossible events and unbelievable occurrences look hyperrealistic, Maier-Aichen uses digital technology to do fairly simple things, adding a cloud, a reflection, or a building to a picture; deepening a tone; flattening a space; shifting the scale; or changing one color to another. He never attempts visual tricks that are any more dramatic or theatrical than reality. All could be true, or explained by a flaw in the printing process. His goal is not to present a fantastic, sci-fi escape from the real world but to delve more deeply into the weirdness of what's already out there. His works resonate because they treat traditional, chemically developed photographs and up-to-the-minute digital imagery as two sides of the same coin: complementary tools for communicating the strangely alienating tenor of our times. Radical in their relativism, Maier-Aichen's images embody profound anxiety about the adequacy of any single technique, method, or perspective. They also give compelling physical form to photography's evolution from light-sensitive film to digitally generated images, capturing the complexity of the transition and the changes in consciousness that go along with it.

As an artist, Maier-Aichen is a realist for whom the truth of the world is too complex to be contained by a single system, to be conveyed by a single medium, to be accounted for by a single theory, or to be described by a single means. Inconsistency and contradiction are built into his photographs, all of which are shot through with both skepticism and beauty. *Untitled*, 2003 (fig. 108) shows the backside of Los Angeles—not the ugly underbelly of the movie industry but the other side of the mountain range on which the famous sign stands. He has made the suburban sprawl of the San Fernando Valley look ominous by using a filter that changes the various shades of green to various shades of red. This transforms the often overlooked and surprisingly verdant valley into a hellish yet lush landscape, whose dirty magenta tints evoke a mysterious and uncontrolled contagion. The artist has also blurred the center of the print, transforming an otherwise crisp image of an unremarkable locale into a picture that seems to be melting down as you view it, both radioactive and Richteresque in its evocation of a familiar world gone horribly

Fig.109

**Fig. 109** Florian Maier-Aichen. *Above June Lake*, 2005. C-print, 86 × 72.5 in. (218.4 × 184.2 cm)

wrong, its promise poisoned. *Above June Lake*, 2005 (fig. 109) makes us queasy; it is even deadlier in its unsentimental depiction of a world in which individuals are incidental. Using only a green-to-red filter, he has turned a satellite-style photograph of a mountaintop ski resort into an image that resembles a close-up of a tidal pool at the same time as it appears to be a telescopic view of an alien landscape. The point-blank picture simultaneously takes viewers back to the primordial ooze out of which primitive life emerged and far into the future, beyond anywhere anyone has gone. Between the two times and places, there is not much room left for individuals. In Maier-Aichen's frighteningly efficient art, we human beings become the missing link between a past we can't go back to and a future we can't imagine. *D. P.*

# WANGECHI MUTU

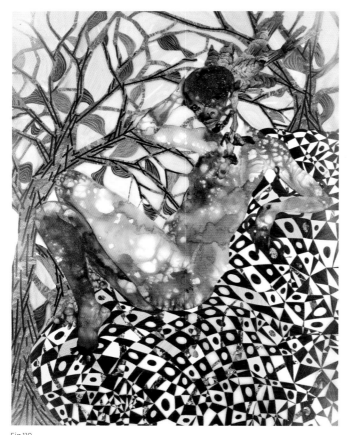

Fig.110

Wangechi Mutu's female figures are transformative beings, mutated warrior women, who set out for battle armed with nothing but their naked bodies to readdress notions of history, race, and beauty. These bodies are far from ordinary. Combining and juxtaposing images culled from fashion, lifestyle, pornography, and ethnographic magazines with luscious colored ink and the occasional spattering of fake diamonds, fur, pearls, and glitter on mylar, Mutu creates her own ferocious breed of amazons, who carry their sexuality like a weapon. Luscious mouths and sultry eyes, manicured hands and waxed legs, full breasts and the occasional vagina taunt with their photographic explicitness. The snakes, birds, butterflies, and other exotic fauna and flora that make up their surroundings enhance the figures' powerful sexual allure, as do the extravagant patterns with which Mutu decorates their skins. Evocative of animal pelts, burn marks, blood cells, or lesions, these patterns, along with legs and hands metamorphosed into mechanical elements or animal limbs, transform the body into the locus of meaning, carrying the marks of disease, torture, scientific experiment, or promise. Partly human, partly animal, partly machine, Mutu's women are as familiar as they are alien. Archaic and futuristic at the same time, they are messengers between past and future, primal prophets of the present.

The present they speak of is one of decadence. The images are meant to "insinuate opulence, but also a sort of dark place where abundance creates something horrific."[1] Mutu feels this moment very poignantly, so it comes as no surprise that her black amazons are as beautiful as they are terrifying. The figure in *Preying Mantra*, 2006 (fig. 110), for example, lures us with her come-hither look and pose, reclining seductively against an ornate ground from which sprout purple trees with pink leaves. Despite the allusion to a rolling landscape, the natural scenario is dazzlingly artificial and the woman takes possession of it as she would a fur coat or leather bag. Her skin is washed in red and purple inks, and we can sense the blood pulsing through her hungry body. She wears a headdress made of calcified wood or a rock formation and an ear adornment made of talon feet clamping a phallic flower. Worn like a trophy, its dangling presence only tightens the web of attraction and repulsion in which this creature entangles us. She confronts us as both victim and victimizer of our desires. Her ink-soaked body powerfully evokes bloodletting as the price for a life of opulence. If abundance is the mantra of contemporary times, the black body, and by extension the African continent, is here put forward as its prey, even if often a complicit one.

*Le Noble Savage*, 2006 (fig. 111) offers a less aggressive and more meditative image. Here the figure kneels in high grass but her body is thrust upward; with her right hand balanced on her hip she reaches into the sky, holding up a palm tree filled with parrots and swarmed by a flock of birds. Writhing green mambas envelop her head and shoulders, and her body is covered with the heads of a lion, leopard, and other roaring animals that, along with flowers and intricate geometric patterns, make up her dress and armor.

1. Mutu in conversation with Dodie Kazanjian, "Fierce Creatures," *Vogue* 196, no. 6 (June 2006), p. 214.

She is firmly rooted on the ground, but her attention and energy is focused on the tree, which she holds like a beacon above her head. Mutu has described the tree as "a torch, a lighthouse, a place of memory that's not bringing you in but taking you backward, back home."[2] *Le Noble Savage* is a very personal piece that locates hope and draws power from the conscious embrace of her cultural roots while sustaining the potential of actively shaping her future in whatever circumstance she might find herself.

For Mutu, this reassertion of her heritage is a necessary ritual. Born and raised in Nairobi, Kenya, she chose to move to the United States to attend art school and has lived in New York since the mid-1990s. Like so many other immigrants vying for a green card, she has been unable to return to her home for over ten years, immigration laws making her literally a prisoner in her chosen country of artistic freedom. Her decision to live outside her homeland was made out of necessity, but her faith in Africa as a country of great potential is absolute; for her, expressing it is now simply more productive from afar.[3]

Nonetheless, Mutu's roots figure in many of her drawings from the last few years. In *Be Quiet, I Saved You Already*, 2005 (fig. 112) the entire composition is developed around a sprawling system of branches, the host of an intricate net woven by a five-legged spidery creature that hovers ominously at the bottom edge. It is all tentacles, whose extremities end in collaged photographs of legs and hands, the torso identified as female by breasts. All body parts are white, except for the head, which is a distinctly darker shade. It is not clearly identifiable as black, but with the white hand clasped over its mouth it does invoke the notion of racial oppression, especially given the title. This, like her morphed insects from the *Creatures* series, represents the destructive hybrid beings foretold by African soothsayers before the arrival of the European colonial powers. Attractive yet repellent, they are forceful reminders of the pervasive subjugation of life on the African continent to the whims and desires of the foreign powers, especially the brutal consequences of the affluent West's insatiable hunger for diamonds, gold, and oil—the raw materials buried in the African soil.

*Your Story My Curse*, 2006 (fig. 113) openly states that one person's happiness often depends on another's misery or, as Mutu puts it, that "there is this tiny percentage of people who live like emperors because elsewhere blood is being shed."[4] In this diptych, one figure reclines like an odalisque on the top of a crouching figure's head and back, finding comfort in the other's discomfort. With one leg amputated and the other foot replaced by a machine part, the supporting figure's stance is far from stable, yet she patiently serves as a throne for the golden girl. Long tendrils sprout from the bottom of the crouching woman's backside, offering an armrest for the subjugating figure as well as venomous fodder for a third. Sucking or spewing, whatever it is the latter does, she does it in mid-jump, with her crow-footed legs pulled under her and her bejeweled left hand extended backward, holding a phallic trophy as if she were about to hurl it at somebody. This mad fury with her blood-red skeletal head is the most frightening one of all, the last in the chain of victimizers and

**2.** Op. cit.
**3.** Op. cit.

**4.** Mutu in conversation with Lauri Firstenberg, in Laurie Ann Farrell, ed., *Looking Both Ways: Art of the Contemporary African Diaspora*, exh. cat., Museum for African Art, New York; Snoeck Publishers, Ghent, 2003, p. 142.

**Fig. 110** Wangechi Mutu. *Preying Mantra*, 2006. Mixed-media on Mylar, 73 ¼ × 54 ¼ in. (186.1 × 137.8 cm)

**Fig. 111** Wangechi Mutu. *Le Noble Savage*, 2006. Mixed-media on Mylar, 91 ¾ × 54 in. (233 × 137.2 cm)

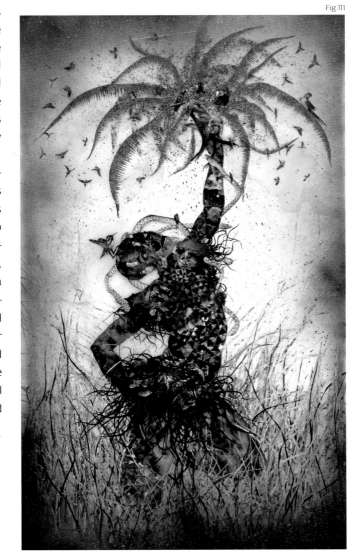

Fig. 111

Fig. 112

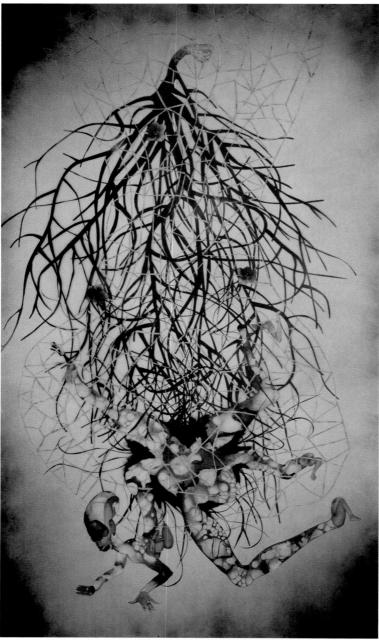

**Fig. 112** Wangechi Mutu. *Be Quiet, I Saved You Already*, 2005. Ink, acrylic, glitter, fur, collage, and contact paper on Mylar, 90 ⅛ × 51 ¾ in. (228.9 × 131.4 cm)

**Fig. 113** Wangechi Mutu. *Your Story My Curse*, 2006. Mixed-media on mylar, 101 ½ × 108 in. (257.8 × 274.3 cm)

a vulture-like avenger of injustice. These altered figures with their prosthetics imply references to the systematic amputation of the limbs of women and children during civil wars in Sierra Leone, Angola, and Rwanda, a pervasive theme in Mutu's oeuvre, which also inspired the 2004 video *Cutting*, where the artist strikes a fallen tree with a machete to the point of exhaustion. The physical exertion draws attention to the original purpose of the machete as a tool of work not killing, a vital instrument in a constructive life that has now become a symbol of destruction and pain.

Mutu's work from the early 2000s, in particular the *Pin-Up* series, which catapulted her onto the international art scene, alluded to these horrors but was mainly engaged with the eroticized female body as the prime carrier of cultural marks. As Mutu has elaborated, "anything that is desired or despised is always placed on the female body."[5] Series such as the *Classic Profiles*, *Creatures*, and *Figures* generally dealt with this social instrumentalization of the female body through fashion and pornography, and in particular the fetishization and primitive stereotyping of black sexuality. The *Tumor* and *Adult Female Sexual Organs* series introduced the larger notion of a world in malaise, or, as Mutu has stated on many occasions, in a state of self-destruction. Although the idea had been implied in the monstrous disfigurement of many of her earlier drawn and collaged figures, Mutu's engagement with the wounds inflicted upon the world "out of greed and our desire to control this earth and each other"[6] has taken on a broader dimension in works such as *Cutting* and *Hanging*, 2005, which confront the damaging dynamic between consumption in the West and suffering in Africa. The large-scale collages included in this exhibition address all of these concerns and more. Their growing formal complexity and thematic density heighten their horrific intimations of violence without sacrificing any of their visual splendor. If history is truly proscribed or worked out on the bodies of women, as Mutu claims, she makes sure that these bodies are powers to contend with. Even with missing limbs, prosthetics, and disfigured skins, these bodies wear their physical trauma with pride, asserting an otherworldly female strength and beauty as the locus of hope and change in a world gone awry. *c. s.*

**5.** Merrily Kerr, "Extreme Makeovers," *Art on Paper* 8, no. 6 (July–August 2004), pp. 28–29.

**6.** Mutu in Kazanjian, "Fierce Creatures," p. 214.

Fig.113

# ANNEÈ OLOFSSON

**Figs. 114–15** Anneè Olofsson. Stills from
*Evil Eye*, 2005. DVD, color, 10:00 min.

Fig.114

Fig.115

Anneè Olofsson's videos and photographic series are haunting mise-en-scènes of existential dilemmas that have a universal resonance. Underlying them is the recognition of solitude as a fundamental human condition, and of death as an inevitable truth, which casts life as a lonely journey to one's ultimate demise. In Olofsson's work, this knowledge instills a fear that is the key to unlocking both one's self and the dynamic of relationships, especially familial ones forged in an attempt to overcome this sense of lonely fragility, and expose its psychological, emotional, and physical complexity. Stark in their chiaroscuro rendering and confrontational in nature, her works are like demons let loose, seducing us with their formal rigor, sensual beauty, and dark humor only to attack and undermine our sense of physical and psychological security.

In *Evil Eye*, 2005 (figs. 114–15), this inevitable trajectory toward death is cast as a violent one. The video shows the artist from the collarbone up; we look at Olofsson's shoulders, neck, and head resting on a light-blue fabric, the soft flow of her hair tenderly framing her face. Her eyes are closed, yet she seems to stare at us through facsimile eyes painted on her lids, which, combined with her stillness, gives us the eerie impression that we are looking at a death mask. The artist's image is accompanied by a voiceover in which she recites violent scenarios where an "I" is killed over and over again by different people for different reasons and in different but always horrific ways. Set against the gentle tones of a Bach piano concerto, the neutrality of Olofsson's voice describing murder after murder is all the more unsettling, especially as we can't help but identify the "I" with the artist and imagine her to be the victim of the crimes she describes .

The murders she enumerates all took place in real life; they were gathered and distilled from reports in the *New York Times*, in which they occupy such a common and widespread place these days that they go almost unnoticed. In *Evil Eye* these anonymous deaths are projected onto the artist and come to haunt us as if we were somehow complicit with the murderers, if only through indifference to the victims because they are so numerous. The title of the work encourages this reading: it alludes to the age-old folkloric belief that the misfortune of one can be brought about by the envy of another. What is even more critical here is the superstition that the evil eye can spell its curse unwittingly; we cannot help but wonder if we have unknowingly caused harm by coveting someone else's beauty, health, intellect, or possessions, and whether this is why Olofsson has chosen to ward away harm by painting her eyes to resemble an apotropaic talisman. But just as we have become accustomed to staring at those painted eyes, Olofsson startles us by opening them, her gaze directed steadfastly into the camera and at us. As the off-screen account of her many deaths continues, she seemingly returns from the dead to confront us with our potential guilt as we watch and listen to her live and die at the same time.

In directly addressing the fear and possibility of physical harm, *Evil Eye* relates back to the photographic series *Demons*, 1999 (fig. 34), which was one of Olofsson's earliest pieces to give shape to her own sense of hauntedness. Responding to intense feelings of loneliness and estrangement during a residency in Gdansk, Poland, Olofsson hired a bodyguard for protection. The resulting nine images capture her being followed as she walks down a hallway, stands at a bathroom sink, sleeps in a narrow bed, or goes for a walk in the forest. The scenes are desolate, sinister, cast in darkness with only enough light to reveal the figures. The bodyguard's watchful presence, hovering behind or over her at all times, is highly ambiguous, more menacing than reassuring. In *Demons Sweat Nausea*, 1999, a related seven-hour video shot in a hotel in San Francisco, the guard watches Olofsson as she undresses and goes to sleep. In both pieces, this self-elected invasion of privacy by

Fig.116

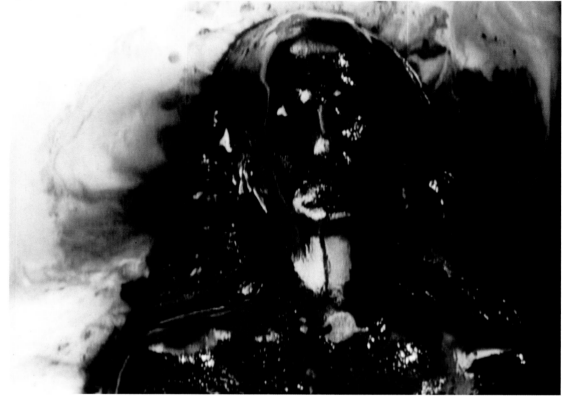

**Fig. 116** Anneè Olofsson. Still from *Say Hello Then Wave Goodbye*, 2004. DVD, color, 12:00 min.

**Fig. 117** Anneè Olofsson. *The Conversations, Island Life—The Mother*, 2006. C-print mounted on aluminum with a speaker behind the photo, 70 ⅞ × 70 ⅞ in. (180 × 180 cm)

a complete stranger only adds to a pervasive sensation of potential danger and suggests the futility of Olofsson's attempts to battle her fearful demons.

*Evil Eye* is even more closely related to *Say Hello Then Wave Goodbye*, 2004 (fig. 116), made a year earlier. In fact, the two read like companion pieces in their formal composition and their foregrounding of physical beauty and its destruction. In this earlier work we see the same view of Olofsson from the collarbone up that we encounter in *Evil Eye*, but it is a white bust, cast in ice, and not her actual body. As we watch, the extremities of her frozen portrait slowly start to darken until the entire bust has turned black and the darkness spreads to the edges of the screen, filling it entirely with her slick, glistening presence. Then the bust's contours begin to disintegrate. Olofsson's features cave in and dissolve into the background, leaving us helplessly contemplating her disintegration to the tunes of Sean McBride until there is nothing left except a black gooey mess, an unwelcome reminder of the base facts of bodily existence.

*Say Hello Then Wave Goodbye*, in turn, directly relates to a piece that Olofsson had realized in Poland on the shores of the Baltic Sea. *Cold*, 1999 shows the artist facing snow and wind in the nude, resisting the cold as long as is physically possible. In this piece she can also be seen only from the shoulders upward; the focus is on her face, all bodily expression concentrated in her eyes, which blink with increasing fervor as the chill takes hold of her and reduces her to tears. The work is a powerful demonstration of the fact that

Fig.117

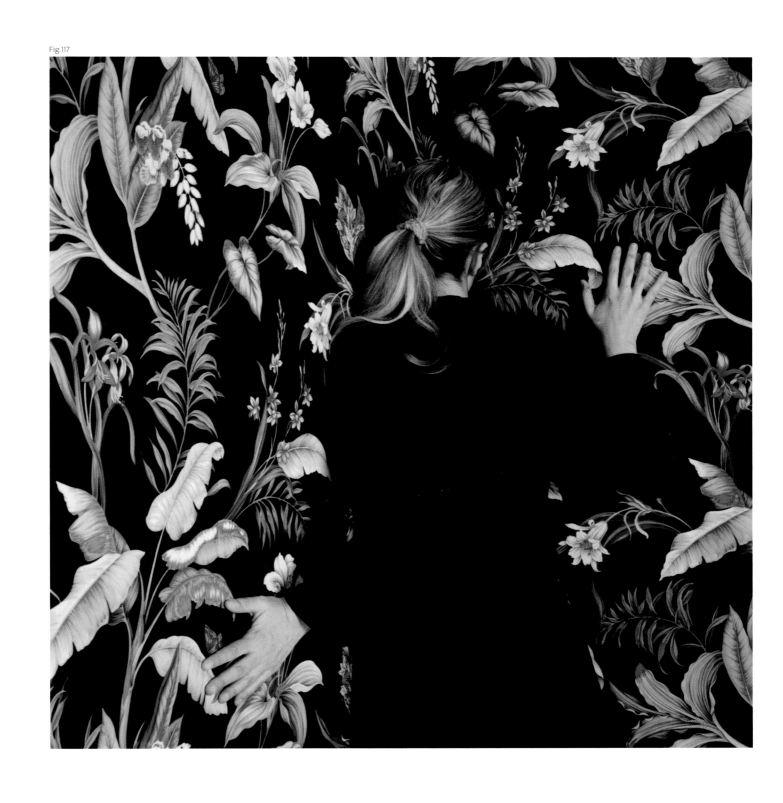

Fig.118

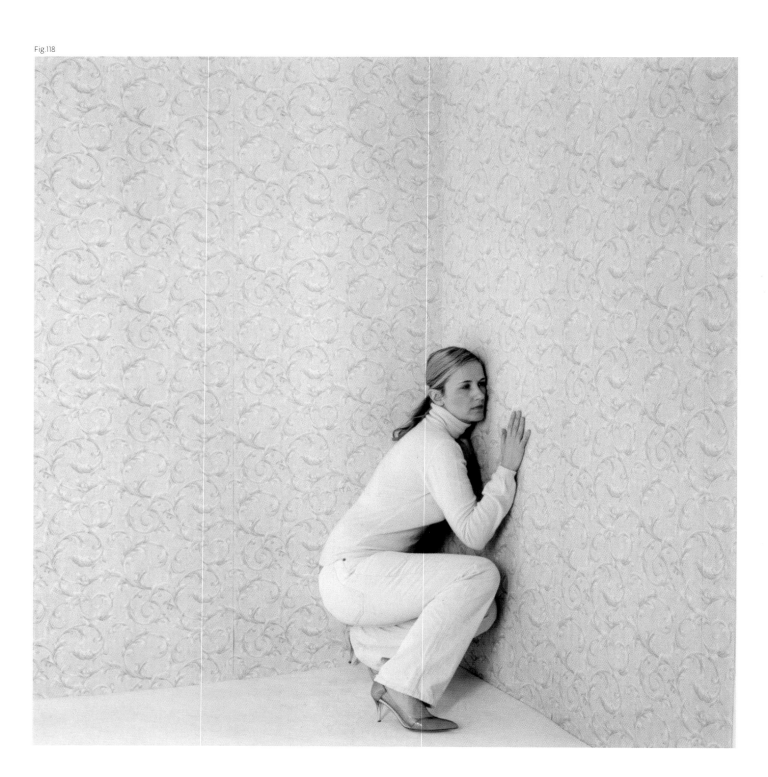

resistance to nature is futile. In *Say Hello Then Wave Goodbye*, Olofsson has abandoned such heroics of youth. The cold has taken over, and it is only a question of time until the body gives way to the ultimate fusion with matter.

Fig. 118 Anneè Olofsson. *The Conversations, Grand Corniche—The Dealer*, 2006. C-print mounted on aluminum with a speaker behind the photo, 70 ⅞ × 70 ⅞ in. (180 × 180 cm)

*The Conversations, Island Life—The Mother*, 2006 (fig. 117) is a corner installation composed of sound, photographs, and wallpaper depicting a paradisiacal scene. In the photographs, we see Olofsson pressing her ear against a wall that is covered in the same wallpaper, as if she is listening to the sounds emanating from within. Attracted by the snippets of a soft voice mixed with music, chirping birds, and rustling leaves, the viewer is encouraged to eavesdrop. We hear Olofsson's voice reading her mother's words, recorded at her home in southern Sweden. Living alone, the mother talks to her cat as she goes about her daily domestic routine. Mixed in with Olofsson's voice are parts of the original recording, love songs by Charles Aznavour and other favorite music that Olofsson grew up with in her parents' house, as well as ambient noises suggesting a natural setting akin to the scenery of the wallpaper. Asked to assume the same position as Olofsson in the photographs, and effectively enacting the image, we become acutely aware of the intrusive nature of the piece as well as our attempts to grasp it. To understand the work, we must participate in a voyeuristic breach of privacy, which becomes more uncomfortable once we realize that our curiosity has driven us to witness the musings of a person filling her solitude. We have bought into the wallpaper motif's false promise of paradise, but instead of entering greener pastures, we have been seduced into contemplating one of our greatest fears: facing the end alone.

This work is the companion piece to *The Conversations, Grande Corniche—The Dealer*, 2006 (fig. 118), where we take part in a break-up. Again, the work pulls us in with a false lure—a wallpaper depicting a beautiful Italianate palace façade—only to ultimately nourish our fears of abandonment. We hear a recorded conversation between the artist and her dealer, but since no names or any other specifics are provided, we are left to revisit and fill in our own failed relationships as we witness this one unravel.

In their use of decorative wallpaper both *The Conversation Island Life—The Mother* and *The Conversation Grande Corniche—The Dealer* invoke Olofsson's photographic series, *God Bless the Absentees*, 2000, which explores the notion of isolation and loss of identity within the domestic realm. Here, her subjects wear clothing made from the same fabric that upholsters their homes; as they blend in with their carpets, couches, or beds, they literally become part of the furniture, unnoticed and frozen in their isolation without even a cat to talk to.

Olofsson herself is the primary subject of her work, complemented by a tight roster of family and friends, most frequently her parents. They divorced at around the time when Olofsson began integrating them in her work, but their willing participation for over a decade in her disquieting, potentially embarrassing and awkward scenarios probes and exposes personal familial dynamics, notably manifestations of continuity and change in the relationship between parent and child. Olofsson's secret eavesdropping on her mother's loneliness in *The Conversation Island Life—The Mother*, is, unlike ours, motivated not so much by curiosity as by concern. In this context it illustrates the ultimate helplessness of a daughter faced with an aging parent and her inability to change that fate. In the end she, too, finds herself excluded and alone.  *c. s.*

# JULIA OSCHATZ

one being is sailing in a [Brueghelesque] landscape on its way to an island. just before arrival it's drowning itself in the ocean. the flock of birds is shaping the word "fuck." fuck the idea of far-out paradises or desirable aims. the future has time enough. haecceity,[1] which neither has beginning nor end, neither origin nor aim. to be in the misty middle.
Julia Oschatz[2]

Julia Oschatz's series of installations *Paralysed Paradise*, begun in 2004 (fig. 119), presents itself as an ongoing set of travelogues, with each exhibition constituting a new chapter, a new adventure in an ongoing journey, comprising drawings, paintings, video clips, and sculptural installations. The protagonist of this journey is a sexless, expressionless being—part human, part animal—who roams the woods and mountains of temperate climates with the same aloof curiosity as it does the tropical landscapes of jungles, beaches, and waterfalls or the arctic snow and glacial regions of faraway places. We encounter it everywhere: staggering over rocky cliffs, traversing deep abysses, exploring caves, navigating the oceans during stormy weather, climbing mountain passes, swimming in lakes and waterfalls, or simply relaxing in a hammock or looking out onto the landscape that unfolds in front of it. The scenery, whether drawn, painted, or projected, still or animated, is always dramatically picturesque, consciously playing off a romantic idea of landscape, but treating it as a cliché rather than an ideal. Oschatz's hybrid being, or Wesen, to call it by its German name, doesn't seem fazed by the grandeur of nature; nor does it pause in immersive contemplation to ponder notions of the sublime.

Generally wearing a gray suit and oversized shoes, it stumbles through these landscapes that are as ravishingly beautiful as they are inhospitable, deceptive idylls that expel our Wesen upon entry and so force it to keep moving. And move it does. For the last three years, Wesen has captivated its audience with its unperturbed tenacity, continuing its quest despite the many trials and tribulations it endures on

Fig.119

the way. Anonymous in its featureless headdress, whose only distinctions are its pointy ears and round snout, it is at the same time strangely familiar. Wesen wanders and searches but with no apparent plan or goal, a world traveler with no intention or ability ever to settle down. Its journey is one with no beginning or end, purposeful only in its undertaking, in the fact that it happens. And so Wesen's raison d'être is just that: being—its meaning encapsulated in its name. Time doesn't exist for Wesen; its presence is always momentary, affirmed one image at a time, but it is a temporariness that perpetuates itself endlessly and into eternity. Wesen could roam the world forever without ever knowing or caring to know why and how it arrived at or left a place. Unlike us, Wesen doesn't question the whys and hows of its existence. Due to this unaware thereness, Oschatz has also described Wesen as a "ghost of the present," forever there to haunt or enchant us with its inexplicable presence.

**1.** "Haecceity" (transliterated from the Latin *haecceitas*) is a term from medieval philosophy first coined by Duns Scotus, which denotes the discrete qualities, properties, or characteristics of a thing that make it a *particular* thing. Haecceity is a person or object's "*thisness.*"

**2.** Julia Oschatz, "Words," from www.julia-oschatz. de (accessed October 30, 2007).

As the title suggests, the wanderings of Wesen are not without peril. Alone in the wilderness it faces rain and snow storms, heat and winds, and above all, solitude. For the lonely traveler there is also the physical threat of violence and death, and Wesen suffers both repeatedly. It is attacked and killed in myriad ways, but wonderfully, it never really dies. Shot, hung, stabbed, or torn to pieces in one image, it will appear resuscitated in the next, as if dying were just another tedious condition to contend with, unavoidable but temporary. There is also something soothing about a living being that seems not only oblivious to, but also unperturbed by, the harm done to it. As much as it often mirrors human behavior, in the end Wesen is not human, and that realization is at once exhilarating and saddening. For what happens is that as we keep following it around through space and time, from image to image and exhibition to exhibition, we become oddly attached to our itinerant traveler and look forward to the encounter as we would to one with an old friend, whose stories still interest and entertain us.

Oschatz's painting style has been aptly described as apparitional, hinting at a reality rather than depicting it. With its subdued palette and loose execution it avoids any kind of pathos. Gray reigns over the occasional spurts of color, but avoids symbolic weight. And nor does Oschatz use it for psychological effect. Even in its worst moments, Wesen is hardly consumed by melancholia or sadness—it would rather

**Fig. 119** Julia Oschatz. *Untitled (43-05)*, 2005. Acrylic and india ink on canvas, 15 × 21 ¼ in. (38.1 × 54 cm)

**Fig. 120** Julia Oschatz. Still from *Between Caspar David and Friedrich*, 2006. Animation and video on DVD, color, 1:17 min.

Fig.120

Fig.121

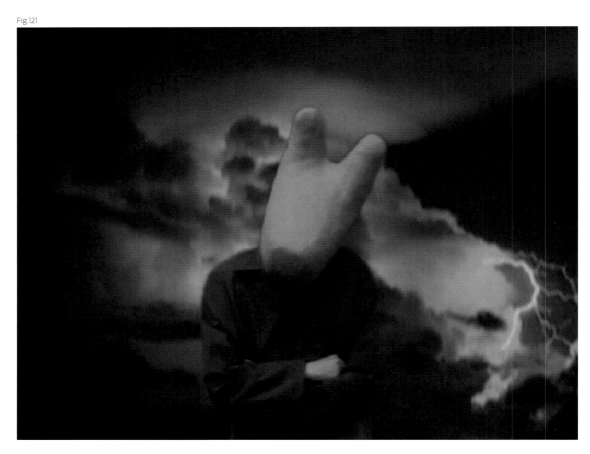

**Fig. 121** Julia Oschatz. Still from *Populated Solitudes*, 2005. DVD, color, 2:12 min. (loop)

**Fig. 122** Julia Oschatz. *Untitled (19-04)*, 2004. Acrylic, india ink, and glitter on canvas, 13 ½ × 17 ¾ in. (34.3 × 45.1 cm)

have a beer than contemplate its condition. Gray is the color of choice because the artist appreciates its indifferent, reductive quality, which emphasizes the paintings' sketchiness. Their provisional character denies association with a grand painting tradition but aligns them more with drawing as a preparatory and experimental practice. Oschatz's willful resistance to any heroic gesture finds poignant expression in a short video entitled *Between Caspar David and Friedrich*, 2006 (fig. 120), where Wesen sprays "FUCK OFF" onto an invisible screen that divides the viewer from an actual landscape that could have been painted by the great German romantic. This gesture also indicates Oschatz's interest in and adherence to surface in all the media she engages. Her filmic vignettes and animations have a theatrical quality, filmed in a room or on a stage where the suggestion of space is far from illusionary, but defined by parallel layers of image and action. In *Populated Solitude*, 2005 (fig. 121), for example, the exotic locales are projected against the wall in front of which Wesen plays out its journey or predicament. Even if there is footage of real locations, the overall effect is that of superficiality and imposition.

The construction of Oschatz's paintings is also flat and illustrative. She doesn't work with a preconceived image in mind or according to an ideal of how to depict landscapes or nature: "I do not paint landscapes but rather dots and lines."[3] However, she bases her dots and lines on a variety of external historical

**3.** *Paralysed Paradise*, exh. cat. Gerhard-Von-Reutern-Haus, Willingshausen, 2005, no pagination.

Fig.122

and contemporary source material: in addition to broadly referencing Western and Eastern traditions of landscape painting, Oschatz delves deep into popular culture, collecting travel magazines and commercials, and mining public archives for images, which she draws, paints, and projects. She often uses a slide projector to trace or redraw found imagery. She likes to work in the dark because it "releases her from responsibility" for the image. "I can hand over the moment. I only fully see the picture after a specific stage is completed."[4] This conscious distraction helps her to achieve the kind of openness and indetermination that she is after.

4. Ibid.

Oschatz is critical of art that comes with too much attitude. She wants her work to transport, not to insist.[5] She achieves this by not putting too much weight on singularity but by pursuing multiplicity instead. The reproduction and copying of images, mechanical or by hand, and in shades of gray and muted colors, are all techniques employed toward neutralizing her artistry to avoid overt demonstrations of talent and invite admiration of her virtuosity. She doesn't believe in genius or skill. Like her Wesen, she just wants her works, "to assume a concrete reality that is neither able to be questioned nor named, one that is extant but exchangeable."[6] In this regard, it is not surprising that her favorite form of presentation is a salon-style hanging of her paintings that de-emphasizes the individual image in favor of the whole installation. Cave or tunnel-like structures constructed from cardboard boxes make up the viewing rooms for her videos. This shifting dynamic between the openness and enclosure of the installation mirrors Oschatz's own ambivalent condition, moving between constriction and vastness, loneliness and freedom.[7]

Oschatz's *Paralysed Paradise* presents a world not unlike our own: beautiful but damaged, inviting yet hostile, enchanting and devastating. Wesen is Oschatz's catalyst for an existentialism that doesn't take itself too seriously. She presents us with an anti-hero who demonstrates to us time and again that the search for a deeper meaning is a never-ending enterprise, that once we leave Plato's cave, we're dedicated to the quest forever. But it also reminds us that there is a lot of fun to be had on the way. Lately, Wesen has ceased to be alone; its world has become increasingly populated by beings and things, by companions that look and act just like it. Its journeys now seem more like expeditions, conquests, or wars; its collaborators are equipped with sledges, binoculars, and guns. We have seen it perched in the crow's nest of a ship many times, but now the boat has become a vessel of conquest and site of mutiny, with Wesen as the captain. But despite these hints at social integration, Wesen seems most at ease on the fringes of society and in a role of (reluctant) pioneer, laying bare the basic conditions of our existence. Oschatz, who slips into the role of Wesen for her films and animations, is right behind it and often ahead of us.

> one being is sitting on a rock, scanning the landscape, partly contemplative, partly nervous, not remarking the beauty. just somewhere. "somewhere else" one being is walking whistling along the scene and jumps out of the screen till a ship passes by. now it is climbing a tree and hanging itself. the rope rips and the being is falling down to the ground. a bird flies out of its nest and the entire scenario gets visible. we see the first being again, which has seen the whole story.
> Julia Oschatz[8]

C. S.

**5.** Op. cit.
**6.** www.julia-oschatz.de (accessed October 30, 2007).
**7.** *Paralysed Paradise.*
**8.** Julia Oschatz, "Words," from www.julia-oschatz. de (accessed October 30, 2007).

Fig.123

**Fig. 123** Julia Oschatz. *Untitled (94-06),*
2006. Oil on canvas, 35 ½ × 23 ⅜ in.
(90.2 × 60 cm)

# DAVID SCHNELL

Fig.124

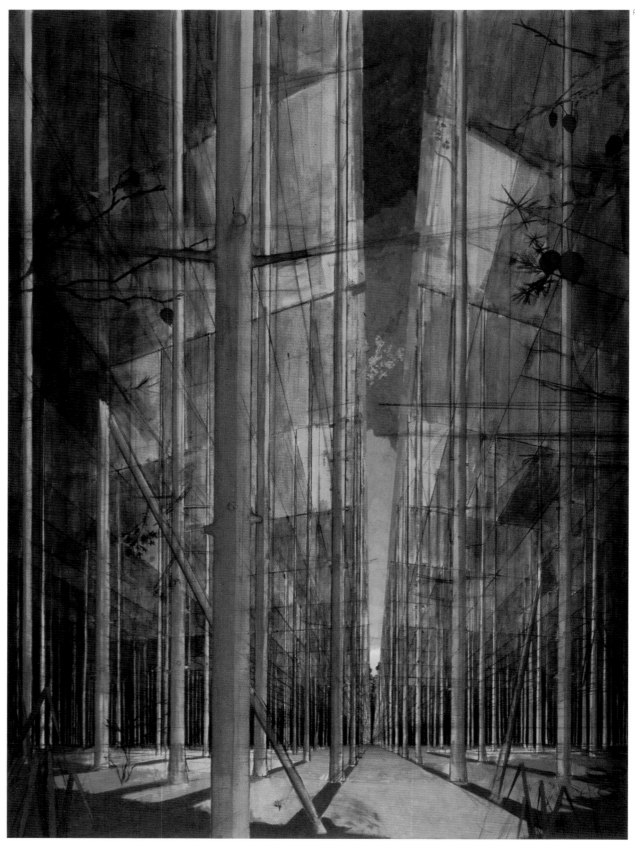

The blink-and-you-missed-it speed of contemporary telecommunications technology collides with the slowly unfolding satisfactions of trips to the countryside in David Schnell's beautifully painted pictures of thick forests, empty pathways, abandoned grandstands, and derelict wooden structures. At once wistful and unsentimental, the Leipzig-based painter's subtly unsettling depictions of nature filtered through several screens of modern life's image-glut cast a melancholic glance back at the history of northern European painting as they look forward to a future that promises nothing but uncertainty. This is not exactly the tried-and-true triumvirate of adventure, danger, and romance that fueled many eighteenth-, nineteenth-, and twentieth-century journey-of-discovery narratives, but a similarly charged, twenty-first-century mixture of anxiety and risk—keyed up by a fair share of paranoia, which makes for a heightened perceptual state in which letting down one's guard is neither prudent nor likely. In the world Schnell depicts, pleasure is fleeting, fugitive, and always infected with the possibility of flipping over into its opposite: pain, dread, and terror.

**Fig. 124** David Schnell. *Lichtung*, 2001. Egg tempera on canvas, 98 ⅜ × 70 ⅞ in. (250 × 180 cm). Private collection

The present takes shape in Schnell's carefully drafted images as if seen from the very near future, from a realistic perspective that looks back on contemporary civilization as if it had pretty much ended—not with a bang but a whimper. His restrained paintings create the impression that the civilized world is a digitally recorded program or live transmission that can be controlled with a handheld remote. In all of Schnell's semi-cultivated landscapes, it seems as if an omnipotent pause button has been pushed, the scenes and settings frozen just as they are—after the last people have departed but before anyone else has arrived or the necessary steps leading up to the next event have begun. Time is suspended.

In the past, art's sublime power was meant to evoke eternity—to deliver the timelessness of profoundly meaningful experiences. Today, Schnell never aims for the grandeur of transcendence nor the invocation of eternity but instead settles for the everyday impact of pregnant pauses—for gaps or glitches that do not stop you in your tracks but sneak up on you slowly, then throw a monkey-wrench into the system that pretends to deliver an uninterrupted flow of instantaneous gratification. His landscapes inhabit those little moments when life stops rushing by and seems to just sit there, like a puzzling picture that defies easy reading and forces you to think twice about what it might mean, how best its ambiguities might be interpreted.

Schnell's paintings unfold during a sort of technologically contrived twilight, a time of manufactured respite and artificial transition that lacks the natural cadences and cyclical rhythms of day becoming night, again and again. Such fluid, organic movements have been replaced with the stop-and-start pulse of digitized time, with queasy uniformity, detachment, and the near-miss resemblance of the real thing: fully present, first-person experience. An eerie stillness and poignant silence fill Schnell's strangely out-of-sync pictures, leaving each viewer in an awkward and oddly powerful position: free to move, imaginatively, through unpopulated settings that feature vaguely mysterious yet strangely familiar architectural structures in dense forests, overgrown fields, and the bucolic countryside.

Schnell's expansive yet claustrophobic landscapes give physical form to dead time, to in-between moments when nothing much happens, less is expected, and an uncanny sensation of disengagement enters one's perception of one's place in the world—when going through the motions or living on autopilot is the best you can do. Edgar Degas painted such instants, often depicting world-weary ballerinas doggedly rehearsing their moves for the stage while strangers (who stood in for viewers) peeked voyeuristically

Fig.125

at the young women and girls, whose behind-the-scenes, lost-in-their-own-heads activities increased the exotic allure of their bodies. In contrast, the dead time that Schnell depicts never becomes a vehicle for the sexually fueled fantasies of individuals. Although it takes shape in the heads of individual viewers, it also spills into the world of shared social space, where its flatline presence becomes the basis of relationships between individuals and crowds, solitary wanderers and the external world, lone souls and the complex infrastructure all around us.

Lichtung, 2001 (fig. 124) depicts a forest of towering trees at sunset, the cloudy sky darkening, and impenetrable shadows filling the empty space in the distance. As if by rote, the imagination does what it is used to, conjuring from its well-stocked image bank of similar pictures—seen in movies, advertisements, postcards, and romantic paintings—a range of formulaic notions about nature's beauty. But such pleasantries quickly disintegrate. The tree trunks lack the idiosyncrasies of the natural world, appearing to be perfectly machined poles that taper gracefully to sharp tips. Hardly a branch or a leaf or a pine needle is visible. And the trees are laid out in an exact grid, the shadow of each falling across other trunks to form a potentially infinite network of perfect right angles. The artificiality of the rigorously interlocked composition is intensified by the flat forest floor, which has more in common with a newly built condo's wall-to-wall carpeting than anything found in nature. As a tightly composed whole, Schnell's landscape has the presence of a resplendent, computer-assisted architectural study of a surrogate world in the near future, where contemporary cellular towers, built to resemble trees, are all that remains of an old-fashioned forest.

Hütte am Feld, 2003 (fig. 125) functions similarly. Depicting what is most probably a defunct fire tower, Schnell's painting instantly evokes Nazi guard towers or other military installations built for surveillance, border control, warfare. With legs and base missing, the schematically rendered fragment of authoritarian architecture hovers over a partially cleared landscape like a grim apparition or irrepressible memory. Its stairs are similarly suspended, their impossible, gravity-defying march heavenward evoking the utopian fantasies of modernist architects, whose grand, change-the-world plans were not totalitarian but still had

**Fig. 125**   David Schnell. *Hütte am Feld*, 2003. Acrylic on canvas, 90 ½ × 63 ¼ in. (229.9 × 160.7 cm)". Tara Sandroni Hirshberg and Kristen Rey, Los Angeles

**Fig. 126**   David Schnell. *Gehege*, 2000. Egg tempera on canvas, 94 ½ × 63 in. (240 × 160 cm). Private collection, Los Angeles

their own authority. Rather than letting viewers imagine that the present can be easily disentangled from the past, Schnell's deceptively simple painting catches us in the complex web of their interrelationship.

Gehege, 2000 (fig. 126) is even stranger. Its foregrounded wooden structure calls to mind the fences and gates that farmers build to prevent their animals from escaping but that allow people to pass easily across their fields. Bedecked with multicolored triangular flags and made of mass-produced lumber, it also resembles a temporary stand built for some kind of competition, perhaps an obstacle on a steeplechase-style racecourse, a judge's observation deck, or a viewing platform for fans. Standing in the middle of a perfectly straight path in a perfectly flat field during a perfectly beautiful sunset, it suggests that whatever its function, viewers have arrived too late to see it in use and can only wonder about its purpose.

The objects in Schnell's paintings are not part of contemporary civilization's infrastructure: civic buildings, massive bridges, endless highways, or other monuments to humanity's harnessing of its collective power. The world his works depict is one in which all that remains is unremarkable—temporary stands, watchtowers, viewing platforms, manufactured forests. Nor are these structures the contemporary equivalents of the pyramids, fortresses, and cathedrals that tourists regularly visit to imaginatively reanimate centuries of dead time, fantasizing about what it must have been like to be a citizen in a faraway place and era. Such imaginative travel expands consciousness as it establishes emotional connections to cultures and ages apart from one's own. Schnell's paintings short-circuit such fantasies. The generic, stripped-to-the-minimum architectural fragments and artificial forests in his pictures memorialize the loss of the imagination's capacity to get away from the familiar, to roam freely and wildly, to break apart from the social structures that make so much of modern life seem prefabricated, so completely and effectively set up that there is nothing much left for an individual to do but to go through the motions. Schnell's paintings are powerful because they neither buy into that dispirited vision nor serve up fake escapes from it. Instead, they give chilling shape to the depth of our alienation.  D. P.

Fig.126

# RYAN TABER AND CHEYENNE WEAVER

Fig.127    Fig.128

**Fig. 127**   Ryan Taber and Cheyenne Weaver. Detail of *In Search of A Myopic's Leitmotif, Mal'Aria*, 2005; model of Chinchona Bark with Wagner's *Bayreuth Festspielhaus, Dermestidae Anthrenus museorum* (Linneaus, 1761) beetles, and leitmotifs from the Ring's *Waking of Brunhilde*. Europly, foam, audio, Dermestid beetles, 60 × 72 × 144 in. (152.4 × 182.9 × 365.8 cm)

**Fig. 128**   Ryan Taber and Cheyenne Weaver. Detail of *In Search of A Myopic's Leitmotif, Mal'Aria*, 2005; model of Chinchona Bark with Wagner's *Bayreuth Festspielhaus, Dermestidae Anthrenus museorum* (Linneaus, 1761) beetles, and leitmotifs from the Ring's *Waking of Brunhilde*. Europly, foam, audio, Dermestid beetles, 60 × 72 × 144 in. (152.4 × 182.9 × 365.8 cm)

Los Angeles artists Ryan Taber and Cheyenne Weaver invite viewers to look at romanticism's love affair with operatic drama through the other end of the telescope. Rather than triggering turbulent emotions via bombastic theatrics and spectacular exaggeration—and sending the soul on roller-coaster rides of ecstatic highs and despairing lows—the artists shrink the stage on which such heart-wrenching stories were once famously played out down to the scale of tabletop dollhouses and model-railroad dioramas. Despite the collaborators' willful min-iaturization of grandiose sentiments, and the matter-of-fact even-handedness of their science-fair-style presentation, there is nothing small-minded, spiteful, or short-sighted about *In Search of a Myopic's Leitmotif, Mal'Aria,* 2005 (figs. 127–31). This spirited, humorous, and seri-ously playful sculptural installation weaves together seemingly unre-lated events from European intellectual history to suggest that even

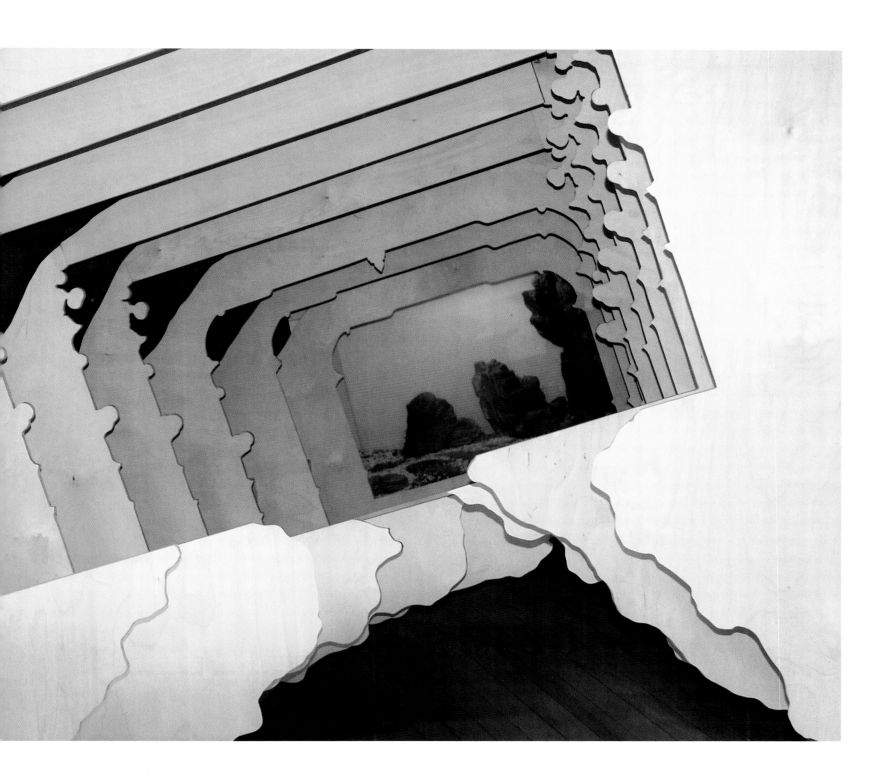

Fig.129

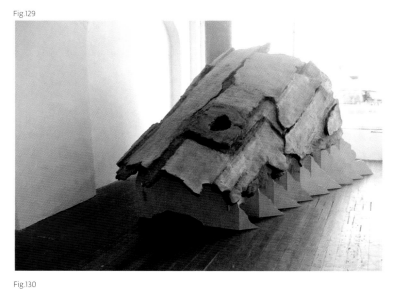

**Fig. 129**  Ryan Taber and Cheyenne Weaver. *In Search of A Myopic's Leitmotif, Mal'Aria*, 2005; model of Chinchona Bark with Wagner's *Bayreuth Festspielhaus, Dermestidae Anthrenus museorum* (Linneaus, 1761) beetles, and leitmotifs from the Ring's *Waking of Brunhilde*. Europly, foam, audio, Dermestid beetles, 60 × 72 × 144 in. (152.4 × 182.9 × 365.8 cm)

**Fig. 130**  Ryan Taber and Cheyenne Weaver. *In Search of A Myopic's Leitmotif, Mal'Aria*, 2005; model of Chinchona Bark with Wagner's *Bayreuth Festspielhaus, Dermestidae Anthrenus museorum* (Linneaus, 1761) beetles, and leitmotifs from the Ring's *Waking of Brunhilde*. Europly, foam, audio, Dermestid beetles, 60 × 72 × 144 in. (152.4 × 182.9 × 365.8 cm)

Fig.130

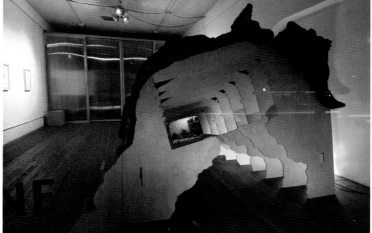

though rationality is not all it's cracked up to be, it sure beats taking things on faith and, more importantly, that it is as fundamental a part of powerful poetry as is inspiration, intuition, and far-flung flights of fancy. Their offbeat work embraces an unpretentious, see-for-yourself ethos that is both optimistic and sophisticated and neither naive nor cynical but pragmatic about the increasingly global reality that contemporary art inhabits. In their installation, digressions do not take viewers away from the truth; even the loopiest departures eventually circle back, shedding light on historical moments that suddenly take on additional meaning because of their juxtaposition with other ideas, perspectives, and moments. Taber and Weaver's research-oriented project may not repair the damage that has been done throughout modern history, nor redeem its tragic losses, but *In Search of a Myopic's Leitmotif* certainly makes life in the present more

interesting than it was, bringing the potential for meaning and the possibility of lasting fascination to anyone willing to entertain ideas whose outlandishness is inversely proportionate to his or her curiosity about the interconnected world in which we all live.

Taber and Weaver's work is formed with the same worlds-within-worlds structure as Russian nesting dolls and those elaborately decorated eggs in which detail-obsessed miniaturists have crafted tiny landscapes that are visible through tiny peepholes. But unlike such self-contained objects, the artists' participatory theater is open-ended and free-form, its disparate components behaving with the rambunctious restlessness of an imagination in action or a mind in hot pursuit of new thoughts, leaping and bounding again and again from idea to inkling to insight, as a view of the big picture slips, often by fits and starts, into focus. It doesn't matter which part of their work you start with, since it doesn't tell a linear story (whose ending could be ruined if given away too soon) so much as presenting various multilayered components that reverberate against one another with out-of-order, every-which-way flexibility. This additive, everything-plus-the-kitchen-sink dynamism creates an odd whole that is not only greater than the sum of its parts, but different each time you explore its strangely pointed nexus of odd facts, idiosyncratic anecdotes, and unlikely but undeniable parallels between truth and fiction, reality and fantasy.

From across the gallery, *In Search of a Myopic's Leitmotif* appears to be a prop from an amateur theatrical production, a big hollow tree trunk made of Styrofoam, plaster, and plywood—all painted to look good from a distance, especially when properly lit. In fact, the twelve-foot-long sculpture is a nearly exact copy of a six-inch-long piece of Cinchona bark, enlarged, at the scale of 24:1, to become a shelter for a model of the remains of the festival theater that Richard Wagner (1813–83) designed and built for the annual performance of his "Ring" cycle. From one end of Taber and Weaver's fake piece of enlarged bark, viewers peer through eight proscenium arches, made of ordinary lumberyard particle board, each proportionally smaller than the one before it. Behind the last one lies a spotlit stage, elaborately set with miniature props and painted backdrops that create the illusion of a vast romantic landscape—an impossible world where the parched desert floor meets snow-capped peaks beneath an expansive sky that seems to open onto infinity. A screen-covered, skylight-style opening cut in the faux bark over the stage allows viewers to see that this part of the sculpture does double duty as a cage for a dozen or so *Dermestid museorum Linneaus* beetles that crawl around the elaborate setup as if it were perfectly natural, munching on whatever they can get between their teeth. Selections from Wagner's tragic operas play over speakers mounted on the gallery walls, where a suite of pencil drawings, modeled on nineteenth-century field etchings, depicts various insects whose limbs, armor, and mandibles have been replaced with modern items that serve similar purposes, including maritime navigation tools, Art Nouveau lamps, shipping trunks, airplane wings, and humidifying misters. On the back of one flying bug rides a tiny Valkyrie in full battle regalia, looking beyond the horizon to distant, as yet undiscovered mysteries.

Then things begin to get interesting. A wall placard informs visitors that Cinchona bark is the source of quinine, the drug used to treat malaria. The fact that the last three syllables of the word 'malaria' spell out an essential component of opera could suggest that malaria is nature's own aria, in this case a bad one, whose symptoms—alternating fevers and chills of debilitating intensity—are strikingly similar to the climaxes of the highly refined artform. The beetles, coincidently, perform their own rhythmic aria.

Fig.131

Fig.132

Generating a barely audible drone as they bore through Styrofoam mountains, they stage their own version of a scene from Wagner's "Ring" cycle. Medicinal quinine often caused vivid fever dreams, acute nausea, and temporary blindness, symptoms that led some victims of the disease to prefer the sickness to the cure.

In any case, the discovery of quinine had monumental consequences for the shape of civilization as we know it. Without quinine, European explorers, adventurers, colonialists, and imperialists would have had a significantly more difficult time traveling throughout Africa, Asia, and South America. With malaria held at bay, scientific research flourished; the majority of the world's plants and animals were categorized. Commerce also took off, making global transportation and international shipping profitable as markets were established, natural resources tapped, and indigenous labor exploited. Taber and Weaver's drawings (fig. 131) mimic similarly detailed studies by Alexander von Humboldt (1769–1859) (fig. 132), the legendary German scientist, explorer, and writer who spent much his life outside of homophobic Germany with his companion, French botanist Aimé Bonpland (1773–1858), cataloguing, chronicling, and studying the world's great diversity of specimens. Bonpland contracted malaria in Venezuela. So it doesn't take a great leap of the imagination to see Taber and Weaver's drawings as feverish visions of futuristic insects—or as the natural, organic sources for ingenious inventions made by adventuresome thinkers at one of Western civilization's most wildly creative and industrious moments.

Likewise, Wagner's festival theater was part of the German's insanely ambitious plans to remake the world in his own image of it, fusing the arts—music, drama, literature, poetry, painting, sculpture, and architecture—in a spectacular extravaganza that appealed to both aristocrats and peasants, transforming them into a nation of like-minded, myth-loving nationalists. For their part, the beetles were typically used by taxidermists and natural history museums to strip bones and carcasses clean for pedagogic display. With great frequency, however, the voracious beetles escaped their containers and devoured entire collections of animal and botanical specimens as well as leather furnishings, books, and wooden benches. Indiscriminate consumers, they did not let taste get in the way of their appetites. Juxtaposed in Taber and Weaver's work, the insatiable insects and the globe-spanning, world-historical ambitions of eighteenth-century German art and science speak volumes about creation and destruction, hope and misery, as well as the limits of control, the inadequacy of good intentions, and the inescapability of unintended consequences. Rather than tying up loose ends with definitive explanations, Taber and Weaver pile on cross-references and coincidences, revealing that truth is more fascinating than fiction, if only our imaginations can keep up with its dizzying twists and turns. D. P.

Fig. 131  Ryan Taber and Cheyenne Weaver. *In Search of a Myopic's Leitmotif, Licheniferous Chinchona*, 2005. Graphite on paper, 11 ½ × 18 ½ in. (29.25 × 47 cm)

Fig. 132  Baron Alexander von Humboldt and Aimé Bonpland, plate 15 from Vol. 1 of *A Collection of Observations on Zoology and Comparative Anatomy*, 1811. Engraving, 13 ¼ × 9 ⅞ in. (33.5 × 25 cm). Natural History Museum, London

# Selected Exhibitions and Publications

## Richard Billingham

b. Stourbridge, England, 1970
Lives and works in Brighton, England

### Education
- 1994 BFA University of Sunderland, England

### Selected Solo Exhibitions
- *Richard Billingham: Zoo*, Anthony Reynolds Gallery, London, March 30-May 5, 2007.
- *Richard Billingham*, Ikon Gallery, Birmingham, June 7–July 16, 2000; Douglas Hyde Gallery, Dublin, August 4–September 23, 2000; Nicolaj Contemporary Art Centre, Copenhagen, October 14–December 10, 2000; Brno House of Arts, September 27, 2000–April 8, 2001; Hasselblad Centre, Göteborg, April 28–June 10, 2001 (catalogue).
- *Richard Billingham*, Luhring Augustine, New York, February 15–March 22, 1997.

### Selected Group Exhibitions
- 7th International Photo-Triennial, Esslingen, Germany, July 1–September 23, 2007 (catalogue).
- *2001 Turner Prize Exhibition*, Tate Britain, London, November 7, 2001–January 20, 2002 (catalogue).
- *Plateau of Humankind*, 49th Venice Biennale, October 6–November 4, 2001 (catalogue).
- *Sensation: Young British Artists from the Saatchi Collection*, The Royal Academy, London, September 17–December 28, 1997; Brooklyn Museum of Art, October 2, 1999–January 9, 2000 (catalogue).
- *New Photography* 12, Museum of Modern Art, New York, October 24, 1996–February 4, 1997.

### Selected Bibliography
- Billingham, Richard. *Black Country* (West Bromwich: The Public, 2003).
- ———. *Ray's A Laugh* (Zurich: Scalo, 1996).
- Billingham, Richard, and Sacha Craddock. *Landscapes 2001–2003* (Stockport: Dewi Lewis, 2008).
- Buck, Louisa. "I Only Make Pictures … Everything Else Is a Bonus," *The Art Newspaper* 13, no. 134 (March 2003): 31 (interview).
- Canning, Claire. "The New Forest," *Tank Magazine* 3, no. 9 (2004): 82–9 (interview).
- Grant, Simon. "The Turner Prize 2001," *Tate–The Art Magazine*, Winter 2001: 22–9 (interview).
- Hornby, Nick. "Life Goes On," *Modern Painters* 10 (1997): 32–4.
- Lewis, Jim. "No Place Like Home: The Photographs of Richard Billingham," *Artforum*, January 1997: 62–7.
- Lingwood, James. "Inside the Fishtank," *Tate (London)*, Winter 1998: 54–8 (interview).
- ———. "Family Values," *Tate (London)*, Summer 1998: 54–8 (interview).
- Remes, Outi. "Reinterpreting Unconventional Family Photographs: Returning to Richard Billingham's *Ray's a Laugh* Series," *Afterimage* 34, no. 6 (May–June 2007): 16–19.

## Berlinde De Bruyckere

b. Ghent, Belgium, 1964
Lives and works in Ghent

### Education
- 1986 MFA Sint-Lucas, Ghent

### Selected Solo Exhibitions
- *Berlinde De Bruyckere*, The Galleria Continua, San Gimignano, May 12–August 27, 2007.
- *Berlinde De Bruyckere: Schmerzensmann*, Hauser & Wirth, London, November 9–December 16, 2006 (catalogue).
- *Berlinde De Bruyckere*, Caermersklooster, Provincial Centre for Art and Culture, Ghent, February 15–April 14, 2002 (catalogue).
- *In Flanders Fields*, In Flanders Fields Museum, Ypres, July 1–October 15, 2000 (catalogue).
- *Onschuld kan een hel zijn* (*Innocence Can Be Hell*), Middelheimmuseum, Antwerp, May 7–June 18, 1995.

### Selected Group Exhibitions
- *Berlinde De Bruyckere: Jenny Saville, Dan Flavin*, Museum of Art, Lucerne, September 8–November 25, 2007.
- *Of Mice and Men*, 4th Berlin Biennial for Contemporary Art, KW Institute for Contemporary Art, March 25–June 5, 2006 (catalogue).
- *Animals*, Haunch of Venison, London, June 24–September 11, 2004 (catalogue).
- *Dreams and Conflicts; The Dictatorship of the Viewer*, 50th International Venice Biennale, May 14–November 2, 2003 (catalogue).
- *Selections Summer 2000*, The Drawing Center, New York, June 21–July 26, 2000 (catalogue).
- *Washington Velvets (Two From Flanders): Berlinde de Bruyckere and Philip Huyghe*, Corcoran Gallery of Art, Washington, D.C., January 27–April 8, 1996 (catalogue).

### Selected Bibliography
- Amy, Michaël. "Universal Resonances: A Conversation with Berlinde De Bruyckere," *Sculpture* 26, no. 2 (March 2007): 34–9 (interview).
- Baert, Barbara. *Berlinde De Bruyckere: one 2002–2004* (Prato: Gliori, 2005).
- "Berlinde De Bruyckere, Artist in Residence, 2000," *In Flanders Fields Magazine*, July 2000: 3–5 (interview).
- Bigi, Daniela. "La Condizione Umana," *Arte e Critica* 35–36 (October–December 2002): 24–5 (interview).
- Braet, Jan. "Een kus van de dekenvrouw," *Knack*, September 27, 2000: 110–14.
- Brutin, Hugo. "Berlinde De Bruyckere, Bewogenheid en esthetiek," *AAA-Arts-Antiques-Auctions*, April 2002: 28–31 (interview).
- De Baets, Isabelle. "The Male Nude Reexamined," *Janus* 18 (Winter 2005): 31–6.
- Ruyters, Marc. "Innocence Can Be Hell: The Art of Berlinde de Bruyckere," trans. Gregory Ball, *The Low Countries: Art and Society in Flanders and the Netherlands* (Bruges: Die Keure, 2002).

## Edward Burtynsky

b. St. Catharines, Canada, 1955
Lives and works in Toronto

### Education
- 1982 BA Ryerson Polytechnical University, Toronto
- 1976 Diploma, Graphic Arts, Niagara College, Welland, Ontario

### Selected Solo Exhibitions
- *Edward Burtynsky: In the Pursuit of Progress*, Winnipeg Art Gallery, January 26–April 12, 2008.
- *Manufactured Landscapes: The Photographs of Edward Burtynsky*, National Gallery of Canada, Ottawa, January 31–May 4, 2003; Art Gallery of Ontario, Toronto, January 24–April 4, 2004; Musée d'art contemporain de Montréal, October 8–January 9, 2005; Museum of Photographic Arts, San Diego, March 20–June 5, 2005; Cantor Arts Center at Stanford University, June 29–September 18, 2005; Brooklyn.Museum of Art, New York, October 7, 2005–January 15, 2006 (catalogue and documentary film).

### Selected Group Exhibitions
- *Image Smugglers in a Free Territory*, 26th São Paulo Biennial, September 25–December 19, 2004.
- *Terrain Vague: Architecture, Photography and the Post-Industrial Landscape*, Atlanta Contemporary Art Center, November 15, 2003–January 3, 2004; Heinz Architectural Center, Carnegie Museum of Art, Pittsburgh, March 20–June 20, 2004.
- *Detourism*, The Renaissance Society at the University of Chicago, November 11–December 23, 2001.

### Selected Bibliography
- Beem, Edgar Allen. "Edward Burtynsky Makes Big Beautiful," *Photo District News* 23, no. 2 (February 2003): 34.
- Burtynsky, Edward. *China* (Göttingen: Steidl, 2005).
- ———. *Quarries* (Göttingen: Steidl, 2007).
- Burtynsky, Edward, and Michael Torosian. *Residual Landscapes* (Toronto: Lumiere, 2001).
- Cundiff, Brad. "Ed Burtynsky," *Studio* 11, no. 6 (November/December 1993): 12–15.
- Diehl, Carol. "The Toxic Sublime," *Art in America* 94, no. 2 (February 2006): 118–23.
- Grande, John K. "Beauty Going Nowhere," *Art Papers* 28, no. 6 (November/December 2004): 22–7.
- Langford, Martha. "Auradynamics, The Task of the Spectator in the New Era of the Aura," *Border Crossings* 22, no. 2 (May 2003): 56–65.
- Mays, John Bentley. "A Melancholy Beauty," *National Post*, April 25, 2001.
- Smyth, Diane. "Another Planet," *British Journal of Photography* 154, no. 7647 (August 15, 2007): 18–27.
- Whyte, Murray. "Burtynsky's Account: Adding up the Price that Nature Pays," *New York Times*, January 4, 2004.

## Sophie Calle

b. Paris, 1953
Lives and works in Paris

### Selected Solo Exhibitions
- *Sophie Calle*, Centre Pompidou, Paris, November 19, 2003–March 15, 2004; Irish Museum of Modern Art, Dublin, June 23–October 10, 2004; Berliner Festspiele, Martin-Gropius-Bau, Berlin, September 10–December 13, 2004; Ludwig Forum für Internationale Kunst, Aachen, January 29–April 24, 2005 (catalogue).
- *Art Now: Sophie Calle*, Tate Britain, London, June 5–August 16, 1998.
- *Sophie Calle: Romances*, Contemporary Arts Museum, Houston, October 1–November 27, 1994; High Museum of Art, Atlanta, January 27–May 11, 1996 (catalogue).

### Selected Group Exhibitions
- *Think with the Senses—Feel with the Mind: Art in the Present Tense*, 52nd Venice Biennial, French Pavilion, June 10–November 19, 2007 (catalogue).
- *Experiencing Duration*, 8th Biennial of Contemporary Art, Lyon, September 14–December 31, 2005 (catalogue).
- *The Museum as Muse: Artists Reflect*, Museum of Modern Art, New York, March 14–June 1, 1999 (catalogue).

### Selected Bibliography
- Bois, Yve-Alain. "Character Study," *Artforum*, April 2000: 126–31.
- Calle, Sophie. *Appointment with Sigmund Freud* (London: Thames & Hudson, 2005).
- ———. *Exquisite Pain* (London: Thames & Hudson, 2005).
- ———. and Paul Auster. *Sophie Calle: Double Game* (London: Violette Editions, 1999).
- ———. and Jean Baudrillard. *Suite vénitienne* (Seattle: Bay Press, 1988).
- Cooke, Lynne. "Doubleblind," *Art Monthly*, February 1993: 3–7 (interview).
- Krauss, Rosalind. "Two Moments from the Post-Medium Condition," *October* 116 (Spring 2006): 55–62.
- Rinder, Lawrence. "Sophie Calle and the Practice of Doubt" in *Art Life: Selected Writings, 1991–2005* (New York: Gregory R. Miller & Co., 2005): 11–19.
- Sante, Luc. "Sophie Calle's Uncertainty Principle," *Parkett* 36 (1993): 74–87.
- van Zuylen, Marina. "Voyeuristic Monomania: Sophie Calle's Rituals" in *Monomania: The Flight from Everyday Life in Literature and Art* (Ithaca: Cornell University Press, 2005).
- Wagstaff, Sheena. "C'est Mon Plaisir," *Parkett* 24 (1990): 6–10.

## Petah Coyne

b. Oklahoma City, 1953
Lives and works in New York

### Education
- 1977 Art Academy of Cincinnati

### Selected Solo Exhibitions
- *Petah Coyne: Above and Beneath the Skin*, Galerie Lelong, New York, January 29–March 16, 2005; Sculpture Center, Long Island City, New York, January 16–April 10, 2005; Chicago Cultural Center, May 14–August 21, 2005; Kemper Museum of Contemporary Art, Kansas City, September 16–November 27, 2005; Scottsdale Museum of Contemporary Art, January 21–May 7, 2006; Albright-Knox Art Gallery, Buffalo, June 9–September 10, 2006 (catalogue).
- *Petah Coyne: black/white/black*, Corcoran Gallery of Art, Washington D.C., October 26, 1996–February 10, 1997; High Museum of Art, Atlanta, April 22–July 27, 1997 (catalogue).
- Grand Lobby installation, Brooklyn Museum of Art, New York, September 22–December 4, 1989.

### Selected Group Exhibitions
- *Passion Complex: Selected Works From the Albright-Knox Art Gallery*, 21st Century Museum of Contemporary Art, Kanazawa, August 1–November 11, 2007.
- *ARS 06*, Museum of Contemporary Art, Kiasma, Helsinki, January 21–August 27, 2006 (catalogue).
- *Materials, Metaphors, Narratives: Work by Six Contemporary Artists*, Albright-Knox Art Gallery, Buffalo, October 4, 2003–January 4, 2004.
- *2000 Whitney Biennial*, Whitney Museum of American Art, New York, March 23–June 4, 2000 (catalogue).
- *Awards in the Visual Arts: 10*, Hirshhorn Museum and Sculpture Garden, Washington D.C., June 12–September 2, 1991; Albuquerque Museum of Art & History, September 15–December 1, 1991; The Toledo Museum of Art, December 15, 1991–January 26, 1992 (catalogue).

### Selected Bibliography
- Castro, Jan Garden. "Controlled Passion: A Conversation with Petah Coyne," *Sculpture* 21, no. 5 (June 2002): 22–9 (interview).
- ———. "Petah Coyne: Baroque Transformations and Humor," *Sculpture* 24, no. 7 (September 2005): 48–53.
- Coyne, Petah. "An Edge of Black," *Aperture* 145 (Fall 1996): 46–52.
- ———. "Petah Coyne - March 24, 1994. Studio, Greenpoint, Brooklyn," in *Inside the Studio: Two Decades of Talks with Artists in New York*, ed. Judith Olch Richards (New York: Independent Curators International, 2004).
- Davenport, Kimberly. "Impossible Liberties: Contemporary Artists on the Life of their Work over Time," *Art Journal* 54 (Summer 1995): 40–52 (interview).
- MacAdam, Barbara A. "'Girl' Talk," *ARTnews* 95, no. 8 (September 1996): 104–7.

## Angelo Filomeno

b. Ostuni, Italy, 1970
Lives and Works in New York

### Education
- 1986 MFA Academy of Fine Arts, Lecce, Italy

### Selected Solo Exhibitions
- *Angelo Filomeno*, Frist Center for the Visual Arts, Nashville, February 15–June 1, 2008.
- *Angelo Filomeno*, Marianne Boesky Gallery, New York, February 11–March 11, 2006.

### Selected Group Exhibitions
- *Pricked: Extreme Embroidery*, Museum of Arts & Design, New York, November 8, 2007–April 27, 2008 (catalogue).
- *Senso Unico: A Show of Eight Contemporary Italian Artists*, P.S.1 Contemporary Art Center, Long Island City, New York, October 21, 2007–January 14, 2008.
- *Think with the Senses, Feel with the Mind*, 52nd Venice Biennale, June 10–November 21, 2007 (catalogue).
- *ARS 06*, Museum of Contemporary Art, Kiasma, Helsinki, January 21–August 27, 2006 (catalogue).
- *Alternative Paradise*, 21st Century Museum of Contemporary Art, Kanazawa, November 5, 2005–March 5, 2006 (catalogue).
- *100% Acid Free*, White Columns, New York, December 10, 2004–January 30, 2005.

### Selected Bibliography
- Ducmanis, Ingrid. "An Angel at my Table," *Brooklyn Bridge Magazine* (May 1998): 44–5.
- Filomeno, Angelo, and Claudia Gian Ferrari. *Angelo Filomeno*. (Milan: Charta, 2003).
- Harris, Susan. "Angelo Filomeno at Marianne Boesky," *Art in America* (October 2006): 199.
- Korotin, Joyce B. "Angelo Filomeno," *Art Review* 4, no. 5 (May/June 2006): 123.
- Neil, Jonathan T. D. "Epistemic Threads: Angelo Filomeno's Unnatural History," *Modern Painters* (April 2005): 56–7.
- Spears, Dorothy. "Costume Shop Boy Makes Good," *New York Times*, February 12, 2006.

## Jesper Just

b. Copenhagen, 1974
Lives and works in Copenhagen and New York

### Education
- 2003 BFA The Royal Danish Academy of Fine Arts, Copenhagen

### Selected Solo Exhibitions
- *Jesper Just*, Brooklyn Museum, September 20, 2008–January 4, 2009 (catalogue).
- *Jesper Just*, Witte de With, Rotterdam, March 3–May 6, 2007; The Ursula Blickle Foundation, Kraichtal, March 4–April 15, 2007; Kunsthalle Wien, Vienna, April 1–April 29, 2007; S.M.A.K., Ghent, April 21–June 24, 2007 (catalogue).
- *Something to Love*, Stedelijk Museum, Amsterdam, December 9, 2006–January 21, 2007.
- *Black Box: Jesper Just*, Hirshhorn Museum and Sculpture Garden, Washington D.C., August 23–December 10, 2006.
- *Something to Love*, Herning Kunstmuseum, Herning, Denmark, February 24–May 29, 2005 (catalogue).

### Selected Group Exhibitions
- *Crack the Sky*, 5th edition of La Biennale de Montréal, May 10–July 8, 2007 (catalogue).
- *Everywhere*, Busan Biennial, September 16–November 25, 2006.
- *Do Not Interrupt Your Activities*, Royal College of Art Galleries, London, April 8–May 1, 2005 (catalogue).

### Selected Bibliography
- Gygax, Raphael. "The Melody of Loneliness," *Tema Celeste* 106 (November/December 2006): 56–9.
- Hirsch, Faye. "Crying Time: The Films of Jesper Just," *Art in America*, February 2006: 94–7.

## Mary McCleary

b. Houston, 1951
Lives and works in Nacogdoches, Texas

### Education
- 1975 MFA University of Oklahoma
- 1972 BFA Texas Christian University, Fort Worth

### Selected Solo Exhibitions
- *After Paradise*, Moody Gallery, Houston, June 3–July 8, 2006 (catalogue).
- *Raid on the Inarticulate*, Adair Margo Gallery, El Paso, November 13–December 31, 2003.
- *Beginning with the Word: Constructed Narratives: 1985–2000*, Galveston Arts Center, Texas, November 25, 2000–January 14, 2001; Stephen F. Austin State University, Nacogdoches, January 20–March 15, 2001; Dallas Visual Art Center, March 30–June 1, 2001; Art Museum of Southeast Texas, Beaumont, June 14–August 26, 2001; Russell Hill Rogers Gallery, Southwest School of Art & Craft, San Antonio, September 13–November 3, 2001 (catalogue).

### Selected Group Exhibitions
- *Texas 100: Selections from the Permanent Collection*, El Paso Museum of Art, September 3, 2006–January 14, 2007 (catalogue).
- *I ♥ the Burbs*, Katonah Museum of Art, New York, January 15–April 9, 2006 (catalogue).
- *A Broken Beauty: Figuration, Narrative and the Transcendent in North American Art*, Laguna Art Museum, California, November 6, 2005–February 26, 2006 (catalogue).

### Selected Bibliography
- Brown, Glen R. "Veiled Images," *Art Papers*, September/October 1994: 63–4.
- French, Christopher. "Mary McCleary," *ARTnews*, October 2006: 189.
- Johnson, Ken. "New Artists Who Are Motivated by Christianity," *New York Times*, August 19, 2005.
- McCleary, Mary. "Craftsmanship" in *It Was Good: Making Art to the Glory of God*, ed. Ned Bustard (Baltimore: Square Halo Books, 2006).
- Romaine, James. "Conversation with Mary McCleary, June 2001" in *Objects of Grace: Conversations on Creativity and Faith* (Baltimore: Square Halo Books, 2002).
- Roosa, Wayne L. "A Fullness of Vision: Mary McCleary's Collages," *Image: A Journal of Arts and Religion* 23 (Summer 1999): 32–42.

## Florian Maier-Aichen

b. Stuttgart, 1973
Lives and works in Cologne and Los Angeles

### Education

- 2001 BFA University of California (Deutscher Akademischer Austauschdienst Grant)

### Selected Solo Exhibitions

- *MOCA Focus: Florian Maier-Aichen*, Museum of Contemporary Art, Los Angeles, June 28–September 30, 2007 (catalogue).
- *Florian Maier-Aichen*, Blum & Poe, Los Angeles, January 21–February 25, 2006.

### Selected Group Exhibitions

- *USA Today: New American art from the Saatchi Gallery*, Royal Academy of Arts, London, October 6–November 4, 2006 (catalogue).
- *Whitney Biennial 2006: Day for Night*, Whitney Museum of American Art, New York, March 2–May 28, 2006 (catalogue).
- *The Blake Byrne Collection*, Museum of Contemporary Art, Los Angeles, July 3–October 10, 2005 (catalogue).
- *Constructed Realities*, Grand Arts, Kansas City, April 5–May 25, 2002.
- *Snapshot: New Art from Los Angeles*, UCLA Hammer Museum, Los Angeles, June 3–September 2, 2001 (catalogue).

### Selected Bibliography

- Eleey, Peter. "Florian Maier-Aichen," *Frieze* (May 2006): 177–8.
- Knight, Christopher. "Trick Photography," *Los Angeles Times*, July 16, 2007.
- Kunitz, Daniel, and Joao Ribas. "The Art Review 25: Emerging US Artists," *Art Review* 56 (March 2005): 111–26.
- Tumlir, Jan. "Outside the Frame: Florian Maier-Aichen," *Aperture* 187 (Summer 2007): 46–53.

## Wangechi Mutu

b. Nairobi, 1972
Lives and works in New York

### Education

- 2000 MFA Yale University, New Haven, Connecticut
- 1996 BFA The Cooper Union for the Advancement of Science and Art, New York

### Selected Solo Exhibitions

- *The Cinderella Curse*, Savannah College of Art and Design, ACA Gallery, Atlanta, May 9–June 24, 2007 (catalogue).
- *An Alien Eye: And other Killah Anthems*, Sikkema Jenkins & Co., New York, May 13–June 17, 2006.
- *New Work: Wangechi Mutu*, San Francisco Museum of Modern Art, December 16, 2005–April 2, 2006 (catalogue).

- *Wangechi Mutu, International Artist-in-Residence*, Artpace, San Antonio, November 11, 2004–January 23, 2005.
- *Wangechi Mutu*, Miami Art Museum, July 22–October 9, 2005 (catalogue).

### Selected Group Exhibitions

- *Collage: The Unmonumental Picture*, The New Museum, New York, January 16–March 30, 2008 (catalogue).
- *Fractured Figure*, Deste Foundation, Athens, September 5, 2007–April 19, 2008.
- *Still Points of the Turning World*, SITE Santa Fe's Sixth International Biennial, July 9, 2006–January 7, 2007 (catalogue).
- *Drawing from the Modern, 1975–2005*, The Museum of Modern Art, New York, September 14, 2005–January 9, 2006 (catalogue).
- *Fight or Flight*, Whitney Museum of American Art at Altria, New York, November 4–February 18, 2005.
- *Africa Remix: Contemporary Art of a Continent*, museum kunst palast, Düsseldorf, July 24–November 7, 2004; Hayward Gallery, London, February 10–April 17, 2005; Centre Georges Pompidou, Paris, May 25–August 8, 2005; Mori Art Museum, Tokyo, May 27–August 31, 2006 (catalogue).

### Selected Bibliography

- Brielmaier, Isolde. "Wangechi Mutu: Re-Imagining the World," *Parkett* 74 (2005): 6–9.
- Ciuraru, Carmella. "Cutting Remarks," *Art News* (November 2004): 116.
- Farrell, Laurie Ann, ed. *Looking Both Ways*. (Ghent: Snoeck Publishers, 2003).
- Gupta, Anjali. "Wangechi Mutu" in *Blanton Museum of Art: American Art Since 1900*, ed. Kelly Baum and Annette DiMeo. Carlozzi (Austin: University of Texas Press, 2006): 220–1.
- Helfand, Glen. "Voluptuous Horror," *San Francisco Bay Guardian Online* 40, no. 14 (January 2006).
- Kazanjian, Dodie. "Fierce Creatures," *Vogue* 196, no. 6 (June 2006): 214.
- Kerr, Merrily. "Extreme Makeovers," *Art on Paper* 8, no. 6 (July/August 2006): 28–9.
- Kruger, Barbara. "Wangechi Mutu," *Interview*, April 2007: 119-20, 158.
- Sirmans, Franklin. "Portfolio: Wangechi Mutu," *Grand Street* 72 (Fall 2003): 157–61.

## Anneè Olofsson

b. Hässleholm, Sweden, 1966
Lives and works in New York and Stockholm

### Education
- 1994 Royal Art Academy, Oslo

### Selected Solo Exhibitions
- *Anneè Olofsson*, Uppsala Konstmuseum, Sweden, April 26–June 1, 2008.
- *Evil Eye*, Aratoi-Wairarapa Museum of Art and History, Masterton, June 9–August 5, 2007.
- *Anneè Olofsson: The Conversations*, Mia Sundberg Galleri, Stockholm, October 5–November 3, 2006.
- *Anneè Olofsson: Skinned*, Västerås Konstmuseum, September 9–October 30, 2005.
- *Anneè Olofsson*, Marianne Boesky Gallery, New York, September 6–October 5, 2002 (catalogue).

### Selected Group Exhibitions
- *You won't feel a thing*, Wyspa Institute of Art, Gdansk, Poland, June 2–September 15, 2007; Kunsthaus Dresden, September 9–November 5, 2006 (catalogue).
- *Shoot the Family*, Cranbrook Art Museum, Michigan, February 4–April 2, 2006; Knoxville Museum of Art, Tennessee, June 23–September 3, 2006; Western Gallery, Western Washington University, Bellingham, October 2– December 1, 2006.
- *The World is a Stage: Stories Behind Pictures*, Mori Art Museum, Tokyo, March 29–June 19, 2005 (catalogue).
- *E-flux Video Rental*, E-Flux, New York, September 15–March 15, 2004; Manifesta at Home, Amsterdam, March 25–September 23, 2005; The Moore Space, Miami, May 12–August 31, 2005; Insa Art Space, Arts Council Korea, Seoul, October 21–February 20, 2006; Extra City, Antwerp, April 19–September 23, 2006; Mucsarnok/Kunsthalle, Budapest, July 27–October 1, 2006; PiST, Istanbul, November 11, 2006–February 10, 2007; Arthouse at the Jones Center, Austin, November 16, 2006–January 7, 2007; I Bienal de Canarias, Arquitectura, Arte y Paisaje, November 27, 2006–February 10, 2007; Carpenter for the Visual Arts at Harvard University, Cambridge, Massachusetts, February 8–April 13, 2007; Centre Culturel Suisse de Paris, April 15–July 15, 2007 (catalogue).
- *Plateau of Humankind*, 49th Venice Biennale, June 10–November 4, 2001 (catalogue).

### Selected Bibliography
- Chapman, Carolyn. "Pushing the Limits," *Washington Diplomat* (December 2002).
- Coulson, Amanda. "Emerging Artists: Anneè Olofsson," *Modern Painters* (October 2005): 64–5.
- LaBelle, Charles. "Anneè Olofsson," *Frieze* 59 (May 2001): 91.
- Olofsson, Anneè. *Anneè Olofsson*. (Esslingen: Galerie der Stadt Esslingen, 1993).
- Szylak, Aneta. "She May Not Be What She May Seem: Interview with Anneè Olofsson," *Art Journal* 61, no. 3 (Fall 2002): 78–87.

## Julia Oschatz

b. Darmstadt, Germany, 1970
Lives and works in Berlin

### Education
- 2000 MA Iceland Academy of the Arts, Reykjavik
- 1998 Diploma, Hochschule für Gestaltung, Offenbach am Main, Germany

### Selected Solo Exhibitions
- *Julia Oschatz: Where Else*. Kemper Museum of Contemporary Art, Kansas City, April 4–July 6, 2008.
- *Julia Oschatz*, Leslie Tonkonow Artwork + Projects, New York, April 12–May 31, 2008.
- *Hermitage Heritage*, Galerie Anita Beckers, Frankfurt am Main, April 4–July 6, 2007.
- *Julia Oschatz: Getting Nowhere Fast*, Institut für moderne Kunst Nürnberg, February 19–April 9, 2007.
- *Julia Oschatz: Cut and Run*, Kunstmuseum Mühlheim an der Ruhr in der Alten Post, August 11–October 1, 2006 (catalogue).

### Selected Group Exhibitions
- *Videonale 11–Festival of Contemporary Video Art*, Kunstmuseum Bonn, March 15–April 15, 2007 (catalogue).
- *Pathetic Fallacy*, Art Frankfurt 2005, April 29–May 2, 2005 (catalogue).

### Selected Bibliography
- Oschatz, Julia. *Julia Oschatz: Paralyzed Paradise* (Willingshausen: Herausgeber, 2005).
- Schutte, Christophe. "Einmal um die Ganze Welt," Frankfurter Allgemeine Zeitung, March 1, 2006.
- Smith, Roberta. "Art in Review; Julia Oschatz," *New York Times*, November 18, 2005.
- Weiner, Emily. "Julia Oschatz: Paralyzed Paradise III," *Time Out New York* 529 (November 17–23, 2005).

## David Schnell

b. Bergisch, Germany, 1971
Lives and works in Leipzig

### Education
- 2002 MFA Hochschule für Grafik und Buchkunst, Leipzig
- 2000 BFA Hochschule für Grafik und Buchkunst, Leipzig

### Selected Solo Exhibitions
- *Streifzuege: David Schnell*, Parasol Unit Foundation for Contemporary Art, London, June 21–July 29, 2006 (catalogue).
- *um zwölf*, Galerie EIGEN + ART, Berlin, November 19, 2005–January 14, 2006.
- *Sonntag*, Galerie Liga, Berlin, April 3–April 16, 2004.
- *David Schnell: New Paintings*, Sandroni Rey, Los Angeles, November 21–December 19, 2003.

### Selected Group Exhibitions
- *Life After Death: New Leipzig Paintings from the Rubell Family Collection*, Mass MoCA, North Adams, Massachusetts, March 19, 2005–March 31, 2006; Site Santa Fe, April 21–June 19, 2006; Katzen Arts Center Museum, American University, Washington D.C., September 6–October 29, 2006; Frye Art Museum, Seattle, February 16–June 3, 2007; Salt Lake Art Center, June 23–September 30, 2007; Kemper Museum of Contemporary Art, Kansas City, November 16, 2007–February 10, 2008 (catalogue).
- *Christiane Baumgartner/David Schnell*, Mönchehaus Museum für moderne Kunst Goslar, July 7–September 26, 2007.
- *Ausgewählt*, Kulturhaus Leuna, Germany, May 3–July 4, 2007 (catalogue).
- *Full House*, Kunsthalle Mannheim, April 2–October 22, 2006.
- *Landschaft*, Galerie EIGEN + ART, Berlin, July 1–August 26, 2006.
- *New German Painting: The Leipzig and Dresden "Schools,"* 2nd Prague Biennial, May 26–September 15, 2005.
- *From Leipzig: Works from the Ovitz Family Collection*, The Cleveland Museum of Art, January 30–May 1, 2005.
- *Cold Hearts*, Arario Gallery, Seoul, April 16–June 26, 2005.

### Selected Bibliography
- Jocks, Heinz-Norbert. "Die Möblierung des Naturraums: David Schnell," *Kunstforum*, June/August 2005: 255–9.
- Lubow, Arthur. "The New Leipzig School," *New York Times*, January 8, 2006.
- Schmidt, Johannes. "New Power, New Pictures: Dresden and Leipzig," *Flash Art* 37 (November/December 2004): 78–83.
- Volk, Gregory. "Figuring the New Germany," *Art in America* 93, no. 6 (June/July 2005): 154–9.

## Ryan Taber

b. Fort Knox, Kentucky, 1978
Lives and works in Los Angeles

### Education
- 2004 MFA California Institute of the Arts, Valencia, California
- 2000 BFA University of Hartford, West Hartford, Connecticut

## Cheyenne Weaver

- (b. San Miguel de Allende, Guanajuato, Mexico, 1979)
- Lives and works in Austin and Los Angeles

### Education
- 2004 BFA California Institute of the Arts, Valencia, California

### Selected Solo Exhibitions
- *In Search of a Myopic's Leitmotif- Ryan Taber + Cheyenne Weaver*, Machine Project, Los Angeles, January 22–February 20, 2005.
- *The Farallon Occupation*, Detour Project Space, San Francisco, November 2001.

### Selected Group Exhibitions
- *Project 29: Machine Projects*, Pomona College Museum of Art, Montgomery Art Center, Claremont, California, February 20–March 15, 2005 (catalogue).

### Selected Bibliography
- Pagel, David. "Around the Galleries," *Los Angeles Times*, February 11, 2005.
- "recentCOLLABORATION + RYAN TABER," http://www.cheyenneweaver.com/collaboration.html (accessed December 20, 2007).

# Notes on the Contributors

Terrie Sultan is director of The Parrish Art Museum. She was director and chief curator of Blaffer Gallery from 2000–8. Her extensive publications include *Jean Luc Mylayne* (Santa Fe: Twin Palms Press, 2007), *James Surls: The Splendora Years*, 1977-1997 (Austin: University of Texas Press, 2005), *Jessica Stockholder: Kissing the Wall*, *Works*, 1988–2003 (Seattle: Marquand Books, 2004), and *Chuck Close Prints: Process and Collaboration* (Princeton: Princeton University Press, 2003). She has published and lectured widely on issues related to contemporary visual art and culture and was awarded the *Chevalier dans l'Ordre des Arts et des Lettres* from the French government in 2003.

David Pagel is a regular contributor to the *Los Angeles Times* and author of *Darren Waterston: Representing the Invisible* (New York: Charta Books Ltd., 2007). He is associate professor of art theory and history and chair of the art department at Claremont Graduate University. Pagel has also organized such exhibitions as *Painting <=> Design*, Claremont Graduate University (2007); *Sush Machida Gaikotsu* at the Las Vegas Art Museum (2007); and *Populence* at the Blaffer Gallery (2005). He has been awarded a Macgeorge fellowship, University of Melbourne, Australia, and an Andrew W. Mellon Fellowship in Contemporary Arts Criticism.

Colin Gardner is professor of critical theory and integrative studies at the University of California, Santa Barbara, where he teaches in the Departments of Art, Film & Media Studies, Comparative Literature, and the History of Art and Architecture. A frequent contributor to various catalogues and the *Journal of Neuro-Aesthetic Theory*, he is the author of two books from the British Film Makers series, *Karel Reisz* (Manchester, UK: Manchester University Press, 2007) and a critical study of the blacklisted film director Joseph Losey (Manchester, UK: Manchester University Press, 2004).

Nick Flynn is an assistant professor of English at the University of Houston. His memoir *Another Bullshit Night in Suck City* (New York: W. W. Norton & Co., 2004) won the PEN/Martha Albrand Award, was shortlisted for France's *Prix Femina*, and has been translated into thirteen languages. He is also the author of two books of poetry, *Some Ether* (St. Paul: Graywolf Press, 2000), which won the PEN/Joyce Osterweil Award, and *Blind Huber* (St. Paul: Graywolf Press, 2002), for which he received fellowships from The Guggenheim Foundation and The Library of Congress. Flynn was also an artistic collaborator on the Academy Award-nominated documentary *Darwin's Nightmare* (2005).

Claudia Schmuclki is curator at Blaffer Gallery, the Art Museum of the University of Houston. She received her M.A. in art history from Ludwigs-Maximilians-Universität, Munich, in 1996. Her curatorial projects for Blaffer include *Amy Sillman: Suitors and Strangers* (2007), *Katrina Moorhead: A Thing Called Early Blur* (2007), and *Urs Fischer: Mary Poppins* (2006). Past exhibitions include *Projects 79: Liam Gillick, Literally* (2003) and *Projects 73: Olafur Eliasson—Seeing yourself sensing* (2001), both at the Museum of Modern Art, New York.

# Index

Page numbers in *italics* refer to illustration captions.

# Reproduction Credits

Courtesy the artist, Ghent, Belgium: figs. 19–23, 68–70

Courtesy the artists, Los Angeles: figs. 16–18, 127–31

Courtesy the artist and Anthony Reynolds Gallery, London: figs. 10, 11, 55, 62–7

Courtesy the artist and Blum & Poe, Los Angeles: frontispiece, figs. 7–9, 107–9

Courtesy the artist and Galerie EIGEN + ART Leipzig/Berlin, © 2007 Artists Rights Society (ARS), New York / VG Bild–Kunst, Bonn: cover, figs.13–15, 124–6

Courtesy the artist and Galleri Christina Wilson, Copenhagen, Copyright © Jesper Just 2000–7: figs. 41, 97–102

Courtesy the artist and Galleri Christina Wilson, Copenhagen / Perry Rubenstein Gallery, New York, Copyright © Jesper Just 2000–7: figs. 38–40, 42

Courtesy the artist and Galerie Emanuel Perrotin, Paris / Miami, © 2007 Artists Rights Society (ARS), New York / ADAGP, Paris: figs. 30, 31, 76–8

Courtesy the artist and Galerie Emanuel Perrotin, Paris / Miami, Erna Hecey & Gehry Partners LLP © 2007 Artists Rights Society (ARS), New York / ADAGP, Paris: fig. 32

Courtesy the artist and Galerie Emanuel Perrotin, Paris / Miami; Arndt & Partner, Berlin / Zurich; Galerie Koyanagi, Tokyo; Paula Cooper Gallery, New York, © 2007 Artists Rights Society (ARS), New York / ADAGP, Paris: fig. 33

Courtesy the artist and Galerie Lelong, New York, © Petah Coyne: figs. 24–7, 79–84

Courtesy the artist and Galerie Lelong, New York, © Angelo Filomeno: figs. 43, 45, 46, 85–90

Courtesy the artist and Leslie Tonkonow Artworks+Projects, New York: figs. 48–51, 56, 119–23

Courtesy the artist and Mia Sundberg Galleri, Stockholm: figs. 34–7, 114–18

Courtesy the artist and Moody Gallery, Houston: figs. 52–4, 103–6

Courtesy the artist and Perry Rubenstein Gallery, New York, Copyright © Jesper Just 2000–7: front and back cover, figs. 91–6

Courtesy the artist and Sikkema Jenkins & Co., New York: figs. 28, 110, 111, 113

Courtesy the artist and Susanne Vielmetter Los Angeles Projects: figs. 29, 112

Courtesy the artist, Toronto Image Works, and Charles Cowles Gallery, New York: figs. 2–5, 71–5

Courtesy Bridgeman Art Library: figs.12, 47, 132

Courtesy Fortissimo Film Sales B.V.: fig. 61

Courtesy Time & Life Pictures / Getty Images: fig. 57

Courtesy of Universal Studios Licensing LLLP and Sofia Coppola (Cinetic Media): fig. 59

Courtesy the Worcester Art Museum, Worcester, Massachusetts: fig. 44

© 2007 The Ansel Adams Publishing Rights Trust: fig. 6

© 1987 Reverse Angle Library GmbH: figs. 1, 58

# Photography Credits

Jan Pauwels: figs. 21, 69

F. Kleinefenn: fig. 33

Dirk Pauwels / Jan Pauwels: fig. 68

Wit McKay: figs. 24–7, 79–80, 84

D. James Dee: figs. 81, 83

Dennis Cowley: fig. 82

Joshua White: fig. 29

Allan Grant/Stringer: fig. 57

Uwe Walter: cover, fig. 15